D0710110

THE BODY/BODY PROBLEM

THE BODY/BODY PROBLEM

SELECTED ESSAYS

ARTHUR C. DANTO

UNIVERSITY OF
CALIFORNIA
PRESS *Berkeley / Los Angeles / London*

University of California Press
Berkeley and Los Angeles, California

University of California Press, Ltd.
London, England

First Paperback Printing 2001

© 1999 by Arthur C. Danto

The epigraph to chapter 2 is from *Bruno's Dream*, p. 240, by
Iris Murdoch. ©1969 by Iris Murdoch. Used by permission of
Viking Penguin, a division of Penguin Putnam Inc.

Library of Congress Cataloging-in-Publication Data

Danto, Arthur Coleman, 1924–
 The body/body problem : selected essays / Arthur C. Danto.
 p. cm.
 Includes bibliographical references and index.
 ISBN 0-520-22908-8 (pbk. : alk. paper)
 1. Representation (Philosophy) I. Title.
 B105.R4D36 1999
 128'.6—dc21 98-39125
 CIP

Printed in the United States of America

08 07 06 05 04 03 02 01
9 8 7 6 5 4 3 2 1

The paper used in this publication meets the minimum requirements of
ANSI/NISO Z39.48-1992 (R 1997) (*Permanence of Paper*). ∞

To Dieter Henrich

Contents

Preface

THE OVERALL SUBJECT of these essays is the traditional one of what our ultimate makeup is, as creatures with minds and bodies; and the central, familiar thesis is that we are beings who represent actual and possible worlds (which means that we are also beings who misrepresent). There is a general problem of how our representations are embodied, presumably in our central nervous system, but I have been struck, in reading through the essays that compose this volume, by how frequently I drew upon analogies between human beings and artworks, preeminently paintings and photographs, to clarify issues in the metaphysics of embodiment and of truth. In the past some years I have written extensively on the concept of art, but what these essays make vivid is the degree to which that concept has dominated the way I have thought philosophically about any topic, and this has set my writing apart from much of the philosophical mainstream. But that can be explained, I think, through the fact that art is typically thought to be marginal to philosophy, a kind of ontological frill, whereas it is in my view absolutely central to thinking about subjects—especially subjects having to do with our own philosophical nature, to which the pertinence of the concept of art seems initially remote. Philosophy and art are not discontinuous fragments of a divided subject, but facets of a single unitary philosophy,

which thinks of art philosophically and of philosophy from the perspectives of art. So although the essays gathered here might be thought to be addressed to a different audience than the one that characteristically reads my writings on art, in fact they project a single, evolving conception of human beings, considered as beings who represent—as *ens representans*—with works of art simultaneously being understood as materially embodied representations.

The overall tendency in the philosophy of mind has consisted in treating human beings as if the relationship between minds and brains were analogous to the relationship between images and paint. But images have historical relationships to one another which cannot be assimilated to the relationship between minds and brains, and how we represent the world must, accordingly, depend upon where we are placed in history and what kinds of representations are available to us at that location. The brains of individuals at different times cannot themselves greatly differ, but the representations they have will differ greatly, and something outside the brain must account for these differences. But history is as marginalized as art in mainstream philosophy, which would like to address us, ultimately, in the most exiguous physicalistic way. So what further sets these essays apart is the centrality they collectively ascribe to history in dealing with what we ultimately are. My hope is not so much to urge more philosophers to become aestheticians, much less philosophers of history, but to make plain what we sacrifice in our ultimate self-understanding if we think of art and of history as anything but fundamental to how we are made, and how our bodies must therefore be in order for this to be true.

I want particularly to express my gratitude to the artist Sean Scully for permitting the use of his work on the jacket of this book. He is one of the most widely admired contemporary artists, and I have always found his work at once pleasurable and profound. I have selected the etching *Large Mirror III* (1997) in part for its beauty, but also in part for the fact that it relates to the representational themes of these essays. The mirror is, after all, the ground analogy for the mind, and its failures and successes

are slyly mapped in Scully's marvelous composition of thin and thick bars. See my essay "Between the Lines: Sean Scully on Paper," published in the exhibition catalog *Sean Scully: Works on Paper, 1975–1996* (Munich: Staatliche Graphische Sammlung, 1996).

I am greatly indebted to Edward Dimendberg, of the University of California Press, for having proposed a collection of my essays, and for agreeing, in the end, to *two* collections, one—a companion volume to this one—on art as a mode of philosophizing. I have too many other debts to consider acknowledging them here, but I must express my further gratitude to Rose Vekony, senior editor of the University of California Press, and to Anne Canright, the best copyeditor I have ever worked with.

Introduction

Philosophy, Representation, and History

GEORGE SANTAYANA WROTE of his philosophy that it would have been the same "under whatever sky I had been born." His view was that, so far as philosophy is concerned, one part or stage of the world is like any other, and that nothing properly philosophical belongs to one rather than another time or place. Santayana wrote a classic in the philosophy of art, *The Sense of Beauty*, in which he argued that beauty is pleasure objectified, by which he seems to have meant that the pleasure caused in us by art or nature, considered aesthetically, is unconsciously projected outward onto its causes and treated henceforward as among their objective properties. Beauty is a subjective state regarded as an objective presence. His philosophical model for this theory was David Hume, who famously argued that the concept of causal necessity is a projection outward of a habit, instilled in us by our experiencing constant conjunctions of like events with like. The necessity we believe connects cause to effect is but the force of habit objectified—a state of mind misread as a state of the world. Under whatever sky, Hume might have insisted, there is nothing more to causality than this, whatever may have been believed by philosophers trapped in earlier systems of thought. And although it can at least be questioned whether Santayana could have arrived at his view under a sky that did not include his great predecessor, Santayana

I

similarly believed that there is no more to beauty than pleasure miscast as an objective property of what happens to give us pleasure, even if, under different skies, different orders of things may cause individuals to feel pleasure.

Santayana came to see his views of beauty as after all indexed to a certain historical moment. "You must remember," he wrote the aesthetician Thomas Munro in 1921, "that we were not very much later than Ruskin, Pater, Swinburne, and Matthew Arnold: our atmosphere was that of poets and persons touched with religious enthusiasm or religious madness. Beauty (which mustn't be mentioned now) was then a living presence, or an aching absence, day and night." His ingenious analysis of the sense of beauty might still hold good, wherever we take pleasure in things. But pleasure and beauty ("which mustn't be mentioned now") had become decreasingly relevant to the experience of art. Nothing in Ruskin, Pater, Swinburne, or Arnold would have prepared anyone for Cubism, or Dada, or German Expressionism. Notoriously, Ruskin was unable to assimilate Whistler to his idea of art, let alone his idea of beauty. Ruskin was so harsh and angry a critic that it is easy to suppose that what he said about the advanced art of his times, in which the connection between beauty and art was beginning to weaken, was the projection outward of the pain it caused him: Whistler's painting was irascibility misread as ugliness. In any case, a philosophy of art based on beauty and pleasure under European skies in the late nineteenth century would be entirely out of touch with art made under the skies of Modernism.

The thought that philosophy must be everywhere and always the same encounters some difficulty with the kinds of transformation exhibited in the change from traditional to modernist, and then postmodernist, art. Philosophies of art based on nineteenth-century artworks are nineteenth-century philosophies of art and cannot easily be exported into the twentieth century, when art is so different from, for example, the Pre-Raphaelite work that Ruskin so admired. The concept of art, which the philosophy of art aspires to understand, may indeed be

timeless. But any familiarity with the history of art must make it plain that most actual philosophies of art were so constrained by their historical moment that they could not easily be applied when future artistic possibilities unfolded, ones so radically discontinuous with the works of art from which they were derived that an initial impulse is, as with Ruskin, to deny them the status of art at all. For to think of them as art means that what we thought was philosophical truth was restricted to a historical moment. One can be certain one's philosophy is indemnified against future history only if the belief can be justified that nothing the future brings will force abandonment of or adjustment in the concept we have arrived at. A truly timeless philosophy of art must be compatible with every possible artworld, as a timeless philosophy of causation must be true under every possible sky, however hidden it may be from thinkers blinded by the smoke of inadequate theories. The bird of wisdom, Hegel writes, takes flight only with the falling of the dusk. Philosophy paints its gray in gray only when the history of its subject will have run its course.

Hegel would not have supposed his philosophy would be the same "under whatever sky." Rather, he saw his philosophy as internally connected with the historical moment in which he arrived at it. His masterpiece, *The Phenomenology of Spirit*, was composed in the university town of Jena, just when the cannons of Napoleon were firing outside its gates. He saw Napoleon as fulfilling through action what he, Hegel, brought to self-consciousness in his writing. His philosophy, he makes plain, would not have been possible at any earlier phase of history. "Absolute knowledge became—objectively—possible," Hegel's great commentator, Alexandre Kojeve, wrote, "because in and by Napoleon the *real* process of historical evolution, in the course of which man *created* new worlds and *transformed* himself by creating them, came to its end."[1] His view was that a true philosophy is internally connected with the history it culminates, the same way we understand what happened in a story only by reading the last page. A skyless philosophy is what philosophers aspire to, but their actual philosophies, like Santayana's aesthetics, are parochial

reflections of specific moments in the history of their subjects. Even under Hellenic skies, in which mathematics was venerated, it would have been difficult to attain an adequate philosophy of numbers. Nothing the Greeks recognized as numbers—integers and fractions—could solve $x^2 = 2$, so one had to invent a special kind of number—irrational numbers—whose relationship to rational numbers had to be reflected in philosophical representations of what numbers are. New kinds of numbers had similarly to be invented to solve equations beyond the reach of the numbers one knew about. To base one's concept of numbers merely on the natural numbers would be like basing one's conception of art on the work of Giotto, at the beginning of art's long development. And in the end the concept of number is astonishingly more abstract than anyone would have recognized whose paradigm was adding 2 and 2.

In his *Lectures on Aesthetics*, Hegel declared that the history of art was just such a story, and that it had come to an end. He based this in part on the view that art was no longer able to relate to society as it once had done, in Greek or in Gothic times, expressing the objective spirit of those eras. A gap had grown up between society and art, which had increasingly become a subject for intellectual judgment rather than, as beauty was felt to be in Santayana's rueful recollection, an object of sensuous or spiritual response. A philosophy of art was now possible. I certainly felt this to be true when I began to write on the philosophy of art, at a moment when it seemed to me at last possible to grasp what the history of art had been about and the time for its philosophy was at hand. If it was good philosophy, it would be true for any sky under which art was to be found; but *my* philosophy of art would hardly have been the same under skies other than those of Manhattan in the latter decades of the twentieth century. I began to take Hegel especially seriously as a philosopher when I was forced to think about the fact that certain works of art that interested me deeply did so precisely because they could not have been made in earlier times. The art of Andy Warhol—the Napoleon of my own philosophy of art history—consisted in part of objects that would not have been possible as art a century earlier than

their fabrication. *Brillo Box*, of 1964, is to a degree characterized by the fact that it would look like a box of Brillo *under whatever sky*. But only under the Manhattan sky in the 1960s could it have been seen as a work of art. It (but not it alone) made clear that there is no special way that works of art have to look: they can look any way at all. And that was like bringing into the art world the values of the French Revolution—*liberté, égalité, fraternité*. Artists were free to make what objects they chose, all such objects were ontologically equal, and works of art constituted a kind of brotherhood, standing to one another in systems of relationships from which mere objects were excluded. Warhol demonstrated that art and reality could resemble one another to whatever degree one desired. But only when this happened could a philosophy of art like mine be thought.

Aside from Hegel's, very few philosophies internalize their own histories, and in this respect most philosophers are disciples of Santayana. They address their subjects, accordingly, in ways from which any possibility of historical difference has been subtracted. Thus knowledge, according to epistemological practice, is had when someone says, "Red here now," when confronted with a patch of red. The tacit agenda is that if certainty is to be found anywhere, it is to be found in episodes like these, episodes that are subhistorical and foundational, like the basic propositions of the logical positivists or the "formulations of what is given in experience," in the philosophy of C. I. Lewis. Philosophers have of course wrangled over whether, even in these most reduced of cognitive encounters, certainty can be ascribed. But for purposes of debate, human beings are represented in a mode of primitivism cleverly captured in a piece of doggerel composed by Quine: "The unrefined / And sluggish mind / Of *Homo javenensis* / Could only treat / of things concrete / And present to the senses." The Java Man is a kind of epistemological cartoon, but it is not greatly distant from the conventional philosophical portraits of *Homo sapiens'* sapience. The epistemologist H. H. Price likened "Here now red" to a thermometer reading and considered a theory suggesting that human beings register differences in their environment the same way thermometers do.[2] We can imagine ourselves in this way as cognitive

thermometers, emitting signals, but that would be so distant a picture of what it means to be human that we know it will have to be abandoned when we seek to close the gap between *Homo javenensis* and, let us say, the philosopher Hegel, who sees knowledge, and especially philosophical knowledge, as having a history. If knowledge were restricted to representations, epitomized by "Red here now," it is difficult to see how we could even understand the concept of history. It would be a staccato of sensory reports.

The *Analytical Philosophy of History*, my first book, addressed itself to narratives as modes of representation. A narrative, I thought, will describe events in terms that later events make available but that generally cannot have been known about when the earlier events took place. Thus someone might point to a tree stump in a Tuscan inn yard and tell this story: Once a holy man climbed the tree that grew there to escape pursuing wolves. The innkeeper's daughter drove the wolves away, and the holy man prophesied that she and the tree would be blessed. The tree was cut down and fashioned into barrel heads for the innkeeper, and on one of these the greater painter Raphael, enchanted by the daughter's beauty, depicted her with her children. This work, the *Madonna della seggiola*, is the jewel of the Pitti collection, and art lovers the world round come to admire it. The narrative refers to an early state of the tree with reference to a later one, and it is perhaps an epistemological privilege of holy men, one denied the rest of us, that they can see the present in prophetic terms—terms that will become available to historians only later, after the events have occurred with reference to which the historical meaning of the earlier ones can be understood. Who could have known when the abduction of a princess by Persian merchants took place that this was the beginning of the tremendous conflict between Greece and Persia? But in telling the story of their antagonism, Herodotus begins his narrative of the Persian Wars there.

It does not especially matter that this story of the Persian Wars is, in Herodotus's view, false and self-serving for one of the antagonists. It does not matter either that the story of Raphael's masterpiece is but

myth. If it is believed, then historical significance is conferred on a stump no more different from other stumps than they are from one another. The tree was singled out by an interest in Raphael's work, in just the way Stratford-on-Avon is singled out as the birthplace of Shakespeare. The birth of William Shakespeare in 1564 was bound to have deep and universal meaning for Shakespeare's parents, but it would be a historical joke to imagine a neighbor excitedly exclaiming that "the author of *Hamlet* has just been born." What could reference to an unwritten masterpiece have had for anyone when its future author had barely entered the world? If it could have meaning, the masterpiece must in some sense already have been written, but be readable only to prophetic eyes, since the implied narrative demands an unavailable knowledge of the future. But there are no cognitive difficulties, after 1600, in redescribing the earlier event as the birth, in 1564, of the author of *Hamlet*. It is a mark of narrative descriptions that in order to have known them true when the earliest event referred to took place, one would have needed to possess prophetic vision. There are problems about knowing the past, of course, but it does not require a cognitive miracle, the way knowing the future would. What makes narrative sentences true is not something present to the senses of someone contemporary with the earliest events narrated. The best they could come up with would be "Stump here now" or "The Shakespeares have a baby boy."

I thought the cognitive asymmetry of narratives, together with the way in which they connected time-separated events, to be so distinctive a feature of historical representation that what I termed "narrative sentences" might serve to distinguish history from any other descriptive endeavor. Of course, historians aim at *true* narratives, and claim on that basis to be contributing to knowledge. But at the time I wrote that book there was, among tough-minded philosophers, some consensus that the discipline of history should be replaced by some set of social sciences, and historical events understood in the light of general laws. That, though, would effectively eliminate the narratives through which, it seemed to me, history acquires its intellectual autonomy. A great deal of

our interest in things has to do with the narratives they elicit: the laws of dendrology and (if there are any) of lumbering will not entail the narrative meaning of a tree stump, which has no special physical aura to distinguish it from others of its kind. This will be true of historical descriptions generally, which are beyond the reach of science, whose descriptions are disinterested and universal. But narrative sentences depend precisely on human interests: later generations so esteemed Raphael's painting that they wanted a story magic enough to explain *its* magic. That interest could have made a shrine of a stump in an inn yard, the way the story of Walter Benjamin's suicide near the Spanish border has conferred that status on what locals say is Benjamin's grave when pilgrims ask to be shown where the great man lies. It could be any grave or no grave at all, but simply a pile of dirt with a counterfeit placard. We are interested in Shakespeare's birth because we are interested in *Hamlet*. Stratford-on-Avon might erect a plaque proclaiming itself "the birthplace of the author of *Hamlet*." That phrase could have been written in 1564, but it could not have meant what it came to mean when *Hamlet* was written, thirty years or so later, and an interest was excited in its author.

Human beings have been pretty much the same, physiologically speaking, under whatever skies have covered successive generations from the first *Homo sapiens* down to us. From the perspective of the human genome, humankind has no history, since historical differences do not penetrate the genetic material, which changes only through mutation. Because the species has not evolved for a hundred thousand years, historical differences between representations cannot be referred to our physical endowment, which has been more or less always the same. This endowment must therefore be consistent with whatever differences there are between one historical moment and another, and at the same time explain how we are able to live in history—which means to represent present, past, and future in relationship to one another and to our interests. Today the tough-minded think of us as so much nervous tissue, and the language in which we must ultimately describe our-

selves is that of highly sophisticated neurophysiological theory. Almost certainly, when I believe that Shakespeare was born in 1564, I am in some neurochemical state, different from that I am in when I (falsely) believe Shakespeare born in 1645. Perhaps that means that having these beliefs is identical with being in these states—that the belief and the neuro-state are one and the same. Having then a common reference, we can drop the language of thought and speak henceforward in the language of synapses and neurotransmitters, as Richard Rorty once contended. But that is true if and only if meaning is restricted to reference—to what Frege called *Bedeutung*—and not to ways in which co-referential terms can mean different things depending on the mode in which what is referred to is presented. The philosophical torment of the mind/body problem arises from the difference between the mode of presentation of neural states and that of states of mind, like beliefs and attitudes. The first essay here, "Representational Properties and Mind/Body Identity," attempts to explain this discrepancy.

Meanwhile, although electric discharges lead only to electric discharges, beliefs give information of an entirely different order, just as— the example is justly famous—"Morning Star" and "Evening Star" convey information which reference to the planet each of them designates will not yield. It was a *discovery* that the Morning Star and Evening Star are one; it happened at a certain moment in history, when beliefs about the heavens were being represented in new ways. Our systems of representations *change* from sky to sky. If we write narratives of the history of science, it will be a history of scientific representations; how one system changes into another has to do with the meanings of representations and not merely (or at all) with the neurophysiological states of scientists at different states, granting that representing refers to neurophysiological states. My own sense is that we can explain changes from one state to another only by explaining the change from one system of representations to the other. But the laws of neurophysiological change alone cannot yield explanations of such changes, because the terms in which we

describe representations have no place in neurophysiology. Eliminativists, who insist that we are only nervous tissue, can explain changes—but not historical changes. The problem is easily solved if we deny, as they do, that there are mental states, there then being nothing to explain, since the whole language of psychology belongs to a discredited theory that neurophysiology will replace. The difficulty, then, is for Eliminativists to account for their own philosophy, which is after all a set of beliefs about beliefs—a representation of mental representations—intended to refute other representations, held by other philosophers. Perhaps in the promised land of future neurophysiology, philosophy will fade away with the mental language it attempts to analyze. But what about the science that will be required to ferry us to this understanding? And what about understanding itself, as for example when someone understands at last that we are but nervous tissue?

Several of the essays in this volume examine the differences between individuals at different stages of a common history making contributions to that history. In "History and Representation," for example, I contrast how the first generation of microscopists represented paramecia, which had just been discovered, and how scientists three centuries later were able to represent these animalcules using instruments and theories of which the first observers of infusoria had to have been ignorant, since the knowledge came only in a future unimaginable to them. In "Beautiful Science and the Future of Criticism," I contrast the work of John Dalton, who discovered color blindness, with the work of Jeremy Nathans and his associates, who discovered the genetic basis for that abnormality. The history of science is not simply a succession of discoveries: it is the successive transformations of an entire body of representations, each of which defines a moment in scientific practice. The bodies of representation which express scientific understanding at either end of two centuries of continuing investigation can certainly not be translated into one another, except for such common elements as an under-whatever-sky philosophy of science might recognize. Seventeenth-century theories of animalcules would be regarded in some ways as crazy

by most twentieth-century scientists. Still, it was those extravagant beliefs, so discrepant with our own, which motivated the observations made through awkward single-lens instruments of magnification and led to modern scientific triumphs (and which, along a different coordinate of culture, gave rise to the flea circus). It *is* the glowing vision of science to arrive at truth, which would be the same under whatever sky. But how is one then to treat scientifically, let alone philosophically, the fact that systems of representation differ to the point of incongruence under *different* skies? If there is anything universal about human beings, it is that given a largely identical biology, they (we) will represent the world differently from stage to stage of the histories in which they (we) participate.

What concerns me in these essays is what must be true of human beings for us to live in history, assigning meanings to past events, telling conflicting stories that justify actions in our own eyes, embarking on courses of action the suitability of which emerges only when the future puts the past in a certain light. I am asking what human beings must be like for representations like these to be housed in our heads, determining us to act and desist in certain ways. That is why histories of representations, as in histories of science or of art, are so crucial to my analyses. There is, I think, an analogy between representations and physiology, on the one hand, and, on the other, between the sentences I type and the swarm of electronic transformations within the computer on which I type them. Someone could analyze computers entirely in terms of electronic transformations, but these sentences have contents in which such firestorms of electric pulses do not figure. Only beings with brains and bodies like our own are capable of living in history; it does not follow, however, that living in history can be understood through our brains and bodies alone. "The Asiatic, according to the Persians, took the seizure of women lightly enough, but not so the Greeks," Herodotus writes. "The Greeks, merely on account of a girl from Sparta, raised a big army, invaded Asia, and destroyed the empire of Asia. From that root sprang their belief in the perpetual enmity of the

Grecian world toward them." Dissonances in moral attitudes generate a great history and enter into the explanation of the rise and fall of powers and the deaths of countless men. Herodotus considers alternative accounts, inconsistent with the ways Asiatics view the history of their calamities. Inconsistency is a logical relationship, holding between representations. Do neurophysiological states stand in logical relationships to one another? Only if they have the structure of representations already. The theories of the Eliminativists, though, were intended to disqualify representation as belonging to an archaic kind of science and as being no more part of human reality than phlogiston, after Lavoisier, was part of chemical reality. But then how is conflict to be explained, say of the sort which engages Eliminativists on one side and the rest of us on the other?

Anyway, as I argue here in various ways, neuroscience is a science, and hence a system of representations in its own right, which defines a moment in a history of representations, owners of which will differ precisely through differences in their representations from one another, and these will be different from stage to stage in that history. Under this view, individuals are systems of representation—are representational *texts.* And texts are held together by connections of an entirely different order from the electrochemical forces that bind neurophysiological processes together. One sentence follows another sentence in the text I am writing—or fails to follow, subverting my intentions. But whatever the relationship—illustrating a point, drawing a consequence, evolving a story—these sentences have no place in the design of my computer. The brain is the brain, under whatever sky, and the neural system the neural system. What is important about brains, however, is the way they house different systems of representation at different times. No philosophy should cut itself off from what makes it possible. It is, after all, a narrative sentence (even if a self-defeating one) that our present theories of mind will be invalidated by the neurosciences of the future!

For some considerable while I have viewed representation as the central concept in philosophy, with differences among philosophers arising

in the ways they account for how representations connect to the world, connect to the individuals who possess them, and connect with one another to form systems of beliefs, feelings, and attitudes. The main connections to the world are causation and truth, each of which figures in philosophical accounts of knowledge and of action: a representation is knowledge when caused by what makes it true (which is what renders knowledge of the future suspect, since what would make its representation true cannot explain the representation unless causation should run backward; something is an action when caused by a representation it makes true. There is doubtless more to knowledge and to action than this exiguous catalog of components and connections, but I mean to stress that only to a representational being—a *res representans*—can knowledge or action be ascribed, as well as error and misperformance, which are after all failures of fit between representations and the world. In the simple, attenuated episodes on which philosophers base their epistemological hopes, representation is an *effect*. In the no less simple episodes of action—like raising an arm or moving a stick—modifications of the world are *effects* of representation. Representation is the common element in the philosophy of knowledge and the philosophy of action, as well as in the analytical philosophy of history. In this collection of linked essays, however, I advance a philosophy of human beings as systems of representations, some of which represent portions of that system, and so constitute the kind of self-consciousness Hegel supposed he had attained to when he wrote the *Phenomenology*, relating earlier and later representations under narrative descriptions.

Representing, of course, is how we would characterize certain public activities—describing, for example, or picturing. Vermeer's *A View of Delft* is a pictorial representation of the city he lived in. Proust's *Remembrance of Things Past* is a description of a life as congruent with the one he lived as *A View of Delft* is to Vermeer's city. These kinds of representations are addressed in the essays on art which compose a companion volume, *Philosophizing Art*, but here I am to be concerned primarily with the philosophical anatomy of beings composed of representations—of

beliefs and thoughts, feelings and intentions, desires and regrets. Descartes, in one phase of his thought, houses representations—what he terms *idées*—in *res cogitans*, or thinking substances, which is preoccupied with how to avoid error and find truth. The *res cogitans* is logically separable from the body that accompanies it through life, thus making room for its immortality, which Descartes considered an achievement of his metaphysics to have established. But in another phase of his philosophy—which I address in "The Body/Body Problem"—he saw the mind as so intimately bound up with the body that together they formed a single, if complex, whole. The *res cogitans* is *embodied*, which means that the representations, which are its essence, are embodied the same way meanings are embodied in physical marks or sounds, or *The View of Delft* is embodied in the paint Vermeer manipulated to achieve it. As such, the *res representans* brings something to the world it would otherwise lack—a point of view, with reference to which objects are transformed into instruments and obstacles, and hence systems of meanings. But points of view—which I discuss in "The Decline and Fall of the Analytical Philosophy of History"—connect us with living in history, since those with different points of view will view the past under different narrative sentences, the way Greeks and Persians did centuries ago. What would it even mean to speak of computers, under the kinds of description in which electronic engineers are fluent, as having different points of view?

In fairness, it must be said that Santayana served as a model for me in having composed *The Life of Reason*, a philosophical work in five volumes, each treating reason under a different aspect: in science, art, religion, politics, and common sense. Somewhat against the literary grain of contemporary philosophy, which for a long time gave privilege to the single article over books, and certainly gave single books priority over the multivolume systems that would have been prized in earlier times, I conceived the hubristic idea of writing a philosophy of representation that would require five volumes, different of course in content from

Santayana's volumes. Beginning with *Analytical Philosophy of History*, I went on to write *Analytical Philosophy of Knowledge* and *Analytical Philosophy of Action*. When I came to write my philosophy of art, it did not *feel* like an analytical philosophy of art, and this is reflected in the title I chose: *The Transfiguration of the Commonplace*. A book on *res representans* was to have concluded the series and completed the system. These essays were written with that goal in mind, but, for better or worse, they will have to stand proxy for that book.

Each of the books just cited was built around some central idea, originally presented in an independently published article in one or another philosophical publication. None of these is republished here, so this is not a collection of my best-known papers. *Analytical Philosophy of History* pivots on the idea of narrative sentences, *Analytical Philosophy of Knowledge* on the theory of beliefs as sentential states, *Analytical Philosophy of Action* on the idea of basic actions and on the structural parallels between knowledge and action. *The Transfiguration of the Commonplace* transfigured its own animating essay, "The Art World," in that it takes representation to be part of the definition of works of art. After that book appeared I published *Connections to the World*, which endeavored to represent the whole of philosophy in representationalist terms and, subversively, to insinuate my own system as a contribution to the question of what philosophical representations are. (Were that book to have been conceived of as part of the larger work, it might have been titled *Analytical Philosophy of Philosophy*.) For complex reasons, I was inhibited from writing the book about human beings as representational systems. What I discovered, however, in selecting from among my essays for the present collection was that those on which the book on us as *res representans* was to be based said pretty much what I would have wanted to say in that book, at least as I conceived it when they were written. Of course, one does not know in advance what differences will emerge when books in fact get written, and a fortiori one does not know how earlier volumes in a multivolume work will look when the later ones are written. Books, too, have to be understood within the narrative of their being written. The

sequence of books, in my case, stretches over twenty-five years, and inevitably, given the nature of narrative connections, earlier ones are no longer entirely seen by their author as they were when written. I would no longer write them quite as I did. The book on knowledge was too tied to discussions of knowledge current at the time but largely irrelevant today. The concept of basic actions, as some of these essays show, does not have the significance I and others ascribed to it when the idea was new. The theses of *Analytical Philosophy of History* I now see in a very different light than was available when I published that book thirty-some years ago. The architecture of the system that the component volumes advance is pretty rickety, and the earlier texts would have to be revised in the light of later thought to make the entire structure a livable philosophical abode. I am not anxious to undertake that task today. So the books must collectively represent progress and regress in the embodiment of a system that explains their unity, even if it remains out of their reach. In a way, the essays here bring us closer to what is supposed to hold the system together than any of the books that contain portions of it. For it concerns us as representing beings whose representations form histories which license describing earlier events in ways unavailable when they took place. How must we be understood if this is what we are?

I have, it must be said, a few reasons for publishing essays that were to have been broken down and reassembled as part of a book on representation, instead of actually writing that book. The first is that such a book would be an exercise in preemptive science, since I—and I believe my contemporaries, however informed they may be on physiology and electronic engineering—can no more imagine the relevant future science than Shakespeare's family and neighbors could have imagined *Hamlet*. My second reason is that the analysis of mental content, hence the content of our representations, is perhaps the most widely cultivated field in contemporary philosophical research, and a book intended for a place in a growing bibliography would be required to take into account the network of distinctions that shape discussions among specialists—internalism and externalism, narrow and wide content, and

the like. This I am reluctant to do. I am reluctant in part because it seems to me that the concept of content, which belongs to internal representations—such as sentential states or images—as well as to external representations—like narratives and pictures—has to be worked out for the class of representations as a whole. Content is after all what makes representations representations, and it is unclear that *mental* content differs structurally from content of any other kind, in books, for example, or maps or paintings or diagrams. And in candor, it is my view that issues currently central in the philosophy of mind will drop out of the picture entirely, as the issues in the philosophy of knowledge I thought I had to be responsive to in *Analytical Philosophy of Knowledge* have since done, so that an entire moment in the history of philosophical thinking has to be archeologized in order to see what my book was about. In the end we want our writings to survive the histories they are part of, and be valid under whatever sky.

There is one further reason, a kind of confession. I have, at various times, sat down to write my book on *res representans*, but I could not make it come to life. The prose was pedestrian in a way not acceptable to me, having written *The Transfiguration of the Commonplace*, which is filled with wild examples, with aphorisms and metaphors, and with the joy one feels in knowing oneself to be in intellectual territory onto which no one else has ventured—territory no one really knew existed. What struck me particularly as I began to sift through the writings that were to have been recomposed into the unwritten *Analytical Philosophy of Representation* was how they had the literary dash and energy I so missed in the book I sought to recompose out of their substance. I thought the writing justified republishing them, and that they might give philosophical pleasures simply as prose and argument and speculation.

Few but specialists read Santayana any longer. But apart from the differences registered in the first paragraphs of this introduction to my essays, I admire him for his philosophical ambition, and for his sensitivity to the literary surfaces of his writings. I began as a painter, and when instead I became a philosopher, I carried with me as a writer the criteria

of art, as if I had changed from one artistic medium to another—or hoped I had. I do not hold it against philosophers who entertain different criteria, but these differences amount in the end to differences in philosophical voice. That more than justified concluding with an essay on philosophical voice as such, in an essay through which, I hope, my own philosophical voice is audible.

NOTES

1. Alexandre Kojeve, *Introduction to the Reading of Hegel,* trans. James H. Nichols Jr. (Ithaca: Cornell University Press, 1969), 34–35.

2. H. H. Price, *Thinking and Experience* (Cambridge, Mass.: Harvard University Press, 1953), 310ff.

Representational Properties and Mind/Body Identity

One thing that would greatly strengthen the Materialist
case would be the production of an *independently plausible*
explanation of why Materialism is introspectively implausible.

D. M. Armstrong[1]

IT IS A NATURAL CONSEQUENCE of the late revolution in philoso-
phy that recent literature should be rich in subtle and ingenious analy-
ses of mental *language* while singularly impoverished in substantive
theories of mind. And although the textbook array of available positions
is widely known, it is a tribute to the realism even of philosophers that
all but one of them have long stood unoccupied. The striking exception,
of course, is Materialism—a theory that has, in its contemporary Aus-
tralian versions, often been attacked, though seldom by philosophers
with a substantive theory of their own to defend. The revolution in
philosophy has produced a breed of philosophical *franc-tireurs*, homeless
critics whose logical acuity is in the service of no special orthodoxy. So
current debate has the shape not so much of a contest between rival
theorists as of bickering between a player and his kibitzers—or between
a man and his conscience—and the body of literature has accordingly
a legalistic, not to say a casuistical tone, less concerned with saying

Originally published in *Review of Metaphysics* 26, no. 3 (March 1973): 402–11. Re-
printed with permission.

something than with determining what can be said. One learns from it more or less what are the violations the earnest Materialist has incurred in his stolid speculative enterprise, with little if any attention being paid to how the world would be were he to fail. Merely to ponder for a moment what other theory could seriously be regarded true, however, must reveal the essentially frivolous spirit in which philosophical criticisms of Materialism have gone on. In any case, this sobering if counter-revolutionary glance out of the metalanguage *zu den Sachen selbst* encourages a fresh examination of those obstacles thought to impede Materialism's establishment. Their removal will not, of course, ensure that establishment; but it will help define the structure of that theory and underwrite the intuition that it alone is likely.

The Materialist who interests me is the one who identifies such things as thoughts with what he speaks of with a degree of grand unspecificity infuriating to the physiologist as "brain processes" or "brain-states." The casual vagueness with which he invokes the brain happens not to affect the logic of his position, and it will prove more useful than to confront him with a physiologist demanding details to face him instead with a philosophical opponent, even if we must resurrect one for the purpose. Let us, then, summon an Idealist from the shadows. *His* view, expressed equally *grosso modo*, is that all brain-states are thoughts. As the "is" of either position is the one of identity, the positions sound at this stage dangerously like mere commutations of one another, so in order to forestall the ignominy of saying the same thing while meaning to sound different, the opponents make sly countermoves. The Materialist says that there are brain-states—or even more unspecifically, that there are "material objects"—which are not thoughts (or not in any obvious way mental); and the Idealist, that there are thoughts which are not brain-states. These detrivialize the contest, but they equally disguise the contest's comical ambiguities. It will appear upon analysis of the main strategies of logical offense that these traditional antagonists have been addressing themselves to different matters all along, and are saying different but quite compatible things. *My* chief reason for exhuming the

contest is to illuminate features of Materialism which hardly can be discerned in the context of current peoccupation with predicates and language games. Allowing myself the privileges of gross discourse which I have accorded my contestants, I shall say: the Idealist has been speaking of the *content* of thought, the Materialist about thoughts themselves. Let us now aim for a fraction of precision.

By the *content* of a thought I have in mind what the thought is *about* or *of*, in a sense of these troublesome prepositions that has equal application to and creates equal difficulties for sentences, pictures, stories, theories, and the like when we speak of what *they* are about or of. The difficulty is due to the fact that the prepositions take an intensional and an extensional reading. On the latter reading, what a story about Saint Sebastian is about is Saint Sebastian himself, so that should the martyrologies be false and no such saint ever have existed, there is nothing for such stories to be about, and hence they are not about Saint Sebastian. Extensionally—and there *is* this sense—aboutness is a relationship between a description and a real thing, concerning which the description says something true or false. On the intensional construction a story about Saint Sebastian remains about him whether that oft-depicted, oft-perforated saint existed in fact or not. This is, if not a non-relational sense of the preposition, at least one that does not require Saint Sebastian *même* as the relevant relatum; and rather than open Pandora's box of ontological monsters by seeking relata, let us utilize hyphens, in the manner of Goodman, and speak of "Saint-Sebastian-stories" when we wish to refer to stories about Saint Sebastian in the intensional sense of "about." Supposing certain difficulties notoriously advanced by Davidson can be maneuvered around, "Saint-Sebastian-story" might stand as a one-place predicate, true of a class of stories with a common content, much as "Saint-Sebastian-picture" is true of a class of pictures, including celebrated exemplars by Signorelli and Mantegna, with a common iconographic motif. Those properties of stories, sentences, pictures, and thoughts in virtue of which such predicates are true of them, I shall designate "representational properties." It is to such

properties as these that the Idealist is in fact referring when he says that brain-states are thoughts. I read him as saying that there are thoughts about brain-states, thoughts whose intensional content is brain-states. Of course there are such thoughts! And when he goes on to say that not *all* thoughts are brain-states, he must consistently mean that there are thoughts of different things than brain-states: thoughts of home, of fair ladies, of Roman martyrs: home-thoughts, fair-lady-thoughts, Roman-martyr-thoughts. The Idealist position gets interesting only when he goes on to say that brain-states exist *only* as the content of thoughts, lacking, as the seventeenth-century philosopher would say, formal reality: or that their formal reality is their objective reality. He gets even more interesting when he suggests that the formal reality of a thought is identical with the objective reality of its content. But for the moment the main thesis is interesting enough, and we might pause to consider what arguments he may have in support of it.

There is a curious argument, invented by Berkeley and evidently thought sufficiently compelling to have been reinvented (predictably) by Merleau-Ponty, according to which a brain-state that is not a thought (=idea) is somehow unintelligible. Try, Berkeley urges, to think of such a thing. Either this is self-defeating, for in thinking of an unthought thing one has ipso facto thought of the thing in question—and the unthought-of thing which is thought of is, in Berkeley's words, "a manifest repugnancy"—or it will not be a *brain-state* one has thought of. And the latter in its own odd way is unintelligible too, given the intensional construction of "of"—even if my thought of a brain-state should be like someone else's thought of a fried egg. On the basis of such reasoning, Berkeley argues the brain into the mind. But so must everything be in the mind if the brain is, in that we cannot intelligibly think of a counterinstance. I am less interested in the logical fretwork of this argument than in the illumination it offers onto the mode in which the Idealist is using language. Translated into the idiom he spontaneously employs, which is the idiom of content, the Materialist thesis must sound like the manifestly repugnant proposition that we think of nothing save brain-states. This *may* be the case with certain obsessively monomaniacal brain-

physiologists, but hardly with you or me. So the Materialist had better resist this transformation. He would be mad to fight it out on Idealist's rules and say that fundamentally brain-states *are* all we think of, the way a disciple of Freud might say that what we perpetually think of, manifest content notwithstanding, is sex. Nothing remotely of that sort is claimed by the Materialist. He wants to say that thoughts *are*, not that they are *of*, brain-states. At this point the interesting thesis alluded to in the preceding paragraph may provide a line of defense for the Idealist, who insists—and this hardly is entailed by his recent argument—that thoughts *are* what they are *of*. I distinguish this from another famous thesis that things are to be distributed into the ideas had of them, a view which collapses formal and objective reality onto one another. Let us not consider these until we have listened to the Materialist in his own idiom.

He is not saying that there are no thoughts: that *would* be a self-defeating thesis, refuting itself the moment it were entertained (for reasons immediately more persuasive than any the Berkeleyan argument may enlist). Nor need he deny that thoughts have contents or satisfy representational predicates. To be sure, if thoughts are brain-states, then brain-states have representational properties if thoughts do. If A is identical with B, whatever is a property of B is a property of A and conversely: the axioms of identity hold here as elsewhere. On the other hand, I feel that while we are constrained to accept these axioms, we need not countenance as properties whatever happens to be true of something. I want especially to suppose that the way something is represented is not a property of it. Or, if you wish to consider these as properties, it would perhaps be best to class them as secondary ones, the way unicorn-pictures belong to the secondary extension of the term "unicorn," the primary extension of which is null. Into the secondary extension I would sweep unicorn-beliefs, unicorn-descriptions, unicorn-stories, and the like. It is the mark, though not the defining mark, of secondary properties that they do not require the existence of things in the primary extension of the relevant term. There are no unicorn-teeth, no unicorn-livers, if there are no unicorns; but unicorn-pictures abound under

the identical circumstance. My reason for what may seem to the casual reader an extravagant distinction is philosophically serious. If we include secondary properties among the properties, there may just be no true identifications, or at least it may be only accidentally true that there are any. Thus Samuel Clemens would not be one with Mark Twain if some did or even could believe, of Samuel Clemens, that he was not Mark Twain and if these beliefs indeed were reckoned properties in the primary way required by the axioms of identity.

Classifying representations as *of* the same thing, once more in the intensional sense, is an exceedingly treacherous business: nothing would necessarily tell one that each member of the class of Joan-of-Arc-representations—from broadsides preserved at Domrémy to Bastien-Lepage's remarkable *Vision of Joan of Arc* at the Metropolitan Museum—is of the same person, so little do they resemble one another. And while a mutual reference to Joan of Arc may help in an external way, the same thing is excluded (I expect) in the case of Beelzebub-representations. A representation of a *thought* may, indeed, not be a representation of a brain-state, and philosophical carpers are to this degree right when they say that their beliefs about thoughts are not beliefs about brain-states, and wrong when they suppose it to follow from this that thoughts cannot be identical with brain-states. A familiar classroom stunner is the observation that one knows what it is for a belief to be true or false but not for a brain-state to be true or false. But this quite confuses the distinction the Materialist insists upon, for what it comes to is that we know what it is for the *content* of a belief—*what* a man believes—to be true or false. A brain-state with which the belief is identical would have the same content. But it is not obvious that when we mark the difference between content and what has the content that the speaker really knows any more about what beliefs as such are than he knows what brain-states are *in se*. In any case, brain-state-thoughts may not be *thought*-thoughts, without it following that thoughts are not brain-states. How would the thinker after all know? He might, given the vagaries of representation, represent brain-states as clusters of electrical charges and thoughts as little words,

so that as *contents* these have no resemblance at all. Not, of course, that this so deeply matters, since, as we have remarked, representations even of the same things may bear to one another no appreciable resemblances. But what is important for *our* progress is the distinction between what belongs to content and what belongs to what has the content in question. In clarification of this the case of representational art is instructive.

Under the prevailing parameters of pictorial representation, which admittedly vary from one art-historical epoch to another, a painting of a tree may fail in two ways. It may fail if it looks like anything save a *painting*—for example, if it looks so much like a tree as to induce the belief that it is one (though we acknowledge that just this would have been deemed a special sort of success by the artists described by Pliny); and it may also fail if, though it looks like a painting, it looks like one of something other than a tree—of Lloyd George, say. Trees, like clouds, may have faces in them, and a painting of a tree that itself has a face of Lloyd George in it should show it as having this face; but this is another and marginal matter. Now, the first sort of failure requires that a painting have nontrivial properties lacked by whatever it is of and vice versa; and it is no violation of the concept of identity that a painting of a tree should be identical with a bit of pigmented canvas, though trees themselves share no relevantly interesting properties with bits of pigmented canvas. What belongs to trees themselves need not belong to things on or with which they are represented. The inevitable discrepancies have always haunted artists with ambitions of the sort that Pygmalion perhaps paradigmatically emblemizes, and one program in the perpetual attempt by art to encroach upon reality has been to attempt to require the vehicle of representation to have such properties of the thing it represents as simply to turn into a real instance of the latter. The American artist Jasper Johns has been exceptionally fertile in examples of this sort. A painting of a flag could *be* a flag; a painting of a target, a target; a painting of a map, a map; and a painting of a painting could be a painting. This, of course, demands that the subject be depicted in rather a special way—for instance, that the edges of the flag shown be

coincident with the edges of the canvas, and so on. The vehicle with which a square is represented in perspective is not typically square itself: to be a square painting *of* a square, the square must be shown head on, its face congruent with the surface of the canvas. And comparable reciprocations are required for paintings of targets which are to *be* targets, and the like. But even when the coincidence has been achieved, so that the vehicle of representation indeed has the properties of the thing represented, the former is *of* the latter, and the distinction would remain, granting that it would now be easy to confuse and difficult to recognize the differences between (say) a square of painted white canvas and a square white painting of a square. Let us now attempt to extend these notions to thoughts.

Pictures, it may be argued, are a misleading example, since the vehicles of representation, being spatial, can have properties of the sort they also show, and because accordingly a program of convergent artistic realism of the sort just described is viable. But it is not clear that thoughts can have the properties had by what they are thoughts *of*, except in the remote, untypical case when they are thoughts of thoughts: *idea ideae.* Thus a fragment at least of Chomsky's celebrated nonsense expression "Colorless green ideas" may not be so lunatic as its author intended it to be. If "green idea" refers to what the idea in question is *of*, it is sensible to suppose that the idea itself is colorless: ideas of triangles, comparably, are cornerless. It would be metaphysically necessary that ideas be colorless if ideas indeed were modes of *res cogitans,* as in the philosophy of Descartes, the latter being aspatial in the way in which colors are not; but we plainly can have ideas of colors though we ourselves are nonspatial beings, in the unlikely event of Descartes's being right. If, on the other hand, ideas are brain-states, brain-states may be spatial and, for all I know, may be colored; but their color need not be the color they are of, any more than the word "green" need itself *be* green (as Johns demonstrated in some marvelous paintings using color-words that were self-referential and false, "yellow" being painted, say, in blue). Thoughts may be vague, indefinite, self-contradictory, without it following that it even

makes sense to suppose that thoughts as such have these properties. Some of the darkest sentences in the literature are presented in lines of print that are themselves triumphs of graphic clarity. We may thence distinguish what is thought of as well as the way in which this is given to thought, without any of this being properties of the thought itself: and this is now perfectly consistent with thoughts being identical with brain-states. We may, for example, distinguish what goes on in my thoughts from what goes on in my brain if we but acknowledge the difference between an extensional and an intensional "in." The thought itself may be located a half-inch back from my forehead, though what is *in* the thought may stand in no spatial relation to my forehead (even when it is my forehead I am thinking of). To confuse these "ins" would be like standing disappointed at not finding adulterous lovers on page 257 of *Anna Karenina.* There is no spatial relation between what goes on in the room where Anna and Vronsky consummate their passion and the page on which the event is described.

The point of these remarks, which are obvious once seen, is that the last place one might look to see what are the properties of thoughts is to their content. But since it is to their content that we commonly make appeal in discussing thoughts, and in which we primarily are interested when we *have* thoughts (as it is the story rather than the print that grips us when we read), it is not surprising that those who have had a great many thoughts, even some profound and novel thoughts, should have little to say about what thoughts are. There is no way, for instance, of easily bringing what they are into line with what they are about, as in the artistic program just discussed. And this, I believe, is generally true for all mental phenomena that take intensional characterizations. The discrepancy would also explain why it would be difficult to tell from the examination of brains anything much about what states of them are *of,* if those states indeed are thoughts. In *Analytical Philosophy of Knowledge* I defend a view that beliefs are sentential states of persons, which George Boolos criticized in a witty way: it would be a good theory, he said, if we could open people's heads and find their thoughts as in fortune cookies. But

this is indeed what becomes possible if thoughts are brain-states and we learn to identify their content, which has, of course, its antecedent difficulties. Suppose, though, that I could examine my own brain from the outside *while* having a certain thought. There would be no way in which I could get what I experience in examining the brain into the thought I was having at the time: say it was an erotic thought. But suppose I were thinking about brain-states, suppose even that I were a picture-thinker, and formed an image of a brain-state that proved to be congruent with the very brain-state in which the image consisted! Then this would be like the square painting of a square, intensional and extensional properties coinciding. But the case is exactly exceptional enough to show why thoughts of things other than brain-states should have so few properties in common with what they are of. This is similar to the case of pictures.

Possibly this distinction may be applied to perception, though whether perception admits an intensional characterization is moot. It is not moot on a representationalist theory of perception—which involves a relationship between perceiver and a "percept" that is "of" what it corresponds to in veridical perception—but representationalism itself is rather moot. It is plainly correct that there is no way in which the experience of perceiving could itself enable us to discriminate among theories of perception, viz., whether we perceive trees, tree-percepts, treeish phenomena, or what; and so we may gingerly speak of the *content* of perception—of what perceptions are *of* in any given case—in such a way as to be neutral between these much-contested views. But this allows us to distinguish perceiving from its content, most naturally, perhaps, on the realist view in which we perceive, say, a tree, and the latter is to be distinguished from whatever processes are involved in perceiving it. In any case, we are normally not conscious of perceiving as itself being part of the content of perception; and accordingly there is nothing in *what* we perceive that could tell us what perceiving itself *is*. Suppose, however, we were to identify perceiving with just those sorts of processes in the brain and the optical nervework which physiologists of perception have minutely described—something few of us, however well and spon-

taneously we perceive, know very much about. Now suppose I examine the optical system of a man who is perceiving a tree: imagine that by mirrors and enlarging devices I can actually perceive impulses along the optic nerve. By split-screen techniques, as it were, I even can see the tree he is perceiving and whatever goes on in him when he perceives it. What then is to prevent me from applying those same devices to myself, perceiving thus a tree and my perceiving of it? How different the two contents of this duplex perception are: rods and cones on the left, leaves and acorns on the right—as difficult to fuse into a single coherent image as, say, the actual paint and the panicked figures in Poussin's *Rape of the Sabine Women*, since the paint with which they are represented is systematically excluded from the content of the representation. Now, by carefully changing focus, I concentrate just on the physiological content to the right. As I draw attention away from the tree I expect some changes on the left—indeed, those changes, whatever they may be, that are to be expected when it no longer is a tree I am perceiving but the physical processes that rather occur when they are what I perceive. Then this again would be like the square painting of the square, the properties of what I perceive approaching the properties of my perception of them. But as with the thought of the brain-state, the case is sufficiently special as to reveal the discrepancies between perceptions and their content— *noesis* and *noemata*, in Husserl's language—and with it the little hope there is that men should have learned much about perception however much they have perceived. For with perception as with thought, it is the content that concerns us.

Identification of perceivings with physiological states, like identification of thoughts with brain-states, *has* to sound implausible when based upon what we phenomenologically encounter when we typically perceive or think. The implausibility derives precisely from the distinction it is critical to draw when making the sort of identification with brain-states the Materialist proposes. We are identifying something that has intensional content with something whose own properties very seldom coincide with the properties it represents. And the identification is made

all the more difficult through the fact that most of us know so very little about brain-states that we are very uncertain indeed whether any of our beliefs or thoughts about their properties are in the least correct. Most people never represent such things through entire lifetimes of thought and perception.

The implausibility of Materialism at the phenomenal level is what we may expect; and once we make the distinctions as we have, it must be plain that any theory of what thoughts *are* must make more or less the same distinction, unless the theory identifies thoughts with their contents, as pure *Vorstellungen*. I cannot here consider that radical view, except to say that it contrasts with a class of theories of which Materialism is only one. Hence the distinction cannot discriminate among these theories in such a way as to validate Materialism and invalidate the others. All the distinctions help do is to show that an awful lot of criticisms thought compelling against Materialism have no force against it whatever. Meanwhile, those who believe that intensionality favors dualisms of one or another sort might ask whether the case of *pictures* requires a comparable dualism of them. If a bit of mere paint can be *of* the Passion of the Lord, why on earth cannot a state of our brain?

NOTE

1. From a paper on some epistemological issues in materialism, read at a symposium on the philosophy of mind at Vanderbilt University in February 1972. The present essay is an expansion of comments I was invited to make on Armstrong's contribution. I wish to express my thanks to Professor Michael Hodges of the Vanderbilt philosophy department for inviting my participation and to David Armstrong for stimulating discussion of the issues.

The Representational Character of Ideas and the Problem of the External World

A false doctor is not a kind of doctor, but a false god is a kind of god.

Iris Murdoch, Bruno's Dream

I

DESCARTES CHARACTERIZED IDEAS as modes of thought and hence states of "res cogitans," but assigned two other sets of properties to them. These properties, which entitle us to treat ideas as semantical vehicles with marked analogies to other such species of these as pictures (ideas *sont comme les images des choses*) and sentences, are: (1) they have representational properties, in that ideas are always *of* something—of chimerae, or bits of wax, or pieces of manuscript; and (2) they are subject to semantical evaluation in terms of truth-or-falsity, or values very like truth-or-falsity. Save in the altogether exceptional instance of the idea of God, representational properties normally underdetermine the semantical value of the ideas they characterize, in that ideas as such can be either true or false, all the while representing what they do represent. That is, except *par rapport à quelque chose*, no idea as such is true or false,

Reprinted from *Descartes: Critical and Interpretive Essays*, ed. Michael Hooker (Baltimore: Johns Hopkins University Press, 1978), 287–97.

where "quelque chose" is understood as something different from the idea itself (see Descartes's Third Meditation; the quotations that follow in this essay all derive from that meditation).

There is a standing ambiguity in the concept of falsehood, which connotes, in one of its senses, mere inauthenticity (e.g., false pregnancies or false friends) and, in the other, failure of descriptive fit with a purported denotation, or failure of denotation altogether (e.g., in false propositions). The best test for determining which of these senses is in issue is the following: a false friend is not a friend, but a false proposition is a proposition—or, if the first sense of *false* is used to form the expression "false proposition," the implication is that the thing so characterized is not really a proposition, not that it is a proposition which is really false. And indeed, it can really be false only if it really is a proposition, in contrast with a false pregnancy, which really isn't a pregnancy at all; there is no such thing as a real pregnancy that happens to be false.

It is essential to Cartesian epistemology that a false idea *is* an idea, which should mean that the idea remains characterized by just the same representational property, invariantly as to whether or not it is true: an idea-of-x is an idea-of-x no matter whether it is false or true. It is this which enables Descartes to suppose that I would have all the ideas which I in fact have, even should none of them be true, or at least that there should be no way of telling, merely from the fact that I have an idea and that the idea be of x, whether it is true or false. (I am shelving the idea of God because of the complexities it would introduce at this point.)

Since an idea is rendered true through some *rapport* with something other than and hence external to itself, the independence of ideas, as representationally characterized entities, from anything external to themselves gives rise to the Problem of the External World: How is one able to deduce, from what an idea is of, that there exists something external to it and in relationship to which it has the favored semantical value? And so it really is consistent with my having just the ideas I in fact have that none of them be true; and it is a problem for Descartes because, unless

the blocked deduction can be made, there is no way to find out—there can be no question of comparing ideas with things.

In any case, it follows from these considerations that "of x" designates a simple property of ideas: it is a one-place predicate true of the idea of x. Or, if it is not a simple property after all, whatever it is in virtue of which "of x" is true of the idea of x, it cannot at least be x itself, for then we could not know that it was an idea of x unless we could have independent access to x to see if the condition were satisfied—and then the Problem of the External World would not arise. It would not because the existence of x would be presupposed in the very characterization of some idea as "of x." So we may assume that the individuation of ideas in terms of their representational properties can be carried out in complete independence of whatever it is in relationship to which they are true or false.

Their meanings, in brief, do not determine the truth-values of ideas, any more than they do (at least typically) in the case of sentences. And so we may conclude that it is a condition for Cartesian epistemology that we should always be able to say what an idea is of, without knowing or even caring whether it is true or false. It is an ultimate aim of this paper to discredit this condition, and hence Cartesian epistemology itself.

II

In addition to ideas, Descartes identifies a set of thoughts that have what he calls *quelques autres formes*, and these, because of their logical affinity to what came later to be designated "propositional attitudes," might here be designated "ideational attitudes"—mental operations over ideas whose linguistic representation might very well be sentence-forming operators over idea-descriptions. Let i stand for an idea, and let R ()x symbolize the representational property "of x" so that the R(i)x reads: "i is of x." The ideational operator is a mode of assigning truth-value to a suitably characterized idea. Letting (T) and (F) be truth-value names, and letting O stand for some ideational attitude, these operations have

the form O[](T) or O[](F), where the blank is to be filled with the description of the idea, for example, O[R(*i*)*x*](T). Then to believe that there are goats is in effect to affirm that the idea of goats is true; and to believe that there are no chimerae is to affirm that the idea of chimerae is false. Descartes furnishes a presumably nonexhaustive list of these *pensées*—*Je veux, Je crains, J'affirme, Je nie*—which are in effect *action*[*s*] *de mon esprit*, while the ideas themselves are the (*sujets*) of such (mental) operations or actions.

It cannot be overstressed that these actions are on ideas and not on things or events in the ideationally external world, so that the fear of flying is not some sort of relationship between Erica and all episodes of aviation but rather is something whose formal analysis runs roughly thus: "Erica fears that the idea-of-Erica-flying should be true," or perhaps, "Erica believes that the conditional idea 'If Erica flies, Erica crashes' is true." Something like this representationalist theory of fear is required—however stilted our phrasing in consequence of it—by the fact that people fear things that don't exist as well as things that do: they fear chimerae as well as goats. Thus fear cannot generally be represented as a relationship between the timorous and concrete objects or events, any more than belief itself may be represented as a relationship between believers and the concrete objects of belief (facts, say)—for then we would be as hard put as Protagoras to account for false beliefs. By our semantical touchstone, a false belief is a belief, after all, one whose subject happens to be an idea that is false, where Protagoras's theory would require the inference that false beliefs are not beliefs (so mistakes are impossible). So a false fear is a fear, only a fear whose ideational subject itself is an idea that is false, as when Descartes fears demons that, if there are none, cannot then be *subjects* of Cartesian phobia.

It is crucial, I believe, for Cartesian philosophy that these ideational attitudes not be ideas in their own right, though of course there can be ideas of ideational actions. But the idea of an ideational action is itself no more an action than the idea of a goat is a goat. Thus I may have the idea of myself as fearing something, or wanting something, or even thinking

something (is true)—but it no more follows from the fact that I have the idea of myself as thinking something that I really am thinking that, than it follows from the fact that I have the idea of myself seated in a cozy chamber in Germany writing meditations that I really am doing that. Perhaps it does follow from the fact that I have the idea of thinking that I really am thinking. But the latter follows only from the fact that it is an idea, together with the fact that the idea was thought; it does not follow from what the idea is of—for instance, myself as thinking something. Indeed, should I have the idea of myself as *not* thinking, such as in deep, thoughtless sleep, naked between the sheets, it would equally follow from the fact that I am having this thought that I think.

Every idea, irrespective of content, is a thought, but nothing else follows from ideas so far as thought itself is concerned: the idea of fear is an instance of thought but not an instance of fear, the idea of belief an instance again of thought but not an instance of belief, and so on. So the knowledge I may have of my own mental actions is not mediated, as is my knowledge of external things, through ideas of these actions; rather, it is direct in some way. And thus a man may have the idea that he is afraid of goats without it really following that he *is* afraid of goats, since ideas do not entail their own truth and *can*, just because they are ideas, be false. But he cannot be aware, in whatever way we are ever directly aware of our own actions, that he fears something and be wrong about that (even if the fear is "false," in the sense specified).

Berkeley drew much the same distinction when he argued that spirits have *notions* but not *ideas* of their own activities; it is a distinction that, moreover, would disqualify a Spinozistic conception of the mind as *idea ideae* if we took the latter literally. It would disqualify it simply because, once more, the idea of myself believing something is not an instance of believing something, at least not through its content, though it may, *as an idea*, be true *par rapport à quelque chose*—in this case the very act of believing, which is not an idea but an operation on one.

Descartes takes the characterization of ideational attitudes as actions quite seriously, since he argues in Meditation IV that he has an absolute

freedom so far as affirming or denying is concerned. By contrast, he regards himself as fairly passive as far as ideas themselves are concerned. His point, of course, is that, whatever their provenance and whatever ideas I may in fact happen to have, mistakes arise only through the affirmation or denial of ideas: I make a mistake when I affirm the truth of an idea $R(i)x$ when the latter is false, for example. But he evidently regards it as possible to "have" such an idea without operating upon it at all. (By contrast, ideational attitudes are logically transitive: they are *on* ideas, and cannot occur without a subject, there being no such thing as believing, for example, without believing something [to be the case]). I can, on the other hand, always describe an idea, say as an idea of x, without taking a posture regarding its semantical value. This, in effect, would be a kind of phenomenology: putting my ideas, as it were, in brackets and scanning them for content without worrying whether they are false or true. It is a second aim of this paper to call this into question: to raise doubts as to whether, in a spirit of neutrality so far as ideational attitudinizing is concerned, I *can* merely describe my ideas in representationalistic terms, merely, that is, in Descartes's words, "comme de certaines modes ou façons de ma pensée, sans les vouloir rapporter à quelque chose d'extérieur."

III

There must be specified two sorts of liaison between ideas and whatever it may be, external to themselves, on which their truth depends when and if they are true: what we may term a *semantical liaison,* and a causal one.

(a) Consider an idea i suitably characterized in representational terms, an idea-of-x. Then $R(i)x$ is true just when there is some object, external to $R(i)x$, call it o, which $R(i)x$ denotes and to which it is *semblable ou conforme.* Descartes was never very specific on this latter condition—let's just say that $R(i)x$ is true when its denotation satisfies its truth-conditions. When, for example, $R(i)x$ is an image, satisfaction consists more or less in satisfying some sort of resemblance function. Not all ideas are images

in this sense, and Descartes himself sees no reason why ideas should resemble their denotations any more than words must. But in any case—and however vague the matter may be—Descartes supposes that it is by an impulse of nature that he believes things outside himself to resemble or conform to his ideas of them (these being symmetrical concepts)—a curious thought if it entails that representationalism is a matter of natural impulse as, say, the sexual appetite is.

(b) It seems to Descartes that the relevant ideas must come from the outside, inasmuch as they do not appear to him to depend upon his will, and so it seems reasonable for him to believe that "cette chose étrangère envoie et imprime en moi sa ressemblance." This belief, however reasonable, is quickly disposed of by Descartes, inasmuch as there may, for all he knows, be hidden causes, within himself, quite capable of producing ideas it just seems to him must come from without. I shall not pursue here Descartes's fascinating thesis that the causes of ideas must bear some internal relationship to the latter's representational properties—that the idea of a substance must be caused by a substance, even if it be some substance other than the one represented by the idea itself—but merely indicate what I believe to be the causal theory required by him. One is justified in affirming an idea $R(i)x$ only when he is caused to have it by the object o, which satisfies that idea's truth-conditions: "que ces choses-là etaient semblable aux idées qu'elles causaient." That is, not only must o satisfy the idea of its truth-conditions; it must also be ultimately with reference to o that I explain the fact that I have the idea of it to begin with.

There are, then, three ways in which, for any such idea, I may be wrong in affirming truth: (a) when there is nothing ulterior to $R(i)x$ which the latter denotes, as in the case of ideas of chimerae; (b) when the idea has a denotation, but it fails to satisfy the further truth-conditions of the idea, as when I affirm that there are purple goats; and (c) when I am caused to have the idea by something other than anything which may satisfy its truth-conditions, as when I am caused to have an idea of goats in a dream by having eaten too much fondue (the case is only complicated,

but not altered, if the fondue is made of goat cheese). Anyone schooled in the devious sinuosities of post-Gettier epistemological analysis will appreciate that some constraints must be put on the manner of causation—for instance, my dog barking at night might cause me to dream that he is barking; so the fine animal that satisfies the truth-conditions of the idea also causes me to have it, yet the fact that I am dreaming is just the sort of condition that inhibits justified belief. Descartes would no doubt want to say something like this: the object must activate the right nerves in the right way. But let us merely acknowledge that these are sufficient conditions for error—without worrying about all the necessary ones—and that they imply necessary conditions for being right. The fact remains that it is consistent with my having all the ideas I in fact have, with just the representational properties phenomenology observes them to have, that they should be false or, if true, have devious causes of a sort that exposes me to mistake in affirming them. For, of the conditions of Cartesian certitude—namely, (a) I have an idea that (b) is true and (c) I am caused to have it by what makes it true—(a) must be independent of (b) and (c), for otherwise the Problem of the External World could not arise.

Everyone is aware that in just one case Descartes denies this independence: it is inconsistent with my having the idea of God that it should be false or caused by anything less than God himself. So the question I want to pose in this paper finally is this: *Is* the idea of God an exception? Is it even *intelligible* to suppose of any of our ideas that, consistently with their having the representational properties they do have, they can be false, or their provenance can be accounted for save by reference to what satisfies their truth-conditions? It will be obvious that if this question is answered negatively, the Problem of the External World is solved. It is solved because it will have to be inconsistent with my having the ideas I do have, representationally characterized as they are, that the idea be false or its occurrence deviously explicable. So the only intelligible position is that if the idea has the meaning it does have, that is, represents what I would describe it as representing, it must be true, and my having

it must be explained by reference to what makes it true. So either the Problem of the External World is unintelligible, or it is solved. To the argument for this I now turn.

IV

Let us consider at this point some semantically interesting entities reasonably similar to ideas when the latter are considered as "prints"—that is, on the most favorable (and, it will turn out, the only) assumption, as *envoyé* and *imprimé* by originals that they resemble or "conform to." Much the same connotations are evoked by the concept of "impressions." The natural metaphor of the perceiving subject of a wax tablet occurs as early as the *Theaetetus,* and the suggestion that the mind might be a kind of tablet or screen would have been natural enough in the seventeenth century when a systematic analogy was available to the camera obscura, with the eye a box. The wax tablet had in favor of its metaphorical appropriateness the possibility that images could be fixed and modified, and it remained for the inventor Fox Talbot to interject a sensitized sheet into the camera obscura which would hold the image when its source disappeared. But although photography lay well beyond the technological horizon, the semantics of the simple snapshot will not be so violently different from the semantics of Cartesian ideas that we cannot exploit some projective analogies. So let us ponder snapshots for the moment.

Consider an aging snapshot of Ted and Alice at Big Sur in 1970. It is not difficult to state in a general way the conditions that must be satisfied in order that an object be described in this way. A snapshot of x must resemble x and be caused, via photochemical avenues, by x. The notion of resemblance opens some room for a certain amount of sophomore skepticism: a photograph of Ted and Alice taken from a passing helicopter at high speed, half a mile up, with a Baby Brownie will resemble them as much as it would any couple taken under those conditions. But the fact that it resembles others *they* resemble from that perspective does

not entail that it does not resemble them, any more than that a photographic portrait of their identical twins will not resemble Ted and Alice, since they resemble their siblings and resemblance is transitive and (perhaps) symmetrical. Resemblance does not require *unique* resemblance; and anyway, what makes something a photograph of Ted and Alice, and not of their identical twins identically posed, is that the former is caused, while the latter is not, by Ted and Alice. The notion of cause seems especially important in those cases in which one's photographs don't look all that much like oneself. Obviously, one won't expect a photograph of Charles Dickens to look like George Eliot, but still, it is possible for a photograph of Charles Dickens to look more like Charles Darwin than like him. But let us block all such difficulties by considering a quite exact photograph of Ted and Alice, so that anyone who knew them and saw it would right away know it was of them. And now let us consider something that exactly resembles this photograph, but which is *not* of Ted and Alice because not caused by them; which is, say, caused by their identical twins, or merely by the chance fall of light on sensitized film. The point I want to make is this: whatever it may look like, something is a photograph of x only if caused by x; if caused by something other than x, it is not of x. In brief, the representational characterization of a snapshot—viz., as *of x*—always implies a causal condition, which, if not satisfied, renders false the representational characterization.

I am of course thinking of simple photographs: the problem is considerably, but irrelevantly, complicated when photographers use models: for instance, let Elliot Gould and Dyan Cannon stand for Ted and Alice, so that something which is really a photograph of them is said to be "of" Ted and Alice, as a painting of a woman in a Phrygian cap on the Place Furstenberg is said to be a painting of *Liberté*. By a *simple* photograph I mean one of something which does not in turn stand for something ulterior.

I shall not press these matters further, but merely transfer them from photographs to ideas. There are, of course, special differences. One can always compare photographs with their objects and test for likeness, but

as Descartes has set matters up, no such operations with ideas are possible; as Berkeley recognized, ideas can only be compared with ideas. Even so, I shall claim, as with photographs, that the representational characterization of something as an idea of *x* carries a causal implication which, if false, falsifies the representational characterization. But this directly entails the following: to the extent that I have doubts about the causal provenance of an idea, to just that extent must I have doubts as to what it is an idea of—or even if it is an idea at all, since if it lacks the proper causal credentials, it may in fact not be subject to representational characterization at all. For I can imagine ways in which a piece of photographic paper can be made to bear a pattern of lights and darks that makes it look exactly like a photograph of something would look, without its being a photograph at all. So a putative idea may not be an idea at all—may merely resemble an idea—if it is analytical to the concept that ideas always are *of* something. And this finally entails that doubts about causal provenance contaminated the phenomenological description of ideas as ideas. To the degree that I have doubts as to whether I have ideas, the Problem of the External World itself is in doubt, since it arises only once the status of what I describe as ideas is presupposed. It arises, that is to say, only with regard to entities that can be about something and stand susceptible to semantical evaluation. Hence it is as though that problem, if it arises, is solved: to describe something correctly as an idea of *x* conceptually entails the existence of something that satisfies the truth-conditions of the idea and that causes me to have the idea in question. Once we know it is an idea and what it is an idea of, there can be no conceptual room for doubt. Every idea licenses an ontological argument.

V

It is a commonplace that truth presupposes meaning; that only once questions of meaning have been settled can we then go on to raise further questions of whether a proposition, for example, meaning what it

does, is true or false. With ideas we have a curious case in which the reverse of this seems true, where meaning oddly presupposes truth. From this it seems to follow that there are no false ideas, for roughly the same reason that there are no false snapshots, at least, not in the *semantical* sense of "false." There are only false ones in the sense of *inauthentic* ones: things that appear to be, but aren't, snapshots. Of course, we speak of falsifying photographs, doctoring them in various ways; but then just to the extent that we intervene in this fashion does the photograph stop being *of* the thing we spontaneously believe it to have been. (Certainly, a person can doctor something in this way so that it *becomes* a picture, but this just complicates the causal conditions without modifying the semantics of the case.) The falsification of photographs has its counterpart in Cartesian epistemology in the persona of the *malin génie*, who may so intervene as to "falsify" our ideas. But to the extent that we suppose this a possible intervention, once more to that extent does the idea lose, or stand to lose, the meaning we would suppose it to have against standard assumptions about its provenance and history. So again it is as though the Problem of the External World, if it arises, presupposes the logical absence of the *malin génie*, since the very statement of the problem appears to require semantically fixed ideas—ideas whose meaning is, in terms of representationality, beyond question. But if *that* condition is satisfied, then, as I have sought to argue, there is nothing left to do to solve the Problem of the External World.

VI

The snapshot's semantics are fairly severe, given the causal presupposition of meaningfulness which snapshots, as well as ideas, carry. But this defines a negative analogy between these vehicles of meaning, on the one hand, and propositions or sentences, on the other. For sentences may suffer alteration in truth-value without sustaining alteration in, or loss of, meaning. Or at least this is commonly the case. There may be sentences which play a central role in establishing the foundations of knowledge and which

must be believed satisfied by what explains someone's believing them true—first-person reports, basic propositions, *Protokollsätze*, and the like. I shall not explore these analyses here, however. For the most part, the semantics of ordinary propositions does not seem to require a causal explanation for meaning, though if someone were to insist upon it, for an important class of sentences at least, he might have made a fascinating start toward resolving a problem that has not been much discussed in recent philosophy of language: how, in coming to understand language, we simultaneously and as part of the same process come to understand the *world*. He would have the beginning of an answer to the question of why and how language *fits the world*.

Let us shun these visionary horizons, however, and return to the Cartesian context, from which I should like to draw now upon a feature that may help confirm the applicability of my argument, and that the applicability of my argument perhaps illuminates. I refer to the role that clarity and distinctness play in the evaluation of ideas. It is always, I think, puzzling to the reader of Descartes to come upon the abrupt criterion of truth he offers, which is that an idea is true if it is clear and distinct; that if it is clear and distinct, it *has* to be true. Clarity and distinctness have reference to the meaning or content of ideas; it is the sudden shift from what appear, after all, to be characterizations of ideas at the phenomenological level to their ulterior *rapports* that seems strange and illegitimate—as much so as the inference from meaning to truth upon which Descartes so heavily relies in the ontological argument. I think we now have some basis for understanding this shift if the sort of semantical apparatus I have sketched here has a structural basis in Descartes's thought. It is this: if the meaning of an idea is clear—if we clearly can say what it is an idea of—then it has to be true; and contrapositively, if it is not after all true, neither is its meaning clear.

Descartes must have supposed that a mere phenomenological scanning of an idea would suffice to arbitrate over matters of clarity and distinctness and hence settle the question of its truth. This is a natural supposition but a wrong one, I think, for an unclear idea in the required sense

would not, after all, be one that, like a badly faded photograph, cannot be made out. In the case of two photographs, we can imagine two items of equal clarity as far as aesthetic discrimination is concerned, only one of which is an authentic photograph—of, say, Ted and Alice—the other merely looking like a photograph, but not really one, because caused by something that disqualifies it as such. The problem in any case is shifted from that of "Which of my ideas, if any, correspond to ulterior objects?" to "Which of the subjects of phenomenological scrutiny are ideas?" It is difficult to believe that aesthetic discrimination can settle this.

The gulf, then, between ideas and the world is replaced by a gulf between Descartes and the very contents of his mind; and the epistemological Problem of the External World is replaced by the problem of understanding the contents of our minds, that is, of reading them for content. What I have argued is that if this problem is overcome, the epistemological problem falls as well. Of course, with Descartes, the entire apparatus of ideas might be corrupt from the start, and the Problem of the External World a misbegotten consequence of an initially bad theory. I have tried only to show that on Cartesian grounds alone, however theoretically shaky, there is a startlingly short way with that vexed and treacherous issue.

Basic Actions and Basic Concepts

I

THE CONCEPT OF *BASIC ACTION* rests upon a not especially controversial observation and a standard sort of philosophical argument. The *observation* is that there occur a great many actions in which what is said to be done—say, *a*—is not done directly but rather through the agent doing something *b*, distinct from *a*, that causes *a* to happen. Thus I move a stone by pushing against it, and the pushing, itself an action, causes the locomotion of the stone when all relevant conditions are supposed benign. Sometimes an agent *m* performs an action in which *b* is done and another occurrence *a* is caused by *b*, but as *a* is only a consequence of *b* and is not itself said to be done, such cases fall outside the circumference of the observation just described. What falls within that circumference I designate nonbasic actions, leaving it open that there may be species of nonbasic actions other than those specified by this observation.

Originally published in *Review of Metaphysics* 32, no. 3 (March 1979): 471–85. Reprinted with permission.

The *argument* is that on penalty by infinite regression, not all actions can be nonbasic on those observed. If as part of doing *a* I must do *b*, and as part of doing *b* I must do *c* . . . , and this is perfectly general, it follows that there can be no actions performed at all. This is not because one cannot perform an infinite number of actions in a finite time, but because the regression puts the beginning of any series logically out of reach. So if there are nonbasic actions, there must be actions in which the agent acts directly—where, in order to do *a*, there is nothing *x* such that *x* causes *a* and the agent does *x*. These are *basic* actions. It is important to stress that it does not follow from the sketched formulation of basic actions that if *a* is done as a basic action by an agent *m*, there is nothing *x*, distinct from *a*, that causes *a* to happen. All that follows is that if *x* indeed causes *a*, the agent does not do *x*. In a normal body, for instance, enormous numbers of physiological occurrences take place when a person pushes against something. Still, pushing will remain a basic action (if it is an action), providing these occurrences are not actions of the agent in their own right.

Note that the observation and argument together yield only a characterization of what it means for an action to be a *basic* one. It yields no intelligence regarding what makes a basic action an *action*. One aim of this paper is to try to settle that question.

II

It is exceedingly difficult to discuss basic actions in abstraction from the observation just recorded and those features of its formulation which generate the regression. If the observation is sound and the argument cogent, we have good reason to believe that there are basic actions if there are nonbasic actions, but *about* the basic actions we are thus far able to say only what the argument compels us to subtract from the data formulated by the observation: they are, as it were, specified by logical erasure. Thus it does not follow from the fact that the occurrences the argument subtracts from are observed that the

basic actions themselves must be observed: for all we so far can tell, they could occur beneath the threshold even of their agents' own observations.

When I first began to discuss this concept, I thought otherwise.[1] I believed that there were certain cognitive constraints on which occurrences could be basic actions, so that even without the concept of the nonbasic action and the infinite regression argument we would have a kind of phenomenological assurance that there were *basic* actions at least. We knew, I thought, not only which of our actions were basic; but knowing that an action was basic was itself somehow part of it being a basic action. Neither of these seems to me any longer true. There are (only for example) some celebrated experiments designed by the psychologist Ralph Hefferline in which subjects control adverse auditory stimuli by twitching their thumbs.[2] So characterized, suppression of disagreeable noise could fall within the circumference of nonbasic actions, inasmuch as it evidently was for the sake of such suppression that the subjects twitched their thumbs: they were *conditioned* to do that and learned very quickly to respond that way. On the other hand, the subjects did not know that they were controlling their environment; they could not say how they did it when told they were controlling it, and could not afterward move their thumbs within the required short interval when they sought to do consciously what they so readily did subconsciously. These cognitive and executive shortfalls may disqualify the original thumb twitches as basic actions, but nothing like this is entailed by the observation and argument on which the concept of the basic action rests. Perhaps it is entailed by the concept of action itself, but inasmuch as this is so far an unclear concept, and inasmuch as philosophers have supposed that our best (some say our *only*) examples of basic actions come from bodily movements, there remains a deep question of which of our bodily movements would be actions and which would not: and there is a danger that we might make the distinction itself depend upon a relative coarseness in our monitoring system. Moreover, we are all by now familiar with split-brain conduct, where the right hemisphere knows not what

the left hemisphere has wrought and one hand complies with the command to grasp a pencil while knowledge that anything of the sort has transpired is screened off (to speak picturesquely) by sectioning of the corpus callosum. And let us not speak of actions whose description is hidden from the agent by the repressive mechanism of the Freudian unconscious.

These considerations apart, however, it is possible that what is tendered as a paradigm of a basic action, like the raising of an arm, may in fact prove under suitable magnification to be a concatenation of tiny movements indiscriminably small in themselves so far as the arm raiser is concerned: inscrutable in the manner of Leibniz's *petites perceptions*, of which they may be analogues. I once saw a film of Matisse drawing a leaf, inscribing that celebrated sharp, clean line onto white paper with what appeared to be a single draftsmanly stroke, incisive as the movement of a sword in the hand of a master. But the identical sweep proved, in slow-motion photography, to be a series of starts and dashes, thrusts and hesitations, as though each segment of what one now appreciated as a broken trajectory implied a distinct artistic decision. In similar fashion, a speeded-up film of what we see as a mountain climber laboriously picking his way up a dreadful slope might make the ascent look as sharp and linear as a skier's brilliant path. So when we raise our arm in a calisthenic gesture, much the same, one is certain, would be revealed: quantities of separate movements fusing, under gross perceptualization, into a single graceful arc. Thus might all our larger bodily movements resolve into component motions hardly grander than the thumb twitches of a Hefferline subject, and thus exist as aggregates of countless minute changes. And these infinitesimals of actions might be separately unperformable, doable only as part of executing the larger movements perception is capable of registering. And these minute motions, were we to count them as basic actions, would be indiscriminable, while the integral movement they are parts of would, though discriminable, not be a basic action but a collection of them. It is perhaps impossible to overemphasize (mea culpa!) the degree

to which a certain physiological recklessness has dominated the philosophy of action in recent times.

<p style="text-align:center">III</p>

The epistemological criterion for the basic action is extraordinarily doubtful, but once it is *put* in doubt, a measure of philosophical interest immediately is drained out of the concept of basic action. A moment's meditation on why this is so is called for.

It would be wholly natural to suppose that I must stand in a quite different cognitive relationship to my own body than to the bodies of others, though on Cartesian assumptions it is not easy to see why this should be so. Once established as a *res cogitans*, logically detached, whatever the contingent liaisons, from the domain of extended things—including the extended thing that I have heretofore designated, through what Descartes may speak of as a rash impulse of nature, as My Own Body— it is difficult to see why I should have any special cognitive access to that particular lump of flesh and bone, so easily dreamt and doubted away, than to any other body. In fact, in many instances there is no difference. I wipe the back of my neck and notice blood on my fingers. Or I see in the mirror that my head is bleeding. Had neither of these quite fortuitous observations occurred, I would (forgive the counterfactual) not have known that I was bleeding. With respect to bleeding (as but one example), I indeed am in my body the way a pilot is in an incontinent ship, who finds out his vessel is leaking in a way not remarkably different from my chance discovery of hemorrhage. It is true that with loss of blood I might grow faint, something that does not happen (to me) when others lose blood; but then when my ship is leaking I may ultimately drown, something that does not happen when the ships of others spring leaks in their sides. So it is quite curious that Descartes should have supposed after all that I am differently embodied than a pilot is enshipped. Now, Descartes of course did not believe I am in my *mind* as a pilot is in

a ship, simply because not only am I one with my mind, but also the mind is so structured that simply to be in a mental state s is to be aware that mental state s is what I am in—states of mind, or consciousness, being spontaneously reflexive. Indeed, mental states would be prime instances of what G. E. M. Anscombe speaks of as "things known without observation,"[3] in the respect that there is nothing o, distinct from s, on the basis of which I know that I am in s (though of course a separate argument would be needed to show that when in s I must know that I am). Between myself and my mental states there is no room for the intrusion of anything to enable me to know those states—I know them immediately and directly—and hence no epistemological prosthetic is required to give me certitude at least of these. The skeptic may drive one into oneself in seeking shelter from doubt, but past that threshold he has no power to terrorize. Nothing counts as an observation, hence nothing counts as a dubious observation. Everyone knows the happy ending of this philosophical fairy tale. But modern philosophy of action has sought to extend the charmed threshold to the boundaries of the body.[4] And by widening the domain of cognitive felicitude to compass my body, by making my body and me as much one as my mind and me, the deepest chasms of metaphysics will have been crossed!

It is a thrilling thought that I am not an alien tenant in what the phenomenologists speak of as the *lived* body; that by a criterion of reflexiveness which makes me one with my self I am one with my body; that there are *bodily* states we have access to with the same sure immediacy Descartes believed (or is believed to have believed) we have access to our mental states. And it is just because actions, and in particular basic actions, were supposed to be known to their agents as immediately as their pains are that actions held the promise of a philosophical interest which quite vanishes when these privileges are falsely grounded. The spaces between ourselves and our bodies—hence, for all practical purposes, between minds and crass things—which the basic action was thought to obliterate, open up all over again, and the Cartesian isolations are as threatening as ever. To be sure, there may always have been rea-

sonable reservations against the cognitive criterion of the mental, and a natural option for those concerned to overcome dualism might simply be to force surrender of the criterion even within the domain it was intended to define, thus overcoming one basis for drawing the Cartesian boundaries. But in any case the doubt acknowledged in the case of basic actions makes it exceedingly risky to use that very criterion for overcoming the basis for drawing the boundaries from the other direction. Basic actions may still retain a philosophical interest, but not as weapons in the ancient war against dualism.

If, however, we cannot provide out of our own experience ready examples of basic actions—if the sole grounds we really have for speaking of basic actions at all are the observation and argument with which we began—the latter acquire a great importance for our theory, inasmuch as we may have only them to go on in drawing up the logical anatomy of the concept.

IV

The argument tells us what we must subtract from the instances of the observation in order to get an action that is basic, so the clearer our concept of a nonbasic action is, the clearer our concept of the structure of a basic action will be. Of course, the fact that we wipe components out of nonbasic actions to characterize basic ones—as though basic actions were elliptical nonbasic actions—leaves an important question, namely whether basic actions can occur outside the context of the nonbasic actions of which they form parts. For the argument tells us only that for every nonbasic action there is a basic action which is a component of it. Now, it seems as though one can move an arm or flex a muscle without these being parts of any larger project, done, as it were, for their own sake with nothing ulterior intended. In fact, however, all this says is that we may move our bodies in these ways without performing any nonbasic action thereby; but whether these bodily movements would then be actions under those conditions is not something the observation and

the argument can enable us to say. For we still have no good analysis of the concept of an action, merely a pretty good analysis of a *basic* action. That is why the question is important.

There are writers who claim that only in the context of a nonbasic action is a movement of the body (for example) a basic *action*.[5] This sounds a rough echo to Frege's celebrated dictum, "Nur im Zusammenhange eines Satzes bedeutet ein Wort etwas." Frege's formulation leaves something obscure behind, namely whether, when we abstract it from its sentential context and hence rob it of meaning, we still have anything we can call a *word*—it may simply be a noise that achieves status as a word only when regimented in the matrix of a sentence. Frege's thought, then, is that only in the context of a sentence is a noise a *word* if it is analytical to the notion of a word having meaning (a nonsense word lacks meaning in a very different sense from that in which a noise lacks meaning). Perhaps by analogy we might say that what within the context of a nonbasic action is a basic action is, outside that context, only a bodily movement. Hence it will not carry its status as an action with it when separately executed.

Consider this in the light of the fact that each action we do through doing something else might be considered a kind of praxis when repeatable, and implies an answer to the question of *how* whatever is done is to be done. The answers to such questions fall into the form of recipes, in which steps are listed in suitable series: a recipe is a sequenced suite of steps that, if followed, yield a predictable result. Now, one can "by accident" turn a key and so, again "by accident," start an engine. But turning a key is a *step* only when done as part of doing something else for the reason of that thing being done. Suppose being a basic action were in just that way something like taking a step, and something then were a basic action only when part of a nonbasic action—as something counts as taking a step only in the context of a praxis (you cannot *just* take a step without this being part of something else!).[6] The philosophical result of this might just be that we are able to get an analysis of what makes a basic action an *action* by examining the contexts in which it alone evidently

acquires that status—a redescription of "mere" movements supervenient upon them when embedded.

Now, the concept of agency has much occupied philosophers in recent times, and it has seemed to many as though it were a primitive notion. Donald Davidson, who has written importantly and interestingly on this concept, has even proposed that the only cases we have of agency are bodily movements, construed as basic actions,[7] and Davidson denies the status of actions to what I term nonbasic actions. But if it is after all true that we get our clearest conception of basic actions by erasure from the concept of nonbasic actions; if we may have no grounds for postulating basic actions apart from the observation and argument that generate our concept of them; and if, finally, not every bodily movement may be a basic action, it is difficult to see how Davidson can be dogmatic in this matter. What I should like to propose in antithesis to Davidson, therefore, is this, at least as a possibility: that it is not in bodily movements as such that the concept of agency is to be located, but rather in basic actions; that basic actions may acquire their status as such in being parts of nonbasic actions, outside of which those basic actions would be but mere bodily movements; and finally, that the concept of action itself is not a primitive concept, but admits of analysis. To a defense of these claims I now briefly turn.

V

It is now and again instructive to turn our gaze from our immediate technical activities as analytical philosophers and ponder for a moment the metaphysical concerns from which such activities spring and in whose service we labor. A great many diverse activities are indifferently designated Analytical Philosophy these days, but one of them has an ancestry that runs back at least to Locke; we may term it, somewhat portentously, the Analytic of Concepts. The deep presupposition of this analytic is the thought that certain concepts are more fundamental than others, in the specific respect that it is into these more fundamental

concepts that the other, less fundamental ones may be analyzed. Thus Locke's simple ideas answer to a demand for determining which descriptive concepts are the most basic for our conceptual system; and his compound ideas are nonbasic specifically because they can be analyzed nonresidually into the most basic ones we have. The principles of analysis would then be explicit definitions, and as such definitions enable the elimination of all nonbasic concepts in favor of admittedly more cumbersome descriptions in which basic concepts alone are employed, it is possible to regard the expressions that connote these nonbasic concepts as so many *façons de parler*, with no ultimate correspondences in the world. The conceptual order, for Locke, is composed of the simple ideas exclusively, the rest being merely *Menschenwerk*. The Analytic of Concepts, irrespective of whether one admits as basic the same concepts as Locke, is thus an attempt to resolve concepts of whatever order of complexity into the most fundamental notions we have; only when such resolution is achieved can we then speak of this notion or that as being *primitive*. Some such framework dominates a great deal of philosophical analysis even, or especially, today, and save with reference to just such a framework, it is exceedingly difficult to see what could be meant by insisting, of a given concept, that it is primitive.

Thus, irrespective of whether we agree with it or not, it seems to me that Hume's analysis of causality is a paradigm of the Analytic of Concepts, for his intention was to show that whatever the rhetorical and pedagogic force of sentences in which the concept of causality (or any concept presupposing it) was used, *it* can be eliminated in favor of concepts more basic than it—for example, conjunction, contact, succession, and the like. Whether these are among the basic concepts is less important than that causation, if Hume is right, is not. Moore's analysis of Good has the contrary force. Once more, irrespective of whether we agree with him in the end or not, the claim he is associated with is that Good is one of the basic concepts, incapable, so the Open Question is intended to demonstrate, of being resolved into any concepts more fundamental

than it. More in the immediately contemporary spirit, the enterprise of defining *knowledge* implies consensus that we are dealing not with a basic concept, but with one that can be analytically eliminated in favor of concepts such as justification, belief, and truth; and while a fully acceptable analysis of the concept remains at present writing still to be given, the entire effort at analysis would be misdirected if we believed it were a basic concept. Rather, our effort should resemble Moore's, namely to demonstrate its basicness (Austin's effort may be understood as an effort to show that "I know" was a basic *use*, in the respect that no other expression has quite the performative force of it.)

Now, the fundamental question for the philosophy of action ought to be whether *action* is a basic concept or not: whether it, in parallel with the concept of knowledge, is capable of resolution in favor of concepts more basic than it, or whether in the end it is, as so many philosophers affirm or imply, a "primitive" concept. In a subtle discussion of what he terms the components of basic actions, Irving Thalberg writes, with a becoming modesty, "We simply disown any claim to have analyzed basic actions—or any kind of action—in a way which yields the 'essence' of action."[8] He has not indeed done that, but the disclaimer pays allegiance to the framework of the Analytic of Concepts in which, it seems to me, the concept of basicality alone makes sense. In any case, it is with reference to that framework that I would like to propose that *action is no more a fundamental or basic concept than knowledge is*, and that the analysis of nonbasic actions shows us how to eliminate the concept in a way that will help answer the question of in what way basic actions are *actions*.

VI

A major implication of the analyses I have sought to give of knowledge and of action is that these concepts are to a remarkable degree parallel, in the sense at least that each involves the same sort and number of more elementary components, though the components are put together

somewhat differently in either case.[9] Knowledge, to put it crudely, is a matter of bringing our representations into line with the world, and action a matter of bringing the world into line with our representations. Both of them thus involve representation and reality, so to speak, but the direction of causality is different in each. Consider Anscombe's marvelous example of a man with a shopping list and a detective who lists what is put into the shopping cart.[10] The two lists in the end may match, but the first enters into the explanation of why those items are in that basket, while just those items being in that basket explains why the descriptions of just those items figure in the second list. The two lists are representations; it does not matter that they are on paper, inasmuch as the same structure would be there if the man only had this list in mind and the detective, noted for his memory, simply memorized what he observed. It is worth noting the logical locus of error in the two cases. The man may make a mistake in putting into the basket something different from what the list says: beer, say, when the list has "beef." The detective may make a mistake in writing "beef" when the basket contains beer. The man rectifies his mistake by replacing beer with beef; the detective rectifies his mistake by putting "beer" for "beef." The man has performed an action, the detective has achieved knowledge. In both their cases there is a representational, an explanatory, and a semantical component to be mentioned, and certain relations among them. It is knowledge when the representation is true and one's having that representation is explained by whatever confers truth on that representation. It is action, again when the representation is true but its *being* true is explained through the impact of the person whose representation it is on the world. Immense (or maybe not so immense) numbers of qualifications and refinements must be added to make these analyses impermeable to the vexations in the domain of knowledge and their counterparts in the domain of action, and much would remain to be said were we to suppose these analyses fully laid out. My interest in them is exhausted, however, at least in the present context, by the recognition that in both these domains, if these analyses or anything like them have a chance of

being sound, the terms "knowledge" and "action" alike may be dropped from discourse (which to be sure they control as intuitions from without until the right analyses are found), yielding to such relatively more basic concepts as representation, explanation, and truth. I dare say we have not touched bottom with these concepts, which are but waystations in our descent to the stratum of basic concepts it is the task of the Analytic of Concepts to enable us to reach. And indeed, if it were not for that goal it would be difficult to see what serious importance the Analytic of Concepts might have.

VII

Now, it may be objected that even if these analyses are indeed sound, they will show us how to eliminate "does" and "knows" from the ultimate description of what preanalytically we may designate nonbasic actions and nonbasic cognitions. But what of basic actions and basic cognitions? Well, if something is a basic action only in the context of a nonbasic one (deferring the correspondent question in the analysis of knowledge for another occasion), its characterization as an action may simply be supervenient in virtue of that location. I shall now seek to reveal a modest piece of structure.

Consider once more the sort of nonbasic action upon which our initiating observation rests: agent m does a by doing b, where a and b are distinct events, b causes a, and the doing by m of b is a basic action. When the nonbasic action is successful (and failure merely raises complications of no immediate relevance to our structure), there is a representation R of m's which, in a semantical sense, a satisfies. It is also true that R enters into the explanation of a, as it will if R is a reason of m's for doing b in case m believes that a if b. Now, I want to claim that what makes b an action is its representational cause; it is a *basic* action because whatever x it may be that causes b, x is not done by m. It may be asked how well this structure fits the Hefferline cases. There is no reason to suppose it does not unless it is analytic to the concept of representation that he whose

representation it is must know that he has this representation. But Freud has taught us of representations that remain effective only in the unconscious system, and we have in any case the example of animals, to whom representation but not self-knowledge may be (or at least commonly is) ascribed. Perhaps it will be a condition for an action to be fully rational that the agent act for reasons he is conscious of, but that may entail that a man who kills someone in blind rage is fully rational because he represents himself then as hateful—but of course there are varieties of meaning to the notion of rationality, and my aim here in any case is not to work out the details of this structure, but only to show how action may be a description that supervenes upon an event when it has a representational cause, and that *action* per se is not a basic concept. *Which* bodily movements may be elicited causally by representations is, naturally, a wholly empirical matter: the limits of our powers are discovered pretty quickly in infancy, but even as adults we may have powers we have not learned about.

It will be remarked that in classing reasons as representations, and in proposing representations as causes, I have insidiously begged one of the major questions in the philosophy of action.[11] So indeed I have, but in compensation let me suggest a schematism that may be of some use for the future development of this topic. Let R be a representationally characterized event, and let Ɍ be an event not so characterized, such as the motion of a billiard ball or, for that matter, the flexion of a muscle. There are, it seems to me, four types of causal episode to consider:

	a	b
(1)	R	R
(2)	R	Ɍ
(3)	Ɍ	R
(4)	Ɍ	Ɍ

Now, case 4 is the sort of causal episode that has been well canvassed in the literature: the concussion of billiard balls, for example. Case 3 is

where some such event as a billiard ball moving causes someone to believe that it is moving: an ordinary R event causes a representation to form in someone's mind. Case 2 is where a representation causes a mere event, as in the case of action. Case 1 would only be illustrated by a man believing something because he believes something else. Now, I don't think that the array of cases necessarily requires modification in our concept of causation: but more than mere causation is involved in cases 1–3. There are, for example, semantic connections between cause and effect: thus, the effect b in case 3 might constitute knowledge when the representation is satisfied by its cause; and the event b in case 2 might qualify as an action when it satisfies its cause, etc. Working these cases out in detail, however, would demand a paper of a different length and motivation than the present one, and the logical question of working out the forms for the laws entailed by these causal episodes is, I should think, the main obligation in the philosophy of the *Geisteswissenschaften*. Here the sketch must suffice.

VIII

The early pages of the modern philosophy of action are thronged with conceptual monstrosities and prodigal confections: immanent causes, knowledge-without-observation, mental causation, agent causation, and basic actions, to name but a few. Each seems generated in fulfillment of a philosophical wish, in which deep irreconcilabilities are transcended and sublated, and restored to a unity as mysterious as the Trinity's. Historians of philosophy may someday credit this ontological extravagance to the first rushings of the metaphysical imagination held back by the now lowered pennons of the Verifiability Principle. But that would not explain the form of the *imaginations*, which seems to spring from a sort of philosophical unconscious that knows no principle of contradiction, and that reads hopes forth as realities, like visionary resolutions of the Middle East Problem, or the androgyne as redeemer in the sexual wars.

Are there basic actions? Yes, if the observation with which we began is accepted and the regressive argument is compelling. But the philosophical importance of their occurrence depends finally on what properties they may be said to have in excess of those they are required to have by the method of deriving their existence. My purpose in this paper has in part been to hold a logical prism to the concept and by refraction split off some of what has been believed to belong to the concept only because it was hoped that it belonged there.

What is left of the concept, once the impurities are refracted out, are two pretty familiar sorts of components and two philosophically straightforward relations. The components are a representation and a bodily movement; and the relationships are given through the fact that the representation *causes* the bodily movement, and the bodily movement *satisfies* the representation. The Wittgensteinian conundrum of what is left over when, from the fact that I raise my arm, the fact that my arm goes up is subtracted, can be given two solutions, depending on whether my arm's going up is a bodily movement or a basic action. If the former, the answer is "Nothing." If the latter, the answer is also "Nothing," but with a qualification: a bodily movement is an action when caused by a representation, and it is a basic action when directly so caused, providing it satisfies the representation that is its cause. "Action" is a description supervenient upon a movement when it has a certain cause, as "scar" is a description supervenient upon a mark when it has a certain cause, for example, a lesion. The structure of the basic action is just the structure of the nonbasic action, minus a step: the same components and relations are exemplified in each. And parallel claims, I am certain, can be vindicated for basic and nonbasic cognitions.

The conceptual portrait just sketched is almost desperately drab in comparison with the metaphysical excitement the first formulations of basic actions seemed to promise. In compensation, it impresses me as having the promise of truth; and if this means that the philosophy of action itself is less exciting than it seemed it was going to be a decade ago, well, that may be because the truth itself is drab. Nevertheless, we

might ponder the wise words of Dr. Johnson, "The mind can only repose upon the stability of truth." The repose of the mind has, of course, not been a philosophical ambition for some considerable while.

NOTES

1. This was true in the papers in which I introduced this concept into the literature; for example, "I do not wish to suggest that the only proof we are entitled to, for the existence of basic action, is by way of a transcendental deduction, for I believe we all know, in a direct and intuitive way, that there are basic actions and which actions are basic" ("Basic Actions," *American Philosophical Quarterly* 2 [April 1965]: 145); and "I should think that the power and the knowledge of the power come at the same time" ("What Can We Do," *Journal of Philosophy* 60 [July 1963]: 440).

2. Ralph Hefferline, "Proprioceptive Discrimination of a Covert Operant without Its Observation by the Subject," *Science* 139 (March 1963): 834–35; and idem, "Escape and Avoidance Conditioning in Human Subjects without Their Observation of the Response," *Science* 130 (November 1959): 1338–39.

3. G. E. M. Anscombe, *Intention* (Oxford: Basil Blackwell, 1959), esp. secs. 8 and 28.

4. See my "Action, Knowledge, and Representation," in *Action Theory: Proceedings of the Winnipeg Conference on Human Action, 1975*, ed. Myles Brand and Douglas Walton (Dordrecht, Neth.: D. Reidel, 1976); reprinted here as chapter 4.

5. Rüdiger Bubner, "Basishandlungen," in *Handlung, Sprache und Vernunft* (Frankfurt: Suhrkamp Verlag, 1976), 91–100.

6. I do not, of course, mean that the project need be completed: the chef may drop dead after cracking the egg, when cracking the egg is the first step in making a soufflé.

7. "We must conclude, perhaps with a shock of surprise, that our primitive actions, the ones we do not by doing something else, mere movements of the body—these are the only actions there are" (Donald Davidson, "Agency," in *Agent, Action, and Reason*, ed. R. Binkley, R. Bronaugh, and A. Marras [Toronto: University of Toronto Press, 1971], 23).

8. Irving Thalberg, *Perception, Emotion, and Action* (Oxford: Basic Blackwell, 1976), 128.

9. The parallels between the analyses of knowledge and of action are explored through my writings on these concepts. See especially *Analytical Philosophy of Knowledge* (Cambridge: Cambridge University Press, 1968) and *Analytical Philosophy of Action* (Cambridge: Cambridge University Press, 1973). It is a matter of sore disappointment to me that I have not hit upon a deep explanation of these parallels.

10. Anscombe, *Intention*, sec. 32.

11. Considerable argumentation on this score may in fact be found in "Action, Knowledge, and Representation" (chapter 4 in this volume).

Action, Knowledge, and Representation

And yet they ought to have made some mention of error at the same time, for error seems to be more natural to living creatures, and the soul spends more time in it.

Aristotle, De Anima

IN THIS PAPER I SEEK to decompose the concept of basic actions in such a way that its philosophical components crystallize about one pole, and its scientific ones about the other. No doubt the scientific components will have a philosophical importance, but it will differ considerably from the philosophical importance basic actions themselves were originally believed to have. The latter derived from the pivotal role basic actions were cast to play in a massive restructuring of the mind/body relationship along lines that promised to reunite bodies with minds and ourselves with both: to restore to an ontological unity what had been sundered by Cartesian dialysis. That counter-Cartesian program I now believe to have failed definitively, and its collapse, which I mean to demonstrate, entails the demolition of the concept of basic actions, at least so far as its hopeful philosophical significance is concerned. I hasten to mute this dour assessment, however: Descartes does not survive altogether

Originally published in *Action Theory: Proceedings of the Winnipeg Conference on Human Action, 1975*, edited by Myles Brand and Douglas Walton (Dordrecht and Boston: D. Reidel, 1976), 11–25. Reprinted by permission of Kluwer Academic Publishers.

the confounding of his rivals; only his distinctions do. But this does not compel us to follow him in housing the terms of the distinction in logically alien substances.

<center>I</center>

Philosophical theories of mind are philosophical theories of body by default. This is so whether, with Descartes, we radically distinguish properties of minds and by so doing isolate a class of predicates logically inapplicable to our bodies just because they are bodies, or whether, in the counter-Cartesian orientation of contemporary philosophy, we psychologize the body and so isolate a class of predicates logically inapplicable to crass material objects like sticks and stones, honoring the metaphysical line drawn by Descartes but locating it elsewhere, employing it to distinguish between orders of bodies rather than between bodies as an ontologically homogeneous order that contrasts in a global way with minds, spirits, *res cogitans*, or the like. By closing the gap between our minds and our bodies, we open a gap between *our* bodies, on the one side, and *mere* bodies on the other, even if this gap happens not to generate any of those deep perplexities—of causality, for example—which motivated closure of the original gap: no special causal concept differentiates the way the hand moves the stick from the way the stick moves the stone. The only remaining problem, perhaps, concerns the way *we* move the hand. Suppose we speak of such movings as actions, perhaps as basic actions; then one consequence of treating our bodies as already having the properties Cartesians relegated to minds is that we are absolved from having to think that such movements of the hand are distinct effects of some special mental cause, acting mysteriously across what ought to be the metaphysically intraversable space between spirit and matter. The basic action, by filling this space, absorbs as its own the philosophical boundaries of the space and emerges as what the earlier philosophy of mind and body would have had to regard as a metaphysical monster, mental and crass at once, one thing, indissolubly compacted of thought and matter, and the

world now seen as constituted of two sorts of bodies, unhaunted by asomatic ghosts. It is this dualism, enshrined, for example, in Strawson's distinction between entities exhaustively describable by sets of M-predicates alone and entities only partially describable by these but fully describable if we augment our basic vocabulary to compass P-predicates (there being no entity exhaustively describable by P-predicates alone), which the new concept of action appears to have made feasible and which explains in some measure the importance spontaneously felt to attach to the concept of action. It is not just that philosophers had hit upon an oddly neglected subject on which fresh work might be done, but that actions were suddenly felt to hold a metaphysical promise not appreciated from the limited contexts of law and morality in which they had traditionally been examined. The study of action must be considered as part of a general movement to rethink the philosophy of bodies, paralleling in Anglo-Saxon philosophy the deep reassessment of the body undertaken on the Continent by Sartre and others, and especially by Merleau-Ponty, a common, single philosophical enterprise, whatever may have been the differences in philosophical style and points of departure. It was Merleau's view, for example, that an exact understanding of the structures of the phenomenal field revealed features that could only be explained with reference to the body, which must itself have a structure radically distinct from that assigned it by Descartes—a thesis Merleau sought to confirm by showing the way in which bodily abnormalities induce structural distortions in the field of phenomenal experience.

The gap that Descartes opened up was not, of course, only in ontology; it was also, and more famously, an epistemological gap, bounded, under this perspective, on the one side by a mind and on the other by the so-called External World. The existence and nature of the gap made it difficult to be certain that the world underwrote our intended cognitions of it, as it made it difficult to see how any of the events that took place in it could be explained with ultimate reference to minds which necessarily stood outside it: it was a gap, in brief, that threatened us at once with radical ignorance and radical impotency, leaving us with

knowledge only of ourselves and with our repertoire of actions restricted merely to affirming or refusing to affirm our ideas. So the body, if it were, so to speak, to fill and hence obliterate the causal gap, might fill and obliterate the cognitive gap as well; just as there exists something already in the world and over which we have immediate control, which we are not required to control from without and across a hopeless distance, so might there be something and perhaps that identical thing, which is at once in the world and of which we have direct knowledge, which we are not required to address from without across a distance rendered hopeless by the logical unavoidability of skepticism. The body, and our special relationship to it as agents and knowers, locates *us* immediately in the world where our body had all along been supposed, on Cartesian assumptions, to have been located as a thing among things. The threats of ignorance and impotency are stunned with a single stroke, the remaining limitations on our powers of knowledge and action being practical only and, if insuperable in many cases, not *philosophically* insuperable and so hopeless from the outset. The triumphant double closure might have been expected if, as Sartre claimed, "knowledge and action are only two abstract aspects of an original, concrete relation."[1]

This relationship, as viewed by Sartre, is complicated by the overall structures of his philosophy, but in gist it is that "I *am* my hand" when my hand is viewed as "the arresting of references and their ultimate end": the body is the center of reference for the interreferential system that is one's world; it is that through which the world is manipulated and known, but which, in *these senses* of manipulation and knowledge, is "at once the unknowable and non-utilizable term which the last term of the series indicates."[2] And Merleau-Ponty, whose views again cannot altogether be detached from the systematic structure in which they are embedded, insists that "the union of soul and body is not an amalgamation between two mutually external terms, subject and object, brought about by arbitrary decree. It is enacted at every instant in the movement of existence."[3] And again: "We have found underneath the objective and

detached knowledge of the body that other knowledge which we have of it in virtue of its always being with us and of the fact that we are our body."[4] These thoughts are brilliantly anticipated in a neglected discussion of the concept of action by Gabriel Marcel, who wrote as early as 1927 that "I do not *use* my body. I am my body."[5]

Merleau speaks of "that other knowledge" where Sartre speaks of the unknowability of the body and hence of ourselves, but this I take to be a lexical perversion not untypical of him: he means "unknowable" relative to a model of knowledge which parallels if it is not identical with what he speaks of as "objective consciousness," the awareness we have of *objects* in contrast with that special sort of consciousness—*conscience (de) soi*—he alleges each of us has of himself. For if I *am* my hand, and if I do not know myself as an object, then I do not know my hand as an object either; or, to the degree that it is an object for me, as when I happen to see it, then I am *not* it. The central experience of moving a hand is supposed to be existential—or lived—and hence in figurative language internal rather than external, as any relation to an object by definition would be. And Merleau effectively concurs when he writes, "My body is not an object."[6] So it is not so much not known as known differently, and in the case of either thinker the implicit claim is that, since I stand at no cognitive distance from my body, between my body and me there is no corridor for the skeptic to haunt, and we eliminate him by eliminating the place he needs to occupy in order to be effective. Predictably, then, Merleau rejects a representationalist theory of bodily knowledge, and he charges the classical psychologists precisely of having construed the knowledge we have of our bodies in terms appropriate to a scientific knowledge of our (or any) bodies (they did so, he explained, because they are scientists and charmed by the scientific model of knowledge), "separating what on the one hand belongs to the spectator or the observer and on the other the properties of the absolute object." "Thenceforth," he concludes, "the experience of the body degenerated into a 'representation' of the body."[7] And indeed, this would have been the Cartesian

picture, at least until Descartes complicated matters with his celebrated, cryptic claim that we are not in our bodies as pilots are in their ships— where we would otherwise have believed him committed to saying that we are in our bodies just that way. I am, Descartes appeared to hold, directly acquainted with my ideas (or representations, if you will), including some ideas of my body. But whether these representations are correct or not is altogether, here as with other ideas except perhaps the idea I have of God, a matter of external correspondences which nothing internal to the ideas themselves can assure me hold true; in fact, it is to suppose that I may have no body at all, or one utterly discorrespondent with my idea of it. For I can think of my body not existing but not of myself not existing, and so cannot be one with my body. The existentialist counterclaim may then be read as follows: if knowledge of my body is not representationalistic, then there is nothing between my body and something which, in at least the central case, an external correspondence may or may not hold; where there is no gap, there is no need to *overcome* a gap; and so the skeptical frets cannot arise, since the ground on which alone they could arise has vanished. "Experience of one's body runs counter to the reflective procedure which detaches subject and object from one another," Merleau summarizes, "and which gives us only thoughts about the body or the body as an idea, and not the experience of the body in reality."[8]

Exactly parallel considerations will apply in the domain of action. A basic action cannot be construed as a causal episode in which, perhaps, the representation of a bodily movement, say as a volition, causes the movement it represents (which was exactly Hume's theory of action); as I stand at no distance from my body, no distance has to be overcome by the dynamisms of causation. It may, of course, be argued that the Cartesian picture of knowledge and the Humean picture of action are philosophically incorrect descriptions of knowledge of, and action with, *external* bodies, including those things physiologically credited as belonging to my body but which, since objects for me, are not part of what I am. But my concern will only be with what one might, in following these conti-

nental theorists, call representationalist theories of bodily knowledge and action. My question is whether these have in fact been discredited, and I suppose the issue will turn on the question of how we might handle in other terms just those things it seems to me representationalist theories were designed to handle philosophically, namely errors in the theory of our knowledge of objects and misperformances in the theory of action. It is this to which my paper will address itself first.

II

The "other sort of knowledge" to which Merleau-Ponty alludes may after all be what G. E. M. Anscombe supposes "modern philosophy has blankly misunderstood: namely what ancient and medieval philosophers meant by 'practical knowledge.'" For like her Continental counterparts, she sees "modern philosophy" as committed to "an incorrigibly contemplative conception of knowledge," a conception according to which "knowledge must be something that is judged as such by being in accordance with the facts."[9] So I suppose that if *practical* knowledge is knowledge of some quite different order, perhaps it is marked by the fact that *truth*, which presupposes at once a vehicle of knowledge—an idea or proposition or something at least to which truth-values may sensibly be attached—together with whatever it is ("the facts") that satisfies the truth-conditions of the vehicle, will not be a constituent in its analysis, for then the enjoined features of contemplativity will reappear. So the knowledge, whatever may be its structure, is nonrepresentational and in some way *immediate*. But if there is no place for truth, neither is there place for error, which on the contemplative model would be *disaccordance* with the facts. But surely there are misperformances or mistakes of action, which Anscombe of all authors has especially taught us to appreciate. But how can this be if the knowledge of one's performance is practical and so lacks a truth-component? There are no misexecutions in the *world*—which is a Spinozistic insight—and no misapprehensions in the understanding, save in relationship to one another: so some reference to

a representation seems implied in the concept of errors of performance. Perhaps, then, it is not so much that we can eliminate representations from our analysis of action as that we require a different relationship to a representation than that in which the facts are alleged to stand to representations in the contemplative model of knowledge: the satisfaction relationship, say. Still, practical knowledge is meant to refer to the sort of knowledge we have of our own actions, and possibly this is different from noticing, in an external manner, that one's arm is moving; or our knowledge that it is our arm which is moving is different somehow from our knowledge that someone else's arm is, or our knowledge that our own arm is moving when it happens to be moved by something external to ourselves and not, say, as a matter of basic action. So let us concentrate for a moment upon another feature Anscombe appears to find in practical knowledge other than its acontemplativity: practical knowledge is an instance of *knowledge without observation*, one of Anscombe's most interesting and puzzling notions.

An action a is not intentional under description D of a if the agent did not know that D was true of a; for not knowing that he was doing D renders inapplicable the question of why he did it, and the applicability of this question is analytical to the concept of intentional action as Anscombe has reconstructed it. But not only must the agent know he is doing a under D; he must know it in some special way, namely nonobservationally, for "the class of intentional actions is a subclass of things known without observation."[10] This move, I believe, is deeply controvertible. Nonobservational knowledge consists in knowing something x where there is no sensation (for example), no "separately describable sensation" distinct from x and on the basis of which knowledge of x is had. So I suppose knowledge of our own sensations must be paradigmatically nonobservational on this construal. But then of how many of my *actions* is my knowledge nonobservational in this way? Do I know without observation, for instance, that I am cutting cheese? For surely if there is a sensation of moving my hand in some special cheese-cutting way, there must be a separately describable sensation of *cheese* being

cut—the sort of sensation I have of cut cheese whether I am its cutter or not. Consider me cutting cheese without looking at what I am cutting. Nothing in the knowledge I may have of my own movements will differ from what I have while cutting cheese while looking at it; so what makes the difference is the separable presence of the perception of cheese in the one case and its absence from the other, the sensations of motility, supposing there are such, being invariant. So the sensation of cheese is separately describable. And suppose a stick of margarine has been substituted for the stick of Port Salut, and my movements remain the same though it is false that I am cutting cheese, even though the movements are the same as they would have been had I been doing so. How then can this be nonobservational knowledge I have when in fact I do have knowledge, namely, when I am cutting cheese and cheese indeed is being cut by me? And if nonobservationality is a criterion of intentional action, how can cutting cheese exemplify intentional action? Yet certainly a theory that makes it impossible for cutting cheese to be an intentional action is haywire *somehow*. What can have gone wrong?

Cartesian psychology would have allowed that I might have nonobservational knowledge of what my intentions are—for instance, to cut some cheese. There may be difficulties with this view, there may be unconscious intentions to which I refer in my own case as theoretical posits in order to make sense of my behavior, I may learn what my intentions are by observing what I do, and so forth. But Anscombe does not wish to countenance intentions at all, as her strictures are not against Cartesian epistemology here but against the sorts of things the Cartesian supposes we can have direct and immediate knowledge of in at least the clearest cases, namely, intentions: "Where is that to be found?" she asks rhetorically; "What is its vehicle?" And her philosophical motives are transparent. To allow intentions to occur in separation from bodily movements that are then intentional in relation to them appears to her exactly to reopen the gap it was a deep Wittgensteinian project to hammer shut: their being intentional was supposed to be inseparable—"not separably describable"—from the movements themselves. In a formulation

she gives but claims others have found obscure, she writes: "I *do* what *happens*." So if *I* cut cheese, the very sundering of cheese into slices—an event in the world—is what I do, no distinction being allowed between what takes place and what I do. "When the description of what happens is the very thing I should say I was doing, then there is no distinction between my doing and the thing's happening."[11] But what if there is a discrepancy? What happens if I should say I were cutting cheese and am doing something but not cutting cheese, margarine being there instead? A philosopher who wanted to say that I *believe* what is the *case* would have an easy time abolishing the distinction between world and representation—the world and representation are one—if there were in fact only true beliefs. But even in that fortunate case his would be a wrong theory, and it is exactly because we have to cope with false beliefs that we find our analysis of true ones has to be considerably more complex than we would have appreciated had error not been seen as a factor. Anscombe's theory does not suffer so much from obscurity as from wrongness. And its wrongness shows the need for there being intentions, whatever may be the problem of their vehicle and location, and whatever the philosophical price of countenancing them.

III

Anscombe's theory works best for mere bodily movements, for with these it may be argued that no separate sensation, say a visual one, tells me that my arm is moving when I move my arm: I know it to be moving, but not *through* anything apart from itself. In such cases, as she says, separate sensation "is merely an aid." And as much might be said regarding homeostatic sensations transmitted under alleged principles of feedback to the brain, which then sends out further signals bearing on the style of the movement. There is even scientific support for this: monkeys whose forelimbs were deafferented within hours of their birth nevertheless acquired the skills of ambulation, climbing, and reaching; and deafferented monkeys whose eyelids were stitched shut so as to foreclose col-

lateral visual aid were retarded in this acquisition by but a few weeks. Researchers concluded that "topographic sensory feedback and autogenetic spinal reflexes are not necessary after birth for the development of most types of movement performed by forelimb musculature in monkeys."[12] So it very likely is with us. But it was our *bodies*, after all, of which we were to have had "the other sort of knowledge" to begin with. If nonobservationality works here, enough of the anti-Cartesian progam of Anscombe's school may be salvaged to make the position respectable.

It is at this point that such phenomena as that of phantom limbs become vexing. Merleau appreciated this fact and wrestled with it heroically, though more from the perspective of feelings referring to what in fact were sectioned limbs than from the perspective of moving them, but it is exactly here that the concepts of knowledge and action become so close as almost to justify by itself Sartre's view that there is only *one* "concrete relation." For Anscombe, I think, the problem arises particularly in connection with the individuation of "separately describable sensations." For while there may indeed be a sensation or feeling of moving an arm as a basic action, the fact of phantom limbs allows the possibility to arise of this feeling being had without the arm moving, since there *is* no arm to move. So something in addition to this feeling is required in the normal case, since the feeling is invariant; or one believes on the basis of a motor habit that it has gone up, in which case a secure glance at the rising arm confirms the belief, as an "aid." But this implies that the knowledge that one's arm has risen is after all not merely practical but contemplative, since the extra sensation is required, even if not normally sought for. And how are we to deal with this?

It may, to a degree correctly, be argued that the feeling of moving an arm is of a portion of a physiological process, where the latter is truncated in the case of the phantom limb and only the portion occurs, though in the normal case in which the arm is normally attached the whole process and not merely the felt portion occurs: so the feeling stands proxy in the normal case for the whole process, though strictly speaking it is only of the portion. Then of at least this fragment there is

practical knowledge, upon which, as it happens, a body of beliefs and expectations has been formed about the behavior of the body, these being exactly confirmed when the body is normal or behaves in the normal way. It is then a matter of experience how far back in the process we may go before the feeling is obliterated—say by amputating more and more of the body until only that bit is left of which practical knowledge may be had.[13] Then all the *rest* is a matter not of practical but of contemplative knowledge.

There are some qualifications to be registered, however. The main one is that there may be basic performances unregistered by any feelings, known to be in our repertoire only through monitoring of their outward somatic effects. Examples of this are available in the findings of N. E. Miller, who has demonstrated the remarkable degree to which such functions as heart rate and brainwave are subject to conditioning, enabling patients to modulate bodily states traditionally supposed immune to the intervention of the will, since nothing introspectively available ever led people to suppose they had such powers.[14] This is true even with parts of our body whose movements we ordinarily would be supposed to know about directly. For example, Ralph Hefferline in experiments with thumb twitches has shown that not only were subjects unaware that their thumb twitches were means by which certain noises were terminated, but they did not even know they were twitching their thumbs.[15] The other qualification is the traditional one, the possibility of illusions of motility, of dreams and the like; and as is well known, it is the argument from such illusions that generates the logical separation of representation from fact and imposes upon us a Cartesian model of knowledge even of our bodies.

I shall not attempt to go further with these qualifications. I raise them only in order to suggest that "practical knowledge" is a seriously compromised concept which does not vanquish the *malin génie*, and that the philosophy of action, whatever we may have learned from its intense recent exploration, has not fulfilled the philosophical ambitions which

generated it, namely to collapse forever the gap between our bodies and ourselves, and hence between the world and ourselves, by eliminating representationality altogether. To be sure, we may have something left we can call practical knowledge, as a sort of knowing-how which has application to our bodies, though I suppose we would wish to distinguish the knowledge of how to move our bodies gracefully, like dancers do, from mere bodily behavior. But this practical knowledge has a scientific name: it is operant behavior; it is that which is subject to conditioning. Operant behavior is the scientific component of the concept of basic actions, and it may indeed have a measure of philosophical importance. But it is something distributed throughout the animal domain, something we share with rats and paramecia, and it cannot, as I began by saying, have the philosophical importance that basic actions themselves were supposed to have. Moreover, our feelings of immediate contact with our schedules of operancy are of limited utility in determining the boundaries of conditionability. Briefly, there may be a great deal we in this sense know how to do, without our knowing that we have this knowledge. And we learn—or come to know—what are our powers through the despised avenues of contemplative knowledge.

But does this then mean that our bodies are to us nothing more than objects of knowledge, hardly different from the other things in the world of which we achieve successful representation? To this, I think, the answer is negative, for there is, I believe, another relationship in which we may stand to our representations. It is to this that I now turn.

IV

We may regard intentions as representations of how we should like the world to be in consequence of our actions, and it seems plausible that we regard the relationship between these representations and those actions as *causal*. Indeed, we may regard knowledge and action as having parallel if inverse structures, insofar as something is knowledge if it is, other

factors bracketed, a representation caused by what makes it true, while something is an action if, other factors bracketed, it is caused by a certain sort of representation. There is a truth-component in the concept of actions so considered as well, but I want to introduce it in the course of making more precise the nature of the causal connection here. For the matter is not beneath controversy, since not everyone will admit that intentions, or more familiarly, reasons, could be causes of actions.

There is a class of very familiar arguments in the post-Wittgensteinian philosophy of action that since causes and effects are distinct events, and hence subject to separate and independent descriptions, and since reasons or intentions cannot be described save with reference to the actions in whose explanation they are enlisted, reasons or intentions cannot be causes of actions nor actions the effects of reasons or intentions. Donald Davidson has demonstrated that for any event counted a cause, a true description of it can be given which has the occurrence of the alleged effect as a truth-condition, so that such a description of the cause is not a separate and independent one.[16] I suppose, for the matter, that we can give descriptions of anything that entails a reference to anything else we choose to formulate in the description, but this need not faze those who find the first argument compelling; it was not their claim that every description of a cause is separate and independent of reference to an effect, but that *some* such description can be found, whereas *no* individuating description of a reason can be given which does not make reference to the appropriate action. And Davidson's argument is powerless against this. Nevertheless, I feel that Davidson's essential point is correct, that reasons are causes of action, and I want to clarify the contrary intuition of the Wittgensteinians by showing *what* it is that their notion of nonindependent description rests upon here. As we shall see, the thought behind their claim is quite similar indeed to that behind Anscombe's flawed doctrine that what we do and what happens are one. And like her view, it is subject to an objection based on misperformances or nonexecution.

Reasons, like beliefs, are, I think, irreducibly intensional in their for-

mulations. From considerations which parallel the phenomenologists' claim that consciousness always is *of* something, we may suppose that all reasons are reasons *that* something should happen or be the case: *that* I should marry, or be on the other side of the street, or become a father, or whatever. Such reasons will be cited in explanation of things I do when I believe the latter to be means to—causes of—that for the sake of which I do them. Suppose I am writing the king of Morocco that a certain prisoner should be freed. That he be freed is my reason for writing this letter, and explains my so doing. Since it is exceedingly unlikely that this prisoner will be freed, or if he is that this will be in consequence of my letter, *that* for which I write the letter may not happen, or it may happen, but not in consequence of my action. My reason nevertheless stands, though no event may occur of the sort without reference to which the reason allegedly cannot be formulated, and hence the formulation clearly cannot depend for its truth on the occurrence of such an event. So the truth of the description does not entail the occurrence of the event, or if it must, then it cannot be true that the given reason is my reason—and this seems flatly absurd. So what we must mean, I believe, is that reasons cannot be formulated without reference to what we might portentously speak of as intensional objects, or, less portentously, without reference to their *contents*, but this object or content cannot be identical with an event in real history of the sort that happens when my action is successful: if the prisoner is liberated and in consequence of my plea for amnesty. And now matters stand this way. Reasons cannot be formulated without reference to content, since their content is a logically inseparable part of reasons. But since reasons-*cum*-content are logically distinct from any events that may correspond to this content, reasons-*cum*-content can be causes of the latter. Perhaps they still are not causes, but not in consequence of the sort of argument alluded to above. For that sort of argument is now seen to be wrong. Briefly, a reason has the form "*a* in order that *p*," where *a* denotes an action and *p* is the content of the reason, and where, in the successful nonbasic action, *e* satisfies *p*, *a* causes *e*, and the reason itself causes *a*. We then causally explain the

performance of *a* by *m* with reference to that reason, presupposing, of course, that *m* believes *a* will bring about *e*. This crude analysis preserves the insights of Davidson as well as of his opponents; their views are not just consistent but complementary, each having a fragment of the truth. The relation between reason and content is logical; the relationship between reason-*cum*-content and action is causal.

But there is more to the matter than this. Namely, reasons are causal through their logical structure, and the theorists Davidson has attacked are right in believing that if causes exist at all, reasons are causes of a quite special sort: for ordinary causes are not such through their logical structure, having none. We may gain a measure of appreciation of what I mean by "logical structure" here if we consider a parallel feature in the concept of knowledge. Take those cases of knowledge in which possession of a true belief is a necessary condition. Then the analysis might run as follows: the true belief that *p* is knowledge that *p*, only if that state of affairs *o* which make *p* true explains the fact that the person in question believes that *p*. Let this sort of explanation take "causes" as a frequent instance. Then I know (for example) that the paper before me is yellow if the paper before me is indeed yellow, and if its being so causes me to believe that it is so. So the paper's being yellow enters into two relations with the belief: explaining its occurrence and making true the propositional content of the belief. Belief-that-*p* has a logical structure, part of which is given by the logical structure of *p* itself as part of the belief; and in the case of knowledge it is through this internal structure that belief is an *effect*. Seventeenth- and eighteenth-century philosophers were specifically interested in explaining the provenance of ideas as effects, when the ideas were construed intensionally—as *of* red or *of* wax or *of* whatever. Indeed, it would primarily have been through their content that ideas were of interest to them at all, though there plainly has to have been a polemical context for Berkeley's thesis that ideas just *are* their content to have been exciting. My concern, however, is only to utilize the parallels between the theories of knowledge and of action to propose that reasons or intentions are causes through their structure in just the

way in which beliefs are effects through *their* structure. And perhaps it is this which is missing from Davidson's account.

In the simplest case, let "in order that *a*" be *m*'s intention or reason for doing *a*, nothing ulterior intended. Then not only must this reason cause *a*: *a* must satisfy, confer truth upon, the description implicit in the reason. So as with belief in the context of knowledge, there is a causal as well as a semantical relationship between representation and the world to be accounted for. And it is the semantical relationship which requires the introduction of internal structure in our analyses of such causes. If I *shout* "p," the echo comes back "p." I have caused the echo, but no truth-relationship holds here between cause and effect, and the internal structure of cause and effect are alike inscrutable or accidental, in contrast with what we require of causes and effects in the theories of knowledge and action. But this is very generally the case with causes and effects: effects do not routinely, and certainly not in the class of instances the collision of billiard balls is meant to exemplify, confer something like truth on their causes, nor causes on their effects. So I think that something more than just being causes of actions is required of reasons, supposing them to be causes to begin with, and the truth-connection may come to the somewhat more internal sort of connection the Wittgensteinians intuited has to be there. This marks the difference between reasons and such other sorts of causes of action as there may be. But it is exactly this further component in the analysis that raises to prominence the representational factor in intentional action, whatever may be its vehicle.

V

I do not feel that reference to representation need, in either action or knowledge, drive us back to the pineal gland and then through some opening in it to a realm of spirit beyond. Elsewhere I have sought to argue for a materialistic account of representations, to which I merely can allude here. But representations, just because they admit of assessment in terms of truth and falsity, are logically external to the world in

which they may in every other respect be located. As agents and knowers, indeed, we are within the world under the concept of causation, and external to it under the concept of truth. Within and without the world at once: that is the philosophical structure of man. In the respect in which representation has been misconstrued or underestimated, the modern theories of practical knowledge and of human action have failed. That we can change the world to fit our representations, as in action, or change our representations to fit the world, as in knowledge, is a marvelous power, but it requires reference to representation, and this, I think, is finally what is going to distinguish the *human* sciences from the sciences of nature, where at least the subject matter is uncomplicated by representational elements.

Whatever the case, the basic action has been decomposed into a representation, on the one side, and a piece of operant behavior on the other, with the former causing the latter and the latter satisfying the former. The two Cartesian substances have given way to two sorts of relationships instead, one causal and the other semantical, but the Cartesian distinction between representations and reality remains, and the powerful modern attempts to fuse them have failed.

NOTES

1. Jean-Paul Sartre, *Being and Nothingness*, trans. Hazel E. Barnes (New York: Philosophical Library, 1956), 308.

2. Ibid., 323.

3. Maurice Merleau-Ponty, *Phenomenology of Perception*, trans. Colin Smith (London: Routledge & Kegan Paul, 1962), 88–89.

4. Ibid., 206.

5. Gabriel Marcel, *Journal Métaphysique* (Paris: Gallimard, 1927), 323.

6. Merleau-Ponty, *Phenomenology of Perception*, 198.

7. Ibid., 74.

8. Ibid., 198–99.

9. G. E. M. Anscombe, *Intention* (Oxford: Basil Blackwell, 1956), 57.

10. Ibid., 14.

11. Ibid., 52–53.

12. *Science*, September 7, 1973, 959.

13. This remaining bit may be thought of as a volition, something that causes the bodily movement, which together with it forms the whole process designated as an action. See my *Analytical Philosophy of Action* (Cambridge: Cambridge University Press, 1973), chap. 3.

14. N. E. Miller, "Biofeedback and Visceral Learning," *Annual Review of Psychology* 29 (1978): 373–404.

15. Ralph Hefferline, "Proprioceptive Discrimination of a Covert Operant without Its Observation by the Subject," *Science* 139 (March 1963): 834–35.

16. Donald Davidson, "Actions, Reasons, and Causes," *Journal of Philosophy* 60 (1963): 685–700.

Outline of a Theory
of Sentential States

A CHARACTERISTIC DEVICE of comedy and tragedy alike is to have the hero believe one thing about x and another about y, while unbeknownst to him x and y are one. Oedipus believes, thus, that Jocasta will make him a highly suitable wife and that his own mother would make him a highly unsuitable wife, learning too late that one woman is the object of both beliefs, abruptly rendered incompatible through the discovery. This fate is spared Tom Jones or the factotum Figaro, each of whom discovers in the nick of time that the lusting lady is his own ma. So just because a person believes that x has a certain property, it will not follow that he believes that y has that property, even though x and y are identical. How different believing is from smelling, by this criterion, since it will follow from the fact that someone smells x that he smells y when x and y are identical. This patent difference between beliefs and smells, between the sentences with which we describe beliefs and smells respectively, marks one of the differences between what philosophers have latterly designated intensional and extensional contexts. It is an intensional context when, among other things, we cannot substitute

From *Social Research* 51, no. 4 (winter 1984): 1001–17.

terms that refer to the same thing with any assurance that truth will be preserved. If algebraic equations were intensional, they would be computationally useless, since computing consists in substituting expressions for expressions having the same numerical values. Intensionality is exhibited by a wide class of psychological states known since Russell as propositional attitudes. That which one hopes will be the case proves to be the very thing—how was one to have known?—one had hoped, in different terms, would never come about. The thing one feared the most proves to be the very thing one had counted on to protect one from the object of fear—as when the obscene phone caller proves to be one's own husband. "Which of us has his desire?" Thackeray asks in resignation at the end of *Vanity Fair*, "or, having it, is satisfied?" Poor Major Dobbin has learned, as the world's wise say we all must learn, that that which satisfies the desire frustrates the man: she whom he desired as a wife turns out to be not at all the wife he desired.

Intensionality has been thought to be the mark of the mental, but there may be mental states, like pain, where intensionality is minimal if it is there at all, and there are matters intensionally characterized which could only be mental if everything is mental. It is nonetheless true that much of mental life is intensionally represented, and considering the difficulty philosophers have had in working out its logic, it is gratifying that it is understood by those who are philosophically rude. Audiences have responded with horror to Oedipus's misstep and with merriment to Figaro's narrow escape long before there was a philosophical vocabulary for dealing with it at all. We are not concerned with something recondite, though intensionality came to philosophical attention almost as a casual by-product of the deep investigations into logic and the foundations of mathematics that constitute one of the intellectual glories of our century. Since representations of representations are always intensional, intensionality is not a topic that a *theory* of representations can shirk.

It was recognized remarkably late—the fact is not, for example, registered in the first edition of Whitehead and Russell's *Principia*

Mathematica—that intensional propositions are counterexamples to the seemingly truistic claim that if *a* are *b* are identical, they then have all the same properties. Of course you may not wish to class as one of the properties of Jesus that he is believed to be the son of God by his disciples. But surely it is a property of Jesus that he is believed to be the son of God by himself, and it may seem arbitrary to let a belief about him be a property in the one case and not the other. But—the tricky example here is of a type familiar to readers of Frege—a great many believed Jesus was not the son of God, though perhaps nobody believed the son of God was not the son of God. So if Jesus really was what he claimed to be, he had some properties under one description which he lacked under another description, and the truism seemed to be false. This was an uncomfortable circumstance, since the truism appeared to be required for the elaboration of mathematical logic. And it was even more uncomfortable for those who thought they had found in the smart new logistic systems something that might be used for the language of science. It could hardly be used as that if psychology was to be a science that studied propositional attitudes—beliefs, phobias, desires, motives—and there could be no way in which psychology could be put into the language of science, since it violated the principle, or seemed to, that if two things are identical they have all the same properties: the so-called principle of the Indiscernibility of Identicals. The unity of science, construed as the unity of the language of science, was held in hostage to the concept of intensionality. Or intensionality was a weeping sore in the flesh of reason.

It was a response of genius, I believe, to propose that all would be well if a way were found in which every intensional proposition could be *translated* into an extensional one, extensionality being partially defined by conformity with just the principle intensionality defies. Translational theses were standard in that period of analytical philosophy—sentences about physical objects were to be translated into sentences about sense data, sentences about mental states into sentences about behavior, sentences about social wholes into sentences about individuals—and this

particular thesis (like so many others) was first propounded by Russell and then elaborated with a kind of Teutonic ponderosity by Carnap in *The Logical Syntax of Language*. It was known as the Thesis of Extensionality. A theorist like Derrida might suggest that there is an instant structural irregularity in the Thesis of Extensionality through the fact that translation *itself* is in violation of the principle it is supposed to salvage, since it will be a rare translation indeed in which the translating sentence has all the same properties as the sentence translated. And beyond that there is a subtle question of whether translation is itself an extensional concept, and what kind of operation extensional translation could be— delicious questions, since, if they are genuine, they furnish excellent examples of the philosophical propensity to allow oneself privileges in the administration of a philosophy that the latter rules out of order. The exposed backside is epidemic in the philosophy of language, but the Thesis of Extensionality carries enough philosophical interest that we may leave its deconstruction to others and scrutinize how it works.

Now one might, since it is a translational thesis in its own right, consider behaviorism as a coarse and local application of the Thesis of Extensionality. As it happens, the thesis puts no constraints on the language into which intensional propositions are to be translated, save that these be extensional. There is, for example, no requirement that they be observational as well. There was a prejudice among the extensionalists, promoted to a dogma by behaviorism, that the language of science had to be observational. Still, quite apart from the fact that behaviorism leaves the general problem of intensionality untouched, since there is more to it than psychology, there is the problem of behaviorism that it cannot explain how Oedipus married his mother believing that she was someone else. After all, there was only the one stimulus (that is, Jocasta). How do we account for the fact that he responded differently to an identical stimulus save through the fact that he was guided by crossed representations? But representations are among the things behaviorism disallows, forgetting, typically, that behaviorism itself is a system of representations, however exiguous.

Carnap's way of dealing with the thesis is immeasurably more coherent, since, among other things, it manages to retain the content of beliefs (and other representations), which behaviorism could not do, in part by recognizing that intensional sentences are finally about representations, or at least partially about them. For Carnap, a sentence like "Oedipus believes that p" is what he terms "quasi-syntactical." It is quasi-syntactical in the respect that it is in part about a sentence, namely p itself. The Thesis of Extensionality translates "Oedipus believes that p" into "Oedipus believes 'p.'" "Oedipus" designates the man Oedipus, and "p" designates the proposition or sentence p. But sentences are among the world's inventory of things, just as persons are. "Oedipus believes 'p'" is about the sentence p in just the same way that "Oedipus says 'p'" is about the sentence p—the sentence uttered by Oedipus. It was Carnap's conjecture that something like this analysis would serve for all intensional contexts and not simply those that describe propositional attitudes, but for the present I am interested only in the psychological application. The sentences "My mother will make me an unsuitable wife" and "Jocasta will make me a suitable wife" are conspicuously different sentences, with distinct grammatical subjects. Even if these designate the same woman, they are different ways of representing that woman; and in being about the representation, the sentences in question are extensional. They are, as it were, about words, not about what the words are about. "There is an absolute gulf between the assertion of a proposition and an assertion about a proposition," Russell wrote in an appendix to the second edition of *Principia*. He was glossing his own remark that "when I actually assert that Socrates is wise, I say something that cannot be said by talking about the words I use in saying it."[1]

This, then, is Carnap's point: in talking about a person's beliefs (or hopes or desires or wants or fears), one is talking about the words in which the beliefs (or whatever) are formulated. And thus one has an extensional translation of the original intensional one, since a description of one set of words need not—usually will not—be a description of another set of words, though the two sets of words might in fact stand

for the same thing. The expression "*p*" occurs, in Carnap's language, "autonomously" in "Oedipus believes that *p*." It does so in the sense that its truth or falsity contributes nothing to the truth or falsity of the sentence that contains it. This is so because in such sentences it occurs, so to speak, as a kind of thing. Words are philosophically interesting because they are things, even if they happen to have a lot of other features. Belief sentences *display* the word-thing the sentence is about. It cannot of course do this with Oedipus himself, but that is one of the differences between persons and words that make the analysis of language so philosophically treacherous: we may be simply displaying a word when someone supposes we are using it to say something.

Whatever its manifest advantages, the Thesis of Extensionality remains very much a logician's theory, for having shown how to make an extensional sentence out of an intensional one, it leaves unanswered what the connection is between, say, Oedipus and *p*: between the person and the sentence the deintensionalized sentence refers to. There would be no such problem with a quotation; when we say, "Oedipus said '*p*,'" we are displaying the very sentence that issued from Oedipus's mouth (or a token of the same type as it), and we all pretty much understand what saying a sentence is. But what is *believing* a sentence; what *is* the sentence we are said to believe? My own view, which I advanced in my *Analytical Philosophy of Knowledge*, is that a clear and natural answer to this question could be given if, when a person believes something, he is in a *sentential state*.[2] Thus, "Oedipus believes '*p*'" is true if Oedipus is in a sentential state of the kind that *p* displays: if he is literally *made out of words*. When Jerry Fodor's beautiful book *The Language of Thought* appeared seven years later, I found in it reasons vastly more powerful than any that had occurred to me for believing that we are constructed sententially. I was looking only for a possible natural theory to underwrite a piece of semantic analysis. A great deal has been thought since I first enunciated that thesis, some of it by me, and perhaps this would be a good place to sketch out some of the features such a theory might have, these being forced upon us by certain features that *we* might have if we

in fact *are* sentential beings—or, more generally, representational beings: beings whose representations are properties of themselves.

1. To be in a sentential state *s*, it is not required that one be conscious of that fact. Sentential states of individuals need neither be objects nor states of that individual's consciousness. So we need have no specially privileged access to our sentential states, as would usually have been supposed when mind and consciousness were closely identified in the tradition, and when it was widely allowed that to be a fact of consciousness was ipso facto to be conscious of that fact. Our beliefs may of course come into consciousness, but they need not; they need not even be subject to the scan of introspection, or "inner sense," as the empiricists termed it. So there is no epistemological advantage in being owner of a set of beliefs so far as those beliefs themselves are concerned, and sentential states are accordingly not defined through any criterion of cognitive accessibility. Rather, we come, often, to discover what our beliefs are in the same way in which we come to discover what the beliefs of others are, and there may be beliefs of a very deep order that we simply never discover that we have. These are concealed not from ourselves so much as from our consciousness.

2. Though not necessarily accessible to consciousness, one's sentential states are not for that reason to be supposed located in the unconscious, in that special technical sense of the term we associate with Freud's discoveries. Nor, for that matter, need they be preconscious in his sense either. Freud congratulated himself for having broken the grip in which the concept of consciousness had for so long held psychology, but nevertheless allowed the concept of consciousness to govern his own reconstruction of mental process. Thus whatever is preconscious can be summoned to consciousness, as it were, and is defined through its accessibility to consciousness. And whatever is unconscious was *once* conscious. So the three states are almost temporal divisions: preconscious, conscious, and postconscious states. I maintain, on the contrary, that there may be sentential states of ourselves which may become objects of our consciousness—things of which we are aware—without ever being *states*

of consciousness. I come to know it as a fact about myself, say, that I believe that *s* without that belief staining my conscious life. A good many of the sentential states Freud imagines are located in the unconscious (his Ucs. system) must, if his explanatory structures are to be accepted, be in the natural language of the individual who repressed them. They must because so many of Freud's explanations require that there be a punning relationship between the unconscious state and whatever is manifest to consciousness as dream or symptom. Hence, only if the repressed sentences carry their phonetic values with them as a kind of *Klangenbild* (sound image) into the Ucs. system could such explanations satisfy a necessary condition for plausibility. Of course, it is not required that the victim have understood the language in question: he may have internalized a sentential noise retroactively rendered meaningful and traumatic through the mechanism of what Freud calls *Nachtragen*.

3. Even if the sentential states of the Ucs. system must, at least for the classical cases of psychoanalytical lore, have been in a natural spoken language, it is not required of sentential states that they be in a natural spoken language internalized after the fact. If Fodor is right in one of his central conjectures, it is required that there be *some* sentential states *not* in a natural language. For the claim is that the very acquisition of a natural language requires the learner to construct a theoretical grammar for the language, and the language in which the theory is then formulated cannot be the language (the child's first language) to be learned. The language that constitutes the "medium of representation" for the natural language being acquired is not itself acquired and, because not a medium of communication, is nowhere spoken. Some critics of the very idea of propositional attitudes have detected an absurdity in the language of thought, but this is because they have tended to identify it with an internalized natural language. It would be absurd if that were so, since it would leave us powerless to explain the mental processes of those who have not yet acquired a natural language (neonates) or who never will acquire one (animals). But the accusation dissipates with the distinction between the language of thought and a natural language. Even so, it may

be that the language of thought is intensional: a dog may believe that his master is to be trusted but that the man in the black hood is not to be trusted, though the hooded man is the master disguised. Snarling at the hooded man is replaced with enthusiastic fawning when the disguise is penetrated or removed.

4. Sentential states are mental states primarily through the fact that they form components of propositional attitudes such as belief, fear, desire, and the like. I mention this because the body may be a system of interconnected systems of information processing, and it is possible that information is processed through the transformation of states of the system that have some kind of sentential structure. Since this cannot be ruled out as a possibility, sententiality can hardly be used as a mark of the mental. But sentential states that are components in propositional attitudes—believing that *s*, for example—may very well be mental. In any case, I shall suppose that those sentential states which have sentential components are mental states, and it is these that I shall primarily be speaking of in the remainder of this outline.

5. Sentential states enter into the explanation of actions and are themselves subject to explanation through other sentential states, or perhaps through causes having no sentential, or relevantly sentential, structures at all. I shall restrict myself to *causal* explanations (leaving it open that there may be other sorts of explanation), and I shall distinguish *four distinct types* of causal episodes, depending upon whether cause or effect or neither or both are sentential states. The following pairs, in which the first member is cause and the second effect, and where an S with a line through it means that the event or state is *not* a sentential state, are the four basic sorts of causal episodes it seems to me important to consider:

	Cause	*Effect*
(A)	S	S
(B)	S	\cancel{S}
(C)	\cancel{S}	S
(D)	\cancel{S}	\cancel{S}

Type D episodes are illustrated by rocks breaking windows upon impact or matches igniting upon being struck or the usual movement of billiard balls by billiard balls—the standard classroom examples in discussions of the concept of causality. If the world were only the concussion of atom upon atom and nothing else, there would only be type D episodes, but such a world could not contain true descriptions of itself, since whatever binds a description into a meaningful unit could hardly be atom knocking against atom. In any case, type C episodes might well be straightforward psychophysical episodes, where distal stimulus causes proximal stimulus and the latter is sentential in structure. Type B episodes might be simple actions as when one's arm goes up because one means that it should go up. And type A episodes compose the bulk of our mental life, for example, where we believe something because we believe something else, or where we believe something because we *hope* it is true, and so on.

6. Sentences are certainly physical entities, modifications of such media as ink or air, depending upon whether written or spoken. Sentential states would be modifications of nervous tissue if materialism is true, but much as I should like to suppose sentential states to be enfleshed in this way, nothing in the way of a position on the mind/body problem is entailed by their existence or occurrence. The fact that the *same* sentence may be embodied in sound waves, ink marks, and neural states (if materialism is true) gives a certain plausibility to what is known as *functionalism* in the theory of mind, but my concern with them lies, for the moment, elsewhere. For however they are embodied, sentences differ from the usual material entities—stones and bones—by virtue of bearing truth-values and hence by virtue of having meaning. Sentential meaning, indeed, is given by the truth-conditions of sentences—"To understand a proposition is to know what must be the case, if it is true," Wittgenstein wrote in the *Tractatus Logico-Philosophicus*[3]—and what truth-value a sentence bears is then a matter of whether or not those conditions are *satisfied*. This is so as much for sentential states of persons as for sentential states of pieces of paper (like the one on which this text

is printed). Type C episodes, thus, might count as pieces of knowledge when the effect is made true by its cause (and skepticism is unavoidable through the fact that neither its having a cause nor its cause satisfying its truth-conditions can be inferred from the effect). Type B episodes count as actions when the effect satisfies the truth-conditions of the cause. These extra conditions beyond those normally required for causal successes help distinguish type B and C episodes from type D. Type A episodes are more complex still. In many psychoanalytical transformations, the effect *misrepresents* its cause in fascinating ways. In inferential thoughts, the effect preserves the truth-values of its cause, and so on. Inference, action, and cognition are clearly connected with our survival as individuals and as a species; unless there are natural, normal, and frequent congruencies between the world that impinges upon us and the way we represent it, we have no way to explain the adaptive role of sententiality in organisms. Although survival is the best evidence that our representations and the world fit one another, it is plain, for reasons already mentioned, that survival begs the question against skepticism.

Whatever the case, on normal assumptions, in my first three types of causal episodes, there are *two types* of relationship between cause and effect: there are the causal relations, however these are to be understood, which are invariant to all four types of case; and then there are the logical or the semantical relationships. These latter have been intensively studied by philosophers in recent decades—the study of such relationships as *satisfaction, reference, exemplification,* and others is pretty much what analytical philosophy *is*. But since they represent ways in which we represent the world successfully or unsuccessfully, reference to them must be compassed by the laws that cover our behavior in the world. That is, the laws of behavior for sententially characterized beings—animals, some machines, and us—must take account of the truth-relations between the world and us, as well as within us, as part of their *own* truth-conditions. We must include truth *in* our laws in order to speak of the truth *of* our laws. This alone distinguishes the laws of cognition, action, and thought from the laws that cover episodes of type

D, but I think it very much a program for the philosophy of science to state the logical form of these laws. It is even more a program for the sciences of representation to discover what these laws are. The so-called human sciences—the *Geisteswissenschaften*—have been almost fatally impeded by the failure to recognize the differences among causal episodes, or by the assumption that episodes of type D exhaust the kinds of causal episodes there are.

The two kinds of relationships between causes and effects yield a pretty metaphysical picture of sententially characterized beings—persons, say. We are within the world under the laws of causation and outside the world under the laws of representation. Within and without the world at once, laws involving both kinds of relationships are required to represent us. But this is to be expected when dealing with beings compounded at once of matter and meaning.

7. Doubtless all four types of causal relationship are involved even in fairly minimal actions, which we explain through someone doing something because he wanted it to happen, and reasoned that doing that thing was the way to get it to happen. Believing that a fly has landed on my face, I slap at it because I want it to go away and believe slapping the way to get this to happen; and of course my body must function smoothly in type D fashion if representation and world are to match up. Even when compiled in this way, however, the impoverished matrix of causal episodes must be far too coarse for even the simplest cases involving human interrelationships, or even those animal relationships in which one animal believes something because it believes that another animal believes something: where there are belief-sentential states embedded in belief-sentential states: beliefs about beliefs, and especially beliefs about the beliefs of others—as well as their hopes, their fears, and the like. I am prepared to follow Continental practice and speak of these as *interpretations*. A woman puts her hand on a man's cheek because she believes he fears she no longer cares for him and believes he will interpret her placing her hand thus as a sign of affection; a girl who wants others to believe she is busy writing a novel will type furiously in her room

in the hope that others will interpret this activity as a sign of her being seized with inspiration. These are complex exercises of hermeneutical skill, but at this stage there is perhaps no great theoretical point in seeking for basic communications and a structure in which to incorporate them. All that should be plain is that in using interpretation to mean forming a belief about a sentential state—in the limiting case, one's *own* sentential states—there is a clear sense in which the laws of the human sciences *are* interpretations, and that there is, here again, a difference of a logical sort to be drawn between the human (or, as I prefer to call them, the representational) sciences and the sciences which represent without representing representations.

This is too delicate and intricate a matter to treat further in a mere outline, but it marks a place where a major extension of analytical philosophy might be made. So I shall conclude the outline by taking up a somewhat more tractable matter that connects with some of the conditions for successful interpretations.

8. I have acquiesced with the early extensionalists in treating sentences about beliefs as asserting a relationship between an individual and a sentence, and have supposed that "believes that" really is a relational expression, though its logic is in fact a matter of the most intense philosophical controversy today. My own view is that "believes that p" ascribes a state to the individual said to believe that p, and that p designates the sentential state embedded in such a state. Here I wish only to comment on the sort of relationship we are dealing with with "designation," when, in the context of "believes that p," p designates such a sentential state. If I *quote* someone, *my* words are also the words the speaker spoke (or said): I *show* the words he said by saying them myself, and so we have a classic case of mimesis. Obviously I am not required, at least not ordinarily, to mime the quoted one any further, for example by simulating his voice or intonation: I am not an actor but a reporter. Now, there is a convention according to which I can orally quote someone's written *or* spoken words, or can inscriptionally quote his spoken or inscribed words—those *very words*, as it were, having different embodiments in different media.

Aristotle proposed that writing is to speech as speech is to thought—and if thought is another medium, like speech and writing, then I can quote a person's thoughts, if those thoughts are sentential. Since quotation is mimetic or, broadly speaking, pictorial, then, when I quote, *my* sentence pictures the subject's sentence, invariantly as to the medium of its embodiment. A sentence about belief is in this sense the quotation of a thought. The quotation displays the content of the belief.

This would be a good analysis if we did not have language affiliation to deal with, for in addition to the medium of its embodiment we have the *language* of its various embodiments to consider. When I say, "Caesar said, 'I came, I saw, I conquered,'" we all know that Caesar's (famous) words were not in English but in Latin. Now, in the main there is no problem in adding to the semantical conditions for quotations—or for belief-ascriptions—that the quoting sentence be in the language of the quoted sentence or that it be a translation of the latter. Often those to whom we report do not have the language of the person whom we quote, and so we must quote in a language they do have. We would find it a very unsatisfactory translation of *Anna Karenina* that left the dialogue in Russian. We ordinarily allow translation to penetrate quotation marks. Wilfrid Sellars has even devised a special notation—what he called "dot-quotes"—to liberate the quotation from the language of the speaker, much in the same way that ordinary quotation marks liberate the quotation from the medium in which the words were originally embodied. Dot-quotes give you the words purged of the particularities of this language or that. The fact that the same word may have different appearances in different languages as well as different media is one of those facts about words which has generated no end of philosophical mystification.

Words nevertheless are not to be liberated by mere notational devices, and it was Saul Kripke, with his usual ingenuity, who showed how deeply true this is for sentences that ascribe beliefs. He produced a case where the translation of such a sentence may be false though the original sentence is true and the translation exact. Kripke's example is this: It is true that Pierre believes that *Londres est joli* but false that Pierre

believes that London is pretty, even though the latter says in English exactly what the former says in French. The reason is that Pierre, as a child, was taken by his francophone family to live in a pretty section of a city they called *Londres*, charming in Georgian facades and plane trees, parks and nannies, friendly bobbies and clean streets. In his later life Pierre falls upon evil times and awakens in a locus of squalor his mates call London. It never occurs to Pierre that London and *Londres* are one: how could it? The problem does not lie with translation but with Pierre and the circumstances of his forming what he fails to recognize are representations, however aesthetically incompatible, of the same city. Were the problem only translational, we could introduce a special language-affiliation marker and translate "Pierre croit que Londres est joli" as "Pierre believes*french* that London is pretty," which does not license us to "Pierre believes*english* that London is pretty," this being a fact that has to be established in ways in which the mechanisms and devices of translation cannot. It is a fact about the words with which Pierre represents what he happens *not* to know are aspects of a multiaspected reality.

Kripke's discovery is almost a demonstration that sentential states are in a language, leaving us with a problem with sentences in the language of thought, which none of us speaks and indeed none of us really knows, since it is inaccessible to consciousness. I can ascribe the belief that New York is interesting to my dog Emilio, but what his expression in the language of thought for New York is I hardly can imagine. I do imagine that New York, for him, is a place of smells, specifically the exciting aromas of other dogs of the Upper West Side—though Emilio surely lacks the concept of the Upper West Side. Like Pierre, Emilio might be transported to a dogless area of New York—Wall Street, let us suppose—and in the language of remembered smells it is doubtful he would realize it was the same city. There is a Turkish proverb that a person with two languages is two people. But the vagaries of translation do little more than exemplify the same situation with which we began this outline, the situations of comedy and tragedy, in which the hero has not realized that his representations are of the same person. Oedipus is but

one man with unintegrated sets of representations, who must pay the price just having representations exposes us to. And this must say something about the mind.

What it says is that the identity of a sentential state is very much dependent upon what other sentential states it co-occurs with. Thus the belief that London is pretty co-occurs, in Pierre's mind, with a different set of beliefs than the belief that *Londres est joli* does. It is as though these occur much as sentences do in *texts*, where we understand the sentence in the light of the other sentences that compose the text. But these relationships which make texts of sentences are very little understood by philosophers, as indeed they are very little understood by any discipline. The textuality of the mind, however, yields another dimension of what has been termed interpretation: we interpret a belief by locating it in a system of beliefs that may be pretty eccentric in the individual whom we are seeking to interpret. This is manifestly true of psychoanalytical interpretation, but so might it be true of someone who seeks to interpret Oedipus when the interpreter knows the identity of the intended bride: is Oedipus ignorant or defiant or what? And it is true of poor dull Pierre. That the mind is more like a book than a program, more a text than a set of arguments, is the threshold of a topic I dare not cross here. It is one direction for research: the logic of texts is a frontier for philosophy and for philosophical psychology. The other direction for research is for science to take, for my conjectures on sentential states are so many floated checks I merely hope an as-yet-unimagined neurophysiology will underwrite.

NOTES

1. Alfred North Whitehead and Bertrand Russell, *Principia Mathematica* (Cambridge: Cambridge University Press, 1950), vol. 1, app. C.

2. Arthur C. Danto, *Analytical Philosophy of Knowledge* (Cambridge: Cambridge University Press, 1968).

3. Ludwig Wittgenstein, *Tractatus Logico-Philosophicus* (London: Routledge & Kegan Paul, 1949), prop. 4.024.

Depiction and Description

[Hogarth's] graphic representations are indeed books; they have
the teeming, fruitful, suggestive meaning of words. Other
pictures we look at—his we read.
 Charles Lamb, "On the Genius and Character of Hogarth"

PICTURES AND WORDS MAY BE grossly distinguished in terms of
how they represent their subjects, and they exemplify, again grossly, the
two chief systems by which we represent the world. The iterated *grosso
modo* derives from the fact that the mode of representation that pictures
exemplify is not uniquely exemplified by them, and the same distinc-
tion one seeks to draw between them and words can be gotten to arise
within the domain of words themselves, which may be seen to represent
in both sorts of ways; thus the deep distinction between the two modes
of representation would be available even if pictures had somehow never
been invented and words composed our only vehicles of representation.
Indeed, it is with respect to words themselves that Plato draws the dis-
tinction at *Republic* 394 between *mimesis* and *diegesis*, or, as they are put
into English in one widely used translation, between "representation"
and "simple narrative." Socrates, there sketching the role of poetry in the
curriculum of the guardians, observes in passing that there are three
classes of poetic representation: "First, that which employs mimesis only,

From *Philosophy and Phenomenological Research* 43, no. 1 (Sept. 1982): 1–18.

tragedy and comedy, as you say. Secondly, that in which the poet speaks in his own person; the best example is lyric poetry. Thirdly, that which employs both methods, epic and various kinds of poetry." Thus Homer will at times describe what a man is doing, for example pleading to have his daughter returned to him; and sometimes he will give us the very words the father uses in pleading for his daughter's return, so that an elocutionist, like Ion the Rhapsode, will pass from the narrative voice, which is diegesis, to mimesis, speaking now in the father's voice, and in such a way, presumably, as to stir vicarious paternal feelings in the breasts of his auditors. It is mimesis when the representing words are the very words they also represent, as the actor says "I love you" when the character says "I love you." And of course it is possible for the character to be telling a tale, hence engaging in diegesis, while the actor, using the very same words, is engaged in mimesis—the mimesis of diegesis is not a bit of narration but, as it were, a picture of narrating. The same distinction is taken up in the fateful section 3 of the *Poetics*, where Aristotle happens to use the word *mimesis* to cover both sorts of representation so elegantly distinguished by Plato: which means that however this difficult concept is to be elucidated, the semantics of Aristotelian mimesis will not involve resemblance save in only one of the cases it covers.

It may be thought that the fact that words may be used mimetically, as in dramatic representation or, for that matter, *oratio recta*, is of less importance than the fact that they can be used diegetically, for all they can be said to mime will be other words, whereas there is no limit to their diegetic employment, inasmuch as we do not narrate merely speech acts and the like, but acts of every sort and, for that matter, natural episodes. But this may betray a certain semantical unimaginativeness on our part. Wittgenstein, at least in the *Tractatus*, supposed that words, when arrayed into sentences, compose pictures that mimetically represent the whole world, which is to say all the facts there are. By means of such pictorial sentences we can represent whatever we might represent diegetically, so that the two systems have equivalent representational power. Of course, he said there are things that can be shown but

not be said, which implies that mimesis is richer than diegesis, but my interest in the subject would be satisfied were it feasible that whatever can be said can also be shown, even if there are further things which can be shown though not said.

The surprising dilation given by Wittgenstein to the mimetic power of words is not especially muted by the recognition that there are pictures such as Hogarth's, which Lamb tells us can be read, and which undeniably have the power of texts, suites of them giving us (like precocious movies) the story of a marriage or the fall of a rakehell or the degradation and death of a whore. But in fact the richness of these engravings has to be brought out by talking about them—it was not mere artistic incapacity that made Lichtenberg write about those pictures instead of giving us a kind of pictorial commentary,[1] and there is a question I can at this point only put obscurely, as to whether everything Hogarth's pictures tell us could be found out by an exercise of pictorial competence alone. The art historian Leo Steinberg has often lamented the failure of his colleagues to look at the paintings they often address under previous descriptions that almost blind them to what is there. But could a person see what Steinberg has taught us to see without reading Steinberg—or could he see it himself without having read as widely as he has? When, in Wittgenstein's image, the ladder has been thrown away, we shall not have diegesis to help us understand our mimetic language. The question I am addressing is whether, even so, everything that once was said can now be shown and pictorial semantics suffices all our representational requirements with no representational impoverishment whatever?

I

Plato's program of poetic censorship was underwritten by a tacit theory that mimesis is not so much a matter of the vehicle of representation copying an external subject it also resembles, but rather of it embodying the subject in an internal way, the subject being present again—re-

present—in the mimesis of it. Since the words of the coward are then literally present in the mouth of the actor imitating the coward, it would be prudent to restrict the range of mimesis to the words of the good and the brave exclusively. This conception of representation as something being present again, in a different medium as it were, is remotely assumed in the medieval tradition in which things were said to exist either *in re* or *in intellectu* or both—or to have, in an idiom familiar to readers of the Third Meditation, objective and formal reality.

In his reply to the objections to this meditation, Descartes writes: "The idea of the sun will be the sun itself existing in the mind, not indeed formally, as it exists in the sky, but objectively, i.e., in the way in which objects are wont to exist in the mind." The idiom is still available. Looking at a drawing by Alberto Giacometti of his studio, I was struck by a sculpture of a horse I had never seen, and was told by the owner, upon query, that "it only existed in drawings" because Giacometti destroyed it. The ease and familiarity of these expressions conceal a far more mysterious theory of representation than any we would be prepared these days to hold responsibly. But consider the great iconoclastic controversies that racked the Byzantine Empire under Leo the Isaurian. The iconodule spoke easily of the mystical presence of the saint in the icon, so that destroying an icon was a further martyrization. Iconoclasts held a not dissimilar theory. Christ's nature is complexly human and divine, but a picture of his divinity would be impossible, and a picture of his humanity would destroy the unity of Christ's person. Constantine V, who summoned an Ecumenical Council to ponder these questions, argued that "an image is made of the same substance as the original," which, as I say, was exactly the iconodule thesis.[2] It would be accepted that the bread and wine of the Sacrament were literally Christ's substance, but it smacked of impiety to Constantine that lumps of wood and glass could literally be consubstantial with Christ. Whereupon the iconodules moved to a theory of imitation rather more familiar to us, not to say more acceptable, according to which mimesis and the original are not consubstantial: the former, according to a helpful gloss by John of

Damascus, stands to the latter as a shadow. The theory nevertheless has a long and stubborn history. "The veneration of his picture was the veneration of the Emperor himself," Kurt Bauch explains in his fascinating study "Imago";[3] thus through his pictures the emperor could enjoy a kind of transpolitical existence, simultaneously present in all corners of his domain. And much the same would be true of the icon, which, almost like a relic, retained the mystical power of the saint. Indeed, as the emperor through his images enjoyed a transpolitical identity, certain events, like the Crucifixion, enjoyed a transhistorical identity, so that by being in the presence of a representation of the event, one was in the mysterious presence of the event itself. The power of the artist, on this view of things, consists not in hitting off likeness, which is but a knack, but in capturing persons and occurrences in what it must be considered a serious demotion to regard (merely) as artworks. For that is what they become when the immanentist theory of mimetic representation fades and the images no longer are perceived as infusions of sanctified existences but as mere external representations in pictorial form. The boundaries of the Church stop marking, as it were, the threshold of sacred precincts, and sacred architecture is metamorphosed into the space of the museum of fine arts (there is a sign in the Frauenkirche in Munich that futilely warns, *Dies ist kein Museum*). It in any case is not simply a quaint fact that pictures were once housed in the Wunderkammer, along with unicorn horns and various detached bits of holy personages still deemed present in them—despite Aristotle's observation that a severed hand is not a hand at all. Nevertheless, once immanentism does fade, the energy must collaterally fade from the controversies in which iconoclasts are ranged on one side.

Immanentism, I speculate, is enshrined, lexically, in the fact that we continue to speak of the *content* of pictures, or for that matter, of the content of stories (for an immanentist theory of diegesis can equally be traced): what the picture (or story) is *of*, or *about*, in a sense of content, the grammar of which is the same as that in which we speak of the contents of a sack or a box. A picture of the duke of Wellington has him,

the duke, as its content in a way that grammar will not discriminate from the way in which a bottle of rum has rum as its content. This may sound fanciful, but my point is that the "of" is deeply prepositional in both cases, and not, as might otherwise appear, a surface transformation of a deep genetive. Thus it is not, in the routine case, the bottle's rum: the bottle is only the vessel, or vehicle, of its content. But neither, in the more remote case, is "The duke of Wellington's picture" a genetive—or at least it is ambiguous as between that and the prepositional form, for it can be read either as "picture owned by the duke of Wellington" or "picture having the duke of Wellington as subject," or both, as when the painting referred to is the portrait of the duke of Wellington by Goya, also in the collection at Apsley House. Consider the disappointment of someone who has heard so much about a book called *L'Histoire d'O*, only to find that it begins (I translate), "Once upon a time there were three bears . . . "—this being known as O's story, which she likes to tell to the other sexual slaves at Roissy, such innocent things, after all! (It would be an inverse disappointment for the collector of memorabilia to bid on what is advertised as "an engraving of the Father of our Country" and to wind up owner of a dollar bill.) I would suppose, though I lack historical evidence for claiming, that the concept of the *medium* is connected to the contentual "of," paint (only for instance) being a medium like ether or water, in which this or that is submerged—a circumstance that perhaps underlies the Pygmalion ambition of pulling a woman out of marble like a fish out of water.

As it is always a pleasure to acknowledge his philosophical suggestiveness, I derive these structures from some hints in Nietzsche's *Birth of Tragedy*, inasmuch as he speaks there of a remarkable shift in the character of the rites of Dionysus, which were at first celebrated in the hope that the god himself would be re-present at (and as) the climax of the orgies, and which later were transformed into primitive dramas that included a representation of the god in the quite routine and unmystical sense in which a neighbor simply played the role of Dionysus. And to round off the philosophical point I am concerned to make, I stress that

the same duplicity of structure that infects the concept of mimetic representation, from immanentism at one end to, at the other, the external sense in which something merely resembles what it stands for, may be found in another concept, close of kin with it, namely the concept of *appearance*. Indeed, we may rephrase Nietzsche's stunning theory in just these terms: in the Dionysiac rite, the hope was that at the climax the god would appear, while in the artistic transformation of the rites one contented oneself with an appearance of the god. In the former case, the god was believed actually to appear, while in the latter, appearance *contrasts* with reality in a way to be expected when the concept of the theater has been stabilized. *Only* in the latter sense can we say such things as that appearances deceive; in the former sense the appearance is the reality. Both senses are current in English: for example, "the sun appeared at the horizon in a luminous glory" or "There was a light at the horizon which appeared to be the sun but which was only the Houses of Parliament in flames." It is this latter sense we have in mind when we say, portentously, that all we are acquainted with is appearances, for if we meant the former, there would be no problem in navigating from appearance to reality, since appearance was nothing more than reality making itself manifest. So it would be categorically irrelevant to the former position, whatever its defects might be, to point out, as the old schoolmaster J. L. Austin pointed out to A. J. Ayer, whom he treated as a dunce, that there is only that sense of appearance in which a rhinoceros appears at the jungle's edge. For Ayer had the other sense in mind, quite as established in usage as it. *Both* senses, to the ultimate confusion of commentators and doubtless to himself, are present in Plato's theory of Forms, where the Forms are immanent in the class of their appearances—the Form *participates* in its instances—and then the instances are dismissed as mere appearances that contrast with the reality of the Forms. Thus Plato has it both ways at once, and part of the excitement of his system is due to its being transitional between two possible views. Finally, the same perplexing "of" occurs in the expression "appearance of," as when we speak, on the one hand, of Garbo's furtive and rare

appearances and, on the other, of her many appearances in film images, Garbo imitators, Garbo dolls, and the like.

II

Prohibition against naming the same thing it was also forbidden to picture, fear of the power delivered to someone who learns one's name, suggests that the relationship between names and nameholders must have been construed as mystically as that between pictures and things pictured. But apart from this, and such expressions as "putting things into words" notwithstanding, immanentism in language, the theory that language connects with the world because it contains the world, has not been a tempting theory. This cannot be because metaphysical exuberance subsides in the presence of semantics—think of the blithe proliferation of possible worlds philosophers have countenanced in order to get semantical purchase on the actual world—but perhaps because concern with sentences in contrast with names is fairly recent. And one almost feels that Wittgenstein, for whom the proposition is so central in the *Tractatus*, was tempted to pictorialize propositions just because something like an immanentistic theory was available. "In the picture and the pictured there must be something identical," he writes at 2.161, "in order that the one should be a picture of the other at all." And again: "The proposition communicates to us a state of affairs, therefore it must be *essentially* connected with the state of affairs." That magical picture-sorcery exists only at the beginning of the history of images, thus belonging, so to speak, to its prehistory, warns Gadamer, does not mean that we shall ever escape altogether from the identification and non-distinction between picture and pictured, with an increased consciousness of the difference. And he continues: "The non-distinction remains an essential trait of all pictorial experience."[4] That we find it at the heart of Wittgenstein's theory in the *Tractatus* is a sober confirmation of Gadamer's thought. For tractarian semantics go deeper than merely supposing a resemblance between picture and fact—in part, I suppose,

because resemblance may be a matter of convention, as Nelson Goodman has suggested,[5] and because Wittgenstein may have wished a nonconventional account of the relationship between language and the world. Indeed, he gives us a kind of metaphysical explanation that could hardly be more Platonistic. "What the picture must have in common with reality in order to represent it . . . is its form of representation" (2.17); and again: "What every picture, of whatever form, must have in common with reality in order to be able to represent it at all—rightly or wrongly—is the logical form, that is, the form of reality" (2.18). So the form is immanent in propositional picture and pictorial fact: it participates in both, as the Form of the Bed is immanent in beds and bed-images.

It is (somewhat) striking that when certain things led Wittgenstein to abandon this Platonism because certain things seemed to lack a logical form—like Sraffa's Neapolitan gesture—Wittgenstein did not so much look for another way of explaining how language might fit the world, but gave up altogether on the idea that language fits the world at all. Instead he looked to the use to which sentences were put in forms of life, as though there could be (linguistic) representation only if there were community of form, as with pictures, and if this is false, representation fails. Language, of course, could be pictorial without being immanentistically related to the world, but I believe it must have been the immanentistic possibilities that attracted Wittgenstein to this certainly amazing theory, and I would like to ponder what his motives may have been—I assume there is more to his endorsing it than a kind of "residue," to use Pareto's term for the possibility suggested by Gadamer[6]—before returning to the larger question with which I began this essay. In fact, there may be rather little to say in response to this question once we have canvassed these motives.

1. It is a main thesis (thesis 4) of the *Tractatus* that "the thought is the significant proposition." Since Frege one must be cautious in supposing a writer to mean something psychological by "thought"—a thought may just be what a proposition expresses rather than something psychological which the proposition communicates—but as the "is" suggests a certain identity, we may read thesis 4 as entailing that the logical form of

the thought is one with the logical form of the proposition. There is a thesis of Aristotle to the effect that thought stands to speech as speech does to writing, and although, Aristotle observes, all men have neither the same speech sounds nor the same writing, it is feasible that a spoken and a written proposition have the same form with the thought. Now, a written sentence does not resemble a spoken one, one being noise and the other marks on a surface, but under formal characterization they are the same even so, as they are the same with a thought, though one knows too little about thoughts to know what it would even mean otherwise to say a set of marks or a set of sounds should resemble a thought. So we may say the same form is, as it were, embodied in three distinct media: those of thought, of writing, and of speech. It may be wondered whether Wittgenstein did not go on to imagine that the relationship between the world and language might not be like the relationship between speech and writing, or between either of them and thought (Aristotle sets up much the same relationship between mental experiences, speech, writing, and "the things of which our mental experiences are images"), as if the world were just one more medium in which the same forms were to be found as in speech and writing. So instead of being an alien and outside thing, the relationship of which to representation is a puzzle, reality is, so to speak, language or thought more crassly embodied, which has after all long since been a teaching of idealism, for example, the world as Divine Visible Language. The implications of a pictorial theory of language, thought, and reality are philosophically stupendous, and whether the theory could be true accordingly merits a moment's reflection.

It is not to the point, besides which it is false, to point out that some languages are pictorial already, for instance Chinese. It is true that certain *characters* in Chinese notation resemble abstractly their denotations, and in some sense share forms with them, at least for the older and less complex characters. But what is crucial is that it is not words as such but sentences (or propositions) which are pictorial in Wittgenstein, and it does not follow from the fact that a string of pictures forms a sentence in a pictorial notation that the sentence itself is a picture. For there

would be a difference to mark between a compound picture (a concatenation of pictographs) and a sentence, and there would be as great a problem in differentiating these as there is in deciding whether chimpanzees, who have produced a suite of signs, have in fact produced a sentence or merely a compounded sign. A difference will also be demanded between a single character, supposing it one of the pictorial ones, and a unit sentence consisting of that character, where it is far from plain that the latter is a picture even if the former is one—and it will moreover not be clear that the form of this unit sentence will be of a piece with the form of the character that it shares, let us suppose, with its denotation or subject. But there is a more telling point, which is that in order for a language to be pictorial, not only written but also spoken modes of language would have to be pictorial, as would, I suppose, thoughts, if thought is a medium of language and not simply (as J. B. Watson often claimed) silent speech. So it matters for the general thesis just as little that some characters are pictures as that some sounds should be onomatopoetic, which is to say *acoustically* mimetic.

Nor do we gain much insight from Wittgenstein's own somewhat ill-considered reference to hieroglyphics at 4.011: "In order to understand the essence of a proposition, consider hieroglyphic writing, which pictures the fact it describes." This is generally false of hieroglyphic writing. It is so because hieroglyphic writing constitutes a kind of pictorial syllabary, where the characters seldom represent what one might suppose they picture, but are there for the *phonetic* value they carry, roughly, but only roughly, in the manner of a rebus-picture. Thus if a cat-picture appears as a hieroglyph, this will be because we need the *sound* "kăt," not the *word* "cat." It would be as though, to fabricate an example, we were to replace the syllable *cat-* in the word "catalog" with a cat-picture. The presence of the picture would not make the word "catalog" have anything to do with *cats*. So the cat-picture does not *as hieroglyphic* picture anything at all, though it stands in a complex relationship to the spoken word that denotes cats. But the spoken word is no picture to speak of. On the other hand, a cat-picture is on occasion used that way, namely to

denote cats, which it happens under Egyptian conventions also to resemble. But when it is used as a picture, a special mark is used in conjunction with it—a picture-stroke somewhat reminiscent of Frege's *Inhaltsstreich*—to indicate that it is being so used. Is the stroke in any way part of the picture? Clearly not: it is a kind of operator that transforms its operand into a picture, something we cannot tell from hieroglyphic alone. (I suppose quotation marks serve in a similar way to transform what they surround into a picture of a set of words.)

Wittgenstein himself needs a kind of *Bildenstreich* as well, especially in view of the familiar criticism that there is no good reason not to say that a fact is a picture of a proposition, or Judy a picture of her photograph, inasmuch as all that makes something a picture of something else is a shared form, and sharing goes both ways. So we need a device for showing which of a co-formal pair stands in a *representational* relationship to the other member. After all, a spoken sentence will not typically represent a written one—or vice versa—they being just the same sentence by virtue of whatever identical thing it is they share. They share that with a thought as well, in the tractarian conception—and so neither of them represents that either. Nor, finally, will any of them on the basis at least of that identical thing which takes us from medium to medium represent a *fact*. In order, then, for something to represent something we have to fall back onto some feature other than a common form, say some such notion as denotation. But then a gap opens up between picture and pictured which makes immanentism a decreasingly plausible theory and perhaps no theory of representation, even pictorial representation, at all—and the shift from immanentism to symbolic representation has to be recapitulated once again, as though we had not learned much since the Greeks. Then a picture is a representation that gives a certain sort of information about what it denotes (what it looks like), for instance, but the internal connection is not needed for that information to be given. It could be given through description.

You cannot *just* get by with what Wittgenstein has darkly in mind by "showing" that, for example, pictures—or propositions—"show the logical

form of reality" (4.1 2 1), for reality equally shows the logical form of propositions. No: something may show the logical form of what it represents if it is a logical picture, but its being a picture is not something it can show if showing is just form displaying itself as form, when we even have to know that it is *displaying*. That is, they cannot show *that they are pictures*, that being something that can only, to use a Wittgensteinian intonation, come from "outside"—which is why I said something like an extra stroke is needed. (I omit the problem that something may exactly resemble something without necessarily having the logical form of the latter, or any form at all, since it arose in such a way as to make it logically formless.)[7]

Once we force a gap between representations on the one side— speeches, inscriptions, and thoughts—and facts on the other side, then despite the possibility that a common form may penetrate them all, the first will have properties unshared by facts (or things) beyond whatever properties of medium may divide them. They will bear semantical values. They will be true or false. They may be true when they in fact resemble—are co-formal with—what they denote, but whatever the case, we require something by way of a semantical apparatus beyond what the meager notion of a shared form, even a shared logical form, can provide. But that apparatus might be all we need to analyze the notion of representation. The concept of a picture falls away, or at least we need as much semantical apparatus to account for what makes pictures represent, their *being* pictures not being enough. So why does Wittgenstein suppose propositions must be pictures? What might be his *grounds?* This brings me to a second set of questions concerning pictorial representations, this time involving psychological considerations.

2. "To understand a proposition is to know what is the case, if it is true" (4.024). Even if propositions are not pictures, the notion of understanding may be easily enough extended to pictorial understanding, however we decide that pictures can be true: to understand a picture is to know what is the case, if it is true. And there may very well be, as Elliott Sober suggests, "a notion of pictorial competence that is strongly analogous to the more familiar notion of linguistic competence."[8] One

wonders if there would be on this extension of the notion a general kind of mimetic competence, which includes pictorial competence as an instance: not every case of imitation can admit a semantical value like *true*, imitation butter in a way being false butter and imitation leather false leather, but only in a nonsemantical sense of "false." When Baptiste in *Les Enfants du Paradis* mimes an episode of petty thievery, this is not an instance of ersatz pocket-picking but a representation, in the circumstances true, of an instance of real pocket-picking. And as a genre of representation, since mimeses admit the appropriate values of truth and falsity, there must be a kind of understanding that goes with them which in the end may or may not be like linguistic understanding. In some way a mimesis *shows* us what it is about, which is what makes the immanentist theory possible. Sentences, *when mimetic*, do the same, but in a way so different from sentences *telling* us what must be the case if they are true that there may be some initial doubts as to whether pictorial competence *is* after all like linguistic competence.

Sober construes pictorial understanding in terms of mastering a function that maps pictures into sentences, the linguistic counterpart of a picture being then a hypothesis that "a person would infer from a picture . . . by using his pictorial competence alone."[9] It may be a fact that persons who understand pictures are able to put into words that which a picture shows, but I am uncertain this is what pictorial understanding amounts to, for then pictorial understanding would require linguistic understanding, and our whole question of whether there could be a pictorial language equipotent with a descriptive language would immediately get a negative answer. Perhaps it already has a negative answer in Sober's own mind, since the range of hypotheses inferrable from pictures "using pictorial competence alone" must be narrower than the range of inferrable hypotheses, and something different from "pictorial competence alone" must be appealed to in accounting for the discrepancy. But then that raises in an acute way the question of how close pictorial competence after all is to linguistic competence. I want to explore this in conjunction with the suggestions of the *Tractatus*.

Most of the argumentation in the *Tractatus* merely provides reasons why it should not be ruled out that propositions should be pictures. But at 4.021 a remarkable observation is made: "The proposition is a picture of reality, for I know the state of affairs presented by it, if I understand the proposition. And I understand the proposition without its sense having been explained to me." This passage is certain to have an implication in our present linguistic atmosphere that it hardly could have had in 1922, largely because it is now a widely accepted criterion of linguistic competence that one in possession of it understands novel sentences in his language without having to have their sense explained—without having to *learn* what their meaning is. To the degree that this should be true of pictures, as doubtless it is (in a way), there may seem at least a strong analogy between pictorial and linguistic competence. The analogy could hardly have been intended by Wittgenstein himself, unless we consider him immensely more precocious a thinker than he is almost adulated for having been, for this criterion was only enunciated by Chomsky much later.[10] In fact the explanation of whatever truth there is in 4.024 must rest more or less on some facts of pictorial psychology that themselves may raise some doubts as to whether the parallel facts in pictorial and linguistic competence really entail any further parallel between the competences, since the facts call for quite different explanations in each.

The psychology is this: we appear to encode pictures of x via the same pathways through which we encode x's themselves, so that there is little to mark the difference between recognizing another instance of something we have already perceived and recognizing a picture of that same thing. Children use the same words to identify pictures of things and the things themselves, and Julian Hochberg has often cited the case of a child brought up in a picture-free environment who found no difficulty in transferring a vocabulary acquired in connection with objects to pictures of those objects, when at last he was shown pictures of them. Hochberg writes that "if the ability to understand outline drawings is entirely learned (and it may not be; it may be innate), the learning must occur not as a separate process, but in the normal course of whatever

learning may be needed in order to see the edges of objects in the world."[11] The Harvard psychologist R. J. Herrnstein has demonstrated that pigeons are able to sort out pictures with a common subject (water, trees, and the face of a particular person), with about the same success rate as humans, though it is interesting that they have this ability only with photographs and not with line drawings.[12] (Hochberg's child had no problem with line drawings or with photographs.) I shall call the learning in question *nonassociative*. Learning something to be a picture of x is of a piece with learning to recognize x itself, so we do not, as it were, learn to associate the picture of x with x in the way in which we have to learn to associate the *name* of x with x. Learning the names of things is exactly associative learning, there being no internal connection here of the sort dreamt of by Cratylus and failure of which reduced him to silence. Something like this is noted in the *Tractatus* a few number-places later, when Wittgenstein remarks that "the meanings of simple signs (the words) must be explained to us, if we are to understand them" (4.026).

This means, I should suppose, that even though we understand sentences by understanding the words that compose them, the relationship between sentences and what satisfies their truth-conditions will differ from the relationship between words and their denotations, for the latter is arbitrary, in much the way Saussure thought it was, whereas the former case may not be arbitrary in at all the same way, and the relationship between pictures and what they are true of may likewise not be at all arbitrary, if, indeed, the mechanisms of perception are the same in both. Sober wishes to exclude recognition of individuals (in the sense of being able to say what their names are) from pictorial competence, even granting that most of us will say "Napoleon" when asked to identify pictures of the famous face. But here he gets into trouble, it seems to me, through presupposing linguistic competence as a condition for pictorial competence. Understanding the meaning of a name is no part of linguistic competence, since we have to have the meaning of novel names explained to us, and this is associative learning. But we do learn to recognize particular individuals and pictures of those individuals evidently

nonassociatively, as witness Herrnstein's pigeons. Neither a picture nor a sentence is understood through association with states of affairs, both sorts of understanding being nonassociative. But whether we can appeal to anything like the sorts of mechanisms perceptual pathways illustrate in understanding pictures, which play that same role in understanding sentences, is moot. This is the question of whether there is a stronger parallel still between pictorial competence and linguistic competence. And here I am not at all sure how to proceed.

For one thing, if it is true that "the same pathways" are involved in learning to recognize pictures of things the outlines of which are learned in the perception of those things as such, and if these same pathways are activated in the perception of two instances of the same thing or of the same thing on different occasions, as much as in the perception of the thing and a drawing or photograph of it, then it is difficult to see in what way pictorial competence can differ from what one might call *perceptual* competence. And it seems to me not to matter whether we proceed from objects to their pictures, as in the case of Hochberg's child, or from pictures to objects, as in the case of someone who does not have to learn anything further in perceiving the Eiffel Tower than has already been achieved in recognizing a picture of the Eiffel Tower. There are things, of course, which exist only in pictures, as unicorns do by zoological and artistic accident, but if they did exist, unicorns would be perceived via the same pathways as their pictures; thus it would be of no consequence to our concept of unicorns were someone to claim to have discovered some in Tierra del Fuego which prove to have that central horn, to be sure, but otherwise have stumpy legs and a trunk, a walruslike body, and piggish eyes—unicorns can be discovered only if they are white and steedlike, dangerous and docile at once. Their pictures tell us what they *must* be like, if they exist, as, in an important sense, the things of the world tell us what their pictures must be like under topological variation and allowing for distortions. All this puts a special light on Sober's claim. Pictorial understanding will be an interpretation consisting of such inferences as a person makes using *perceptual competence alone*. And one

impediment to proceeding further is that there is not a topic in the literature of philosophy as muddled by conceptual strife as the topic of what do we perceive.

Now, it will not follow from the fact that no further learning is required to perceive a picture of x, once one has learned to perceive x, that perceiving x itself requires no learning. Nevertheless, it is difficult to see what perceptual, and hence pictorial, competence can come to if it does not have reference to what perception without special learning can disclose—unless it has reference to what, paraphrasing a famous title, the person's eye tells the person's brain. It is convenient to represent this in terms of predicates that can be seen to apply to an object without reference to something outside the field of perception. We may, thus, recognize a pair of shoes and even recognize them as worn. But something is worn only if there has been a history of wearing, so the predicate "worn" makes reference to something outside the field of perception. So by perceptual competence one might mean the ability to perceive an object under such descriptions as do not imply inferences to something outside the perceptual field, those predicates which do entail such inferences involving learning in a special way. Thus such complex interpretations as a scholar like Edgar Wind gives of such complex masterpieces as Giorgione's *La Tempesta* will involve something in excess of pictorial competence.[13] My hunch is that Wittgenstein thought of pictures, the meanings of which do not have to be explained to us, as pictorial representations of things, the meanings of which do not have to be explained to us *because we perceive them for what they are without having to undergo instructional interventions.* They would be pictorial counterparts to the mythic basic sentences, the *Protokollsätze* of the epistemological legends of logical positivism, sentences which may be exhaustively verified by sense experience or introspection, sentences which require nothing beyond immediate experience for their verification and which can provide the foundations for whatever else can be known, or understood, or reasonably believed. And the theory of understanding he must have had in mind will be the familiar verifiability theory in one or another of

its disguises. No one can seriously suppose that we understand *La Tempesta* without having to have its meaning explained to us. Or *The Transfiguration* of Raphael. Or *Marriage à la Mode* by Hogarth. The line that separates such pictures as these from those we understand simply in consequence of our perceptual competence is *just* the line that separates mimesis from diegesis.

Let us acquiesce for a moment in the theory of basic sentences, to the extent of granting that to understand such a sentence is to know what perceptually must be the case if it is true. Would we seriously want to suppose, as with what one might call basic pictures, that the same pathways, as it were, enable us at once to perceive what makes the sentence true *and* to understand the sentence? That sentential understanding requires nothing in excess of perceptual competence? Would a child brought up in a sentence-free environment, but full, let us say, of facts, spontaneously understand sentences when finally they are spoken, simply on the basis of having coped perceptually with a fact-strewn universe? The question is put rhetorically because I would be amazed if the answer were yes. One reason I would be amazed is that sentences, unlike pictures, are in a language, and vary enough from community to community that one must suppose learning has to be invoked to account for the differences. Perhaps Wittgenstein was obsessed with a pictorial language not simply because it allowed a natural, so to say causal account of semantics, but because it would be *universal* in the respect that those with comparable perceptual equipment would need nothing by way of extra learning to understand the language, and the problem of communication, which took up so much of Wittgenstein's later attention, would be solved when we solve the problem of representation. It might indeed be universal in this sense. But what it could represent would be restricted to what we can be said to perceive without further learning. A language the content of which was restricted just to that would not say much. And pictures that showed just that would not show much. But when we go beyond that, something considerably beyond pictorial or perceptual competence will be required. It is doubtful, then, that a pictorial lan-

guage could achieve the power of representation afforded by a discursive one without help of some sort from the discursive language.

III

If pictorial competence is a kind of cognitive bonus, included, so to speak, in perceptual competence, it is a reasonable corollary that a significant degree of match between x and a picture of x must exist, irrespective of the cultural determinants of picture-making. It is this matching which gives the magical theories of immanentism their antecedent plausibility, and which gives Goodman's account of pictorial representation its implausibility, as he makes no room for it. Goodman supposes pictorial representation to be more or less exhausted through denotation. But denotation is the most external of semantical concepts, since anything can be used to denote anything, and if all there were to picturing was denoting, pictures would be like names, and names exactly demand associative learning. Goodman of course uses another concept—the predicate "x-picture" classifies the sort of picture it is, as "Louis XVI" classifies the sort of furniture it is. But as he gives us no further connection between denotation and classification, something can be an x-picture and denote anything at all. So we at least want it to denote what it does denote *because* of the kind of picture it is, and this then brings in matching properties. Were it not for these the meaning of every picture would have to be explained to us, and not just the meaning of diegetic pictures, as we may call them, where matching is less and less important—as it is of no importance whatever in the semantics of sentences, which match their denotation chiefly in quotational contexts. It is striking that perceptual competence with such sentences will enable us to recognize their denotations without understanding the sentences at all. If linguistic competence were like pictorial competence, we would be hard put to explain linguistic understanding altogether. And this suggests that the psychologies of linguistic competence and of pictorial competence must be quite different indeed.

It is with respect to matching that philosophers have proposed various limits on picturing which are, of course, not limits on representation as such at all. Descartes claims that he cannot form a picture or an image of himself, on the grounds that what a picture is of is spatially extended, and since he can doubt the existence of anything spatially extended but not his *own* existence, he is logically unpicturable. Berkeley argues in the same vein that he can form no idea of himself, since he is a spirit, and spirits have, but are distinct from, ideas; and images are at least a subclass of ideas. He nevertheless supposes that he can *represent* himself, namely through what he terms a "notion." Sartre similarly concludes that he cannot be an object for himself, hence his consciousness of himself must be different from self-consciousness. Leo the Isaurian forbade idols on the grounds that God has no boundaries, but pictures must have them, hence all images of God are false and certainly ought not be worshiped. The reply was that through the Incarnation God took a human form (which makes sense at last of how man can be in God's image) and hence *can* be pictured *in that incarnate form*. But once more, there would not be even on the iconoclast's theory a limit on representing God in general, except, perhaps, an epistemological limit. There are other famous limits in the philosophical literature, as when the seventeenth-century theorists argued that we cannot form an image of a chiliagon, though we can form a concept of one (otherwise we would not know what it was we could not form an image of)—and Berkeley obversely argues that we cannot form any abstract general ideas of triangles, since any triangle-image is of this or that particular species. Berkeley could perhaps have profited from a course in Byzantine iconology, but we must resist the temptation to do more than simply remind the reader of these limits on picturing which are not limits on representation at all, and not even limits on picturing save for the class of basic pictures where matching plays so central and indeed so psychological a role.

It would be fascinating to approach the famous ineffabilities of the *Tractatus*—"Whereof you cannot speak," etc.—in these terms. It would be fascinating to discover whether these are ineffabilities for any lan-

guage whatever, or whether in fact they are parochial ineffabilities, having solely to do with pictorial representation, or pictorial language, if there is in fact such a thing. The *Tractatus* never makes clear whether the ideal language is to be spoken as well as written, but if both, then surely we can hardly invoke the "same pathways" through which we glossed 4.021. Writing may, of course, stand to speaking in the same relationship in which pictures are said to stand to their prototypes in Byzantine theories of representation, where it is through what is visible that we ascend to what is not, a necessary but transitory step—which would finally give some sense to a thesis of Derrida that writing is prior to speech . . . but perhaps not enough sense to preserve us from thinking we were trying to save the pictorial theory at any philosophic cost.

There is a further problem, too deep to do more than mention in closing. The structure of a sentence is not descriptive in its own right, though philosophers of language have at times defended a theory that the structure of our grammar projects a structure onto the world which we recover as a metaphysics. But if language were pictorial, a matching condition would be presupposed by units of it being true, and the structure of pictures and the structure of the world would be one. The world's deep structure could be read off the face of its representation. I don't know if there are negative pictures, but if there are, there must be resident negations if the pictures match the world—they must be pictures of negation. But if they are not that, and something like an operation of negation is demanded of anything we are prepared to call a language, then something in excess of what can be pictured is needed, and the powers of a pictorial language, and of mimesis generally, are inadequate to our linguistic needs—even if negation as part of logic—or of grammar— is not descriptive or representational in its own right.

It is along these lines that I would resolve the question with which I began this essay, as to whether what can be said can also be shown, so that in terms of representation alone there is little to choose between mimesis and diegesis. There may be reasons, of course, to choose mimetic over diegetic representation, as there may be reasons to choose analog

over digital coding in the processing of information. But to pursue these lines further than this exceeds my present power of analysis.

NOTES

1. Georg Christof Lichtenberg, *The World of Hogarth*, trans. Ines and Gustav Herdan (Boston: Houghton Mifflin, 1966).

2. See Steven Runiciman, *Byzantine Style and Civilization* (London: Penguin Books, 1975), 87.

3. Kurt Bauch, "Imago," in *Beiträge zu Philosophie und Wissenschaft: Wilhelm Szilasi zum 70. Geburtstag* (Munich: Franke Verlag, 1960), 9–28.

4. Daß nur am Anfang der Geschichte des Bildes, sozusagen seiner Prähistorie angehörig, der magische Bildzauber steht, der auf der Identität und Nichtunterscheidung von Bild und Abgebildetem beruht, bedeutet nicht daß sich ein immer differenzierter werdendes Bildbewußtsein, das sich von der magischen Identität zunehmend entfernt, je ganz von ihr lösen kann. Vielmehr bleibt die Nichtunterscheidung ein Wesenszug aller Bilderfahrung" (Hans Georg Gadamer, *Wahrheit und Methode* [Tübingen: J. C. B. Mohr, 1965], 132). "Diese Dinge," writes Kurt Bauch, "sind heute so aktuell wie vor 1200 Jahren. Und die 'Ikonen' sehen so aus wie damals" ("Imago," 16).

5. Nelson Goodman, *Languages of Art: An Approach to a Theory of Symbols* (Indianapolis: Hackett, 1976).

6. Wilfredo Pareto, *The Mind and Society* (New York: Harcourt Brace, 1935), passim.

7. This problem I take up exhaustively in *The Transfiguration of the Commonplace* (Cambridge, Mass.: Harvard University Press, 1981).

8. Elliott Sober, "Mental Representation," *Synthese* 33 (1976): 116.

9. Ibid., 114.

10. Noam Chomsky, *Cartesian Linguistics* (New York: Harper & Row, 1966).

11. Julian Hochberg, "The Representation of Things and People," in E. H. Gombrich, Julian Hochberg, and Max Black, *Art, Perception, and Reality* (Baltimore: Johns Hopkins University Press, 1972), 70.

12. Robert Herrnstein, Donald H. Lovell, and Cynthia Cable, "Natural Concepts in Pigeons," *Journal of Experimental Psychology: Animal Behavior Processes* 2, no. 4 (1976): 285–302. There is some evidence that the ability to perceive certain things is hard-wired and perhaps an evolutionary product.

Although they can identify photographs of individuals, pigeons fail with draw-ings (for example, of Charlie Brown). But they also fail with photographs of cer-tain artifacts such as automobiles. If they do not perceive pictures of automo-biles, there is a question of how they might perceive automobiles themselves.

13. Edgar Wind, *Giorgione's Tempesta* (Oxford: Clarendon Press, 1969).

Freudian Explanations and the Language of the Unconscious

SOCRATES:	Well, now, I wonder whether you would agree in my explanation of this phenomenon.
PROTARCHUS:	What is your explanation?
SOCRATES:	I think that the soul at such times is like a book.
PROTARCHUS:	How so?
SOCRATES:	Memory and perception meet, and they and their attendant feelings seem to me almost to write down words in the soul, and when the inscribing feeling writes truly, then true opinion[s] . . . come into our souls—but when the scribe within us writes falsely, the result is false.

Plato, Philebus, *38–39*

There is no element whatever of man's consciousness which has not something corresponding to it in the word; and the reason is obvious. It is, that the word or sign the man uses *is* the man himself. For, as the fact that every thought is a sign, taken in conjunction with the fact that life is a train of thought, proves that man is a sign. . . . Thus my language is the sum total of myself; for the man is the thought.

C. S. Peirce, Collected Papers, *5:314*

I

FREUDIAN THEORY IS SOMETIMES treated as though it licenses a hermeneutical overlay on all our thought and conduct, none of which really and deeply means what we would suppose it does without benefit of that theory, and none of which is properly explained in the ways we would spontaneously explain it. It is as though Freud had discovered a system of "signatures" on the basis of which we decipher conduct, read through to its final, ulterior signification, decode its surface meaning. Whatever we do, and however fantastically various the modes of our behavior, the final meaning is everywhere and barrenly the same—so much so that one need hardly unriddle the signatures anymore, knowing in advance that the same dismal, fatal note sounds throughout, like the echo in the Marabar Caves.

Freud himself implied nothing quite so leveling or mechanical, and although certain everyday occurrences—slipups and errors, lapses of memory, and preeminently dreams—proved, according to his theory, to have a purpose in the economies of mental life scarcely appreciated before him, and even to be intentional enough to be explained through reasons rather than (mere) causes. Freud resisted treating all conduct as only symptomatic, as he resisted the dissolutive explanatory temptations of what he disparagingly spoke of as Pansexuality. I believe that if we examine the structures of psychoanalytic explanation, we shall find a deep argument less against Freud himself than against the insensitive generalization of his theories that aims at absorbing the whole of thought and conduct to a simple explanatory principle. It is an argument peculiarly against wholesale Freudianism itself, and not against absorbing the whole of conduct to some single explanatory principle, whatever may be the arguments available against that sort of reductionism.

From *Psychoanalysis and Language*, edited by Joseph H. Smith (New Haven: Yale University Press, 1978), 325–53.

Philosophers have sometimes resisted such reductions by mounting one or another version of what are termed Paradigm Case arguments: If one learns the meaning of a term *T* with reference to certain instances, then of those instances we cannot coherently with the meaning rules of our language deny that these instances are *T*. Freudianism, then, is accused of traducing these meaning rules and collapsing into nonsense, entailing the inapplicability of just those terms we know best how to employ and through which we describe what is closest to us as humans. But, the argument continues, we cannot intelligibly sacrifice these uses without in effect sacrificing the forms of human life we live. Or, it has been argued to whatever effect, Freud expanded immensely the denotation of such a term as "sexual" while holding its connotation constant, a simultaneous dilation and contraction in meaning under which the concept suffers semantical fracture, so much so that it no longer can be clear what the theory comes to. I have no great sympathy with this style of argument, or with the conceptual conservatism its use enfranchises, but I have no interest in pausing to harass the tattered regiments of common-usage philosophy.

My argument turns, rather, on certain features of *representation* that figure prominently in Freud's striking explanation of dreams and symptomologies. What I want to maintain is that representations could not have these features if they did not have those other features through which they cause thought and conduct in non-Freudian ways.[1] Roughly, my thesis has this form: it is impossible, much as it is impossible for every description to be metaphorical,[2] for every term to be a pun. And Freudian explanations involve, typically, a punning transformation of terms, dreams, and symptoms having as their roots plays on words.

Let us consider a somewhat strange example of "mental causation" offered by G. E. M. Anscombe as preliminary to our discussion: "A child saw a bit of red stuff on a turn in a stairway and asked what it was. He thought his nurse told him it was a bit of Satan and felt a dreadful fear of it. (No doubt she said it was a bit of satin.) What he was frightened of was the bit of stuff: the cause of his fright was his nurse's remark."[3] The

child was afraid of something (ribbon, say) that does not ordinarily elicit fear, and the etiology of the phobia enlists a factor that, as we shall see, plays a considerable role in Freud's theory: an unwitting play on words. The child is (rightly, in view of his religious education) afraid of Satan. The nurse says what is on the stair is some satin; so the child is afraid of what is on the stair—I assume a parity of phonetic values between the two words that does not quite carry over into Middle American speech. I can imagine a child growing to adulthood with a curious, mysterious fear of red satin, which his therapist will be able to explain (and perhaps cure) only to the extent that he can archeologize this early, forgotten episode—like someone who finds himself unable to see Greece because as a child he had a fastidious mother.

Using now a Saussurian distinction between the signifier (*signifiant*) and the signified (*signifié*)—between sign (sound image) and meaning—we have, as it were, two phonetically indiscriminable signs with quite discriminable meanings; and what has happened is that the child has effected an interchange of signifieds, in consequence of which his subsequent behavior is manifestly weird. This sort of interchange presupposes properties of representations—in this instance associated phonetic values—distinct from their meanings, inseparable from their representational properties. Then what I want to claim is that signs (representations) can be causal through both sorts of properties, so that there are two distinct ways in which they may enter explanations, much as there are two distinct ways in which they enter communication. In Freudian explanations they are, as in Anscombe's example, causal through confusions of meaning of the sorts exemplified in puns. And confusions of meaning of this order are not possible unless signs have fixed meanings to confuse. But the distinction is crucial, and there is a difference in logic that we are constrained to mark depending upon which of the two ways a sign in fact occurs. Let me illustrate this by commenting on a famous pun.

Paul Grice, to bring out a point in his discussions of conversational implicature, cites the dispatch sent by a British general upon his conquest

of Sind: "*Peccavi.*"[4] This, as Latinists appreciate, translates into the English sentence "I have sinned," which then admits the punning "I have Sind"—a turn of wit that would have been impossible with the latter-day name of approximately the same territory, Pakistan. The general, as it happens, was Sir Charles Napier,[5] and he was not just announcing his victory in a remarkably arch way; he also was saying that he had, *literally*, sinned in winning, that his means were morally reprobate—and indeed they were, as anyone who reads those pages in the British conquest of India recognizes. There was, in fact, a major debate in England over the rightness of his conduct of his campaign. My concerns here remain logical rather than moral, however; I wish to comment on the overdetermination of his message as a linguistic specimen.

For one thing, we lose the overdetermination if we translate the message into any language but English—for example, *ho peccato, ich habe gesündigt, j'ai péché* all lose the *sounds* that make the pun possible. And it is the sounds in particular that I am thinking of as properties of the signifier in abstraction of the signified. Translation is a particularly good test of whether such features of signifiers play a significant role in the content of any given message. Thus, it is a fair assumption that translations must be truth-preserving: that S' cannot be a good translation of S if S and S' differ in truth-value. For example, "Paris has five letters" obviously refers to the word rather than to the city. If we translate the statement into Italian this way, "Parigi ha cinque lettere," we get something obviously false. So it would only be a matter of luck that "Paris hat fünf Buchstaben" comes out right. Phrases whose semantics involve reference to signs as *significant* are made true or false on the basis of properties of these as entities—not on the basis of properties of their *significations* or their normal referenda. And it is these language-locked features of signs that play the central role in much of psychoanalytical explanation. These are, as it were, textual features that are lost or sacrificed when the texts are translated, and which, because they are *entities* as much as cities or stones, are untranslatable in this dimension of their being; it is

only in their status as significant that we can translate them by finding equivalent signs having the same meaning.

Let me, before proceeding to our structures, cite two examples, both from French psychoanalysts who are especially sensitive to these factors, which turn on essentially untranslatable features of signs that nevertheless play an important part in the analysis of conduct. These examples, if they are sound, imply something crucial about psychoanalysis as well as about us: our conduct is deeply involved in these features of our own language, so much so that it would not be possible, one feels, to psychoanalyze a person whose language one did not know—say, by using a translator.[6] The wider implications of this I shall defer until later in the paper.

The first example comes from Jacques Lacan. It is always difficult to know when he is being serious, as he is a profoundly frivolous writer, but he draws the example itself from a study by Freud of fetishism, which gives it a measure of validity. Nevertheless, Lacan's own sensibilities make him alive to features in the example that might have been utterly lost to someone who thought merely in the explanatory frameworks of street-corner psychotherapy. Here, then, is a man who can achieve sexual satisfaction only when something is shining on his partner's nose—a *Glanz auf der Nase*. Let me quote Lacan's gloss:

> Analysis showed that his early, English-speaking years had seen the displacement of the burning curiosity which he felt for the phallus of his mother, that is for that eminent failure-to-be the privileged signification of which Freud revealed to us, into a *glance at the nose* in the forgotten language of his childhood, rather than a *shine on the nose*.[7]

Here the transformation from *glance at the nose* to *Glanz auf der Nase* contains two elements it is important to distinguish. The nose may indeed be a visual metaphor for the penis. It is explicitly so treated in one of Goya's *Caprichos, El Vergonzoso*, and Goya writes in his sardonic accompanying commentary: "It would be a good thing if those with such obscene faces were to hide them in their pants."[8] And perhaps "the nose"

is an infantile usage for what certainly at the time could not have been designated by its right name with propriety. But, and this is the point, the nose has the appropriate shape to function in almost a universal lexicon as a substitute symbol for the penis.

Freud at times in *The Interpretation of Dreams* supposes that there might almost be a universal lexicon of such symbolic equivalents: "All elongated objects . . . sticks, tree-trunks and umbrellas . . . all sharp weapons, such as knives, daggers, and pikes," represent the male member. "Boxes, cases, chests, cupboards and ovens" correspond to the female organ, also cavities, "ships, and vessels of all kinds." "Small animals and vermin represent small children."⁹ Freud is perhaps insufficiently sensitive to cultural parochialisms, which in some measure restrict the universal obviousness of some of these symbols, but in any case, the connection between the English *glance* and the German *Glanz* (and note that the English word has to be spoken in a British accent to get the phonetic equivalence) is not at all of this order of equivalence: it is a substitution that goes through only at the level of sound, and is so bound up with the physical qualities of spoken language that to destroy Freud's explanation it would suffice to show that the person involved had never known English, even if he indeed had had the more typical Freudian curiosity alluded to.

Let me bring the difference out this way: There is a painting by Titian titled *Venus with the Lute Player*. Venus is holding a flute, and it is disgustingly easy to give this a "Freudian interpretation." It could be given, moreover, by anyone who knows the game of "elongated objects." In the corner lies a *viol d'amore*. The term "viol" carries implications, at the phonetic level, of rape. (Think of the condensation in *Finnegans Wake*, where Joyce writes, almost at the beginning, of "Sir Tristram, violer d'amores. . . . ") Did Titian intend this connotation of sexual violation? I have absolutely no idea, but my point is less one in iconography than psycholinguistics: unlike the flute, the viol can be read as *that* sort of symbol only by someone in whose language there is a phonetic parity between the two pertinent senses of "viol."

My second illustration (which concerns a dream, since my first example had to do with a symptom) comes from a well-known paper on the unconscious by Jean Laplanche and Serge Leclaire. Much of it turns on the analysis of a dream, in which a girl, Liliane, appears. The dreamer and the girl are in a forest; at a certain point a unicorn crosses their path, and "we walk, all three of us, toward a clearing that we suppose is below."[10] With the substance of the dream analysis I shall not be concerned, but I want to remark on this: The French word for unicorn is *licorne*, and as the analysis proceeds, the first syllable, which is morphemically indiscernible from the French word for bed (*lit*), becomes important. It also appears in the name Lili, which echoes also the infantine word for milk (*lolo*). A complex content is thus gradually found in the dream through these echoes. I have no idea whether their analysis is in fact sound. All I wish to say is that it is based not upon any properties of unicorns as such, but on the *word*—in French—for unicorn; and furthermore, that an American, having just the same dream, could not have it represent what it does in French: there is no phonetic echo from "uni-" to "bed," much less "Lili" to "milk."

To be sure, the single protruding horn can have, in virtue of Freud's glossary, a phallic significance transcending language: it is not an accidental application of a theory of sympathetic resemblances that the Chinese should have regarded pulverized rhinoceros horn as an aphrodisiac. The point, however, is that if we translate the dream, we lose its meaning utterly. Part of the meaning of the dream is given by features of the description of it in which words are mentioned rather than used. It is the *word* "licorne" *as a word* that carries the symbolic charge; and it is just these sounds that do not carry over, here or elsewhere, into a translation. The same bedeviling properties haunt the psychoanalyst that haunt the translator of a poem, the meaning of which resides in part in the acoustic or graphic identity of the words it is composed of, and not merely in what these words might mean—which can, in principle, simply enough be transferred to verbal equivalents in another language. The translation of a poem has to be more than a translation: it has to be a

reconstruction preserving the music of the sounds, so far as this is possible. We dream in our own languages in such a way that only someone who knows the language can unriddle the dream. And this, I think, goes a certain distance toward illuminating the claim advanced in the epigraphs to this essay—that we are built as a text is built. "We are such stuff as dreams are made on," if we see Shakespeare's line through Freudian lenses.

<center>II</center>

I want now to discuss for a moment some questions about the unconscious—the Ucs. system, as Freud designates it. I think a good beginning in the philosophical analysis of unconscious beliefs has been made by Arthur Collins in his 1969 paper "Unconscious Beliefs," though I think it does not go as far as it ought in explaining how unconscious beliefs are possible.[11]

Begin by considering a well-known asymmetry between the avowal and the ascription of belief: I cannot say that I believe that p, but p is false, but I can without tension say that *you* believe that p, but p is false. Imagine that a therapist ascribes to me the belief that competition is dangerous; *he* need not believe that competition is dangerous in order to say that *I* do. Suppose he ascribes this belief to me on the basis of a great deal of evidence—namely, my avoidance of competitive situations, or my failure whenever I am in them, though it is plain enough that I could have succeeded instead. This might be the case, for instance, if I went to a therapist with a complaint of impotence and there was no physiological basis for my failure to secure erection. But I could also fail examinations of all sorts, including ordinary Tests of Life—getting a decent job, finding a romantic partner, and so forth. The therapist acquaints me with this evidence. I accept his explanation: it makes sense of a great deal of my conduct. To be sure, I do not consciously believe that competition is dangerous *as such*. But I do—I may say—believe it unconsciously. There is no contradiction here of the sort that affects "I believe that p, but p is

false, a contradiction (of whatever sort) that we now see implies a presumption of consciousness. So "I believe that *p* (unconsciously), but *p* is false" is a possible utterance. The upshot, then, is this: A belief of mine is unconscious if (1) I can believe it is false while knowing it to be mine and (2) I come to know it is my belief on the basis of the same sort of evidence by which I know what your beliefs are.

In Collins's view, the Ucs. system is, in effect, an Other Mind. Needless to say, none of this has to imply, even if true, that the knowledge of the truth will set me free: knowledge need not entail cure. But I would like to shelve therapeutic considerations completely and just stick to the philosophical points. And admirable as Collins's analysis is, I think one point in it that is overlooked is the *peculiarity* of unconscious beliefs. He has addressed himself only to certain epistemological disparities and parities; he maintains that none of our ordinary beliefs can be unconsciously held and has overlooked the possibility that "competition is dangerous" could be a perfectly ordinary belief. And is the difference between conscious beliefs and unconscious beliefs merely the difference between conscious and unconscious? Note that this would make the patient's conduct altogether rational in the sense that doing what he does would be exactly right *if he held the belief to be true*: it would be paradigmatic of rational conduct. Of course, he may fail to satisfy a test of rationality in that he believes *p* and also does not believe it; but as I indicated, this inconsistency is exactly muted if we qualify the belief ascriptions as conscious and unconscious, just as there is no incoherence in "I believe that *p*, and you don't."

A degree of progress has been made on the matter by Peter Alexander, who has argued brilliantly that a condition for a belief as an unconscious reason for conduct is that it *would not be a reason if it were conscious*.[12] This suggests a stronger criterion than any we have so far encountered, for after all, it is wholly reasonable to assume that the beliefs of Other Minds at least are conscious to them—*they* must believe them true if they believe them at all; and all Collins has furnished us with in distinguishing consciousness from unconsciousness is this difference between

self-knowledge and other-knowledge. It is only complicating psychology to say that our unconscious is an Other Mind to us.

As indicated above, Collins says that none of our ordinary beliefs can be unconsciously held. But what is the criterion of ordinariness or normality? At least a beginning is made in saying that a belief is *unordinary* if it would not be given as a reason for the action *it in fact would explain* if it were conscious: it is not a reason that the agent would, or perhaps could, sensibly give for what he does. And the difficulty, in a way, with Collins's example is that one could very easily cite as a reason for one's conduct that one believed competition was dangerous.

Let us consider, then, Alexander's example of a man lunging at lampposts with his umbrella. Perhaps, like Collins's imaginary example, this is not intended to be taken with clinical exactitude as a routine symptom. Seeing someone behaving that way, we might rationalize his conduct by supposing him to be practicing fencing moves, or trying to unstick his umbrella, or, ineffectually, trying to impale fireflies. These would all be rational enough, but the truth is that it is to be explained through his Oedipus complex: I want to kill my father, who is my rival for my mother's love, but since I cannot admit to myself either the incestuous wish nor the parricidal one—indeed, am not conscious of it—I find some substitute way of gratifying my wish, in this instance lunging away at lampposts. And "I want to kill my father" could not be offered as a reason for lunging at lampposts unless I espoused some special magical theory and believed my behavior was a means to that, which is unlikely. The normal pattern of explanation in the case of action is this: I do *a* because I want *b* to happen, from which it is plausible to suppose that I also believe *a* to be a good means to *b*, or at least not inconsistent with the production of *b*.

Imagine I see a man posting a letter. The very use of the word *posting* implies that he intends the letter to arrive at a destination and regards putting it in a mailbox as a good way to ensure that that happens. If I see a man putting a letter deliberately in a trash can, so deliberately as to rule out the possibility that he is throwing it away, it is reasonable, especially if the letter has an unfranked stamp, to ascribe an error to him: Quixote-

like, he has mistaken a trash can for a mailbox, or he's just absentminded. But suppose he says no, he has no confidence in the postal system, or he has more confidence in the department of sanitation than in the postal service and believes that his action is a means to having his letter arrive at its intended destination. Then, apart from my wondering why he has bothered to put a stamp on the letter, I can regard his behavior as rational; it is just his beliefs that are devious or false. But in any case, R counts as a reason for b only if the bridging beliefs can be attributed to a person. The question is, can they be so attributed in Alexander's case?

I think that what Alexander brings out is that we do not suppose the lunger *unconsciously* to hold the bridging belief that is required to rationalize his conduct. Or we do so only if we adhere to the universal applicability of the model just sketched, and resort to the unconscious system in order to assure that it applies in every instance, whereas it is not plain that this is the case here. If it were, the behavior would be rational enough. As is more plausible, the bridging belief is not even unconsciously held. "The behavior," writes Alexander, "does not seem to be related to the alleged reasons in the way in which ordinary behavior is related to ordinary good reasons for it." But then he does not tell us how it is related to its reasons, only suggesting, in the manner of Paradigm Case argumentation, that we cannot call neurotic behavior rational without changing the meaning of either "good reason" or "rational" in some unhelpful way.[13]

Nevertheless, Alexander does, through his examples, suggest a partial analysis of irrational behavior, which after all is what we are after: b is an irrational piece of conduct if R is m's reason for b but m does not hold the necessary bridging beliefs. The question then to be asked is this: If he does not hold the requisite beliefs, in what sense does he *have* a reason for this conduct? In what way can R *be* a reason and yet not connect in any way through his own system of beliefs with what it is allegedly to explain? Unless we have an answer to this, we still have no very clear picture of irrational behavior. My claim is that Freud gives us such an answer, and indeed, we have already established the way in which this answer works. To this I now turn.

III

It is widely appreciated that Freud believed that dreams, as well as symptoms, were fulfillments of unconscious wishes, wishes that, though active enough to continue to cause conduct of a highly symbolic order, were not available to the person whose wishes they were. They were not so much forgotten as repressed, the wishes themselves being so forbidden or threatening that their owner could not admit to having them. In dreams especially, it is important to distinguish the *manifest dream content*, which is in some measure epiphenomenal, from the *latent dream thought*, itself housed in the unconscious, which stands to it in a causal relation and also in one further, more semantical relationship, which I would like to spell out.

Let the unconscious element be $W(p)$—the wish-that-p-be-the-case. Let the manifest element be $W(p^*)$—the wish-that-p-be-represented-as-fulfilled. But matters are not so simple as, say, wanting a glass of water and dreaming that one in fact has a glass of water: p itself undergoes a transformation as it passes the barrier from unconscious to conscious. This transformation is all that concerns me now. In *some* way, it is a very heavily disguised form of p, since there is no direct way that p can come to consciousness: Freud supposes it would be too painful and, indeed, that one would wake up, one function of dreams being to preserve sleep while allowing the repressed wish to rise transfigured to consciousness. Let the transfiguration of p be p^*. Freud at one point thought p^* might plausibly be a translation of p, the unconscious and conscious systems standing to one another as two languages do. He then abandoned this theory in *The Interpretation of Dreams* in favor of another one, which retains just the sorts of properties of representations I have been discussing. In the following excerpt, he now supposes that p^* is a rebus on p:

> The dream-thoughts and the dream-content are presented to us like two versions of the same subject-matter in two different languages. Or, more properly, the dream-content seems like another transcript of the dream-thoughts into another mode of expression, whose char-

acters and syntactic laws it is our business to discover. . . . The dream-content . . . is expressed as it were in a pictographic script, the characters of which have to be transposed individually into the language of the dream-thoughts. If we attempted to read these characters according to their pictorial value instead of according to their symbolic relation, we should clearly be led into error. . . . A dream is a picture-puzzle of this sort and our predecessors in the field of dream-interpretation have made the mistake of treating the rebus as a pictorial composition: and as such it has seemed to them nonsensical and worthless.[14]

A rebus is a very elementary sort of puzzle, in which the "solution" is a sentence, the words of which are sounded in such a way as to generate homonyms that can be given pictorial representation—as "pick" in "take your pick" has as a homonym the "pick" of "pick and shovel" and can thus be represented via a picture of one. We solve the rebus by pronouncing the words that go with the individual pictures, replacing these with homonyms, and getting a spoken sentence that makes sense—the solution of the rebus. Usually, the pictures have nothing to do with one another; indeed, the row of pictograms in the typical rebus is nonsense.

Let me give some examples of rebuses. On the cornice of the house of Jacques Coeur in Bourges are alternate cockleshells and hearts. The French word for heart is *coeur*, his last name; the shell symbolizes the *coquille de St. Jacques*, the emblem of the pilgrims: so Jacques Coeur. In the tympanum of St. Domenic's in Rome is a spotted dog where some prominent religious figure might be expected. This is one of the *domini cani*, the "dogs of God"—which, of course, is a rebus for *Dominicani*, the Dominican Order, for whose leader the church is named. An Italian printer celebrates his fiancée, Caterina, by showing a broken chain on which is superimposed a king. The chain is *catena*, king is *re*: hence *cate-re-na*.[15] The two pieces of the chain correspond to the broken word. The fish is a symbol of Christ, but again, through a rebus: the word *ichthos*—Greek for fish—in fact is an acronym for Jesus Christ the Son of God, Savior (Ieusous Christos Theou Hyios, Soter). And so on. Duchamp's

L.H.O.O.Q. is a good French rebus, yielding a mild obscenity when the letters are pronounced in French (but not in English). What is important to notice is that none of the *Bilderrätsel* show anything that tells us very much about what the phonetically equivalent solution describes. What have dogs to do with Dominicans, or fish with Christ?

Freud wrote:

> Suppose I have a picture-puzzle [*Bilderrätsel*], a rebus, in front of me. It depicts a house with a boat on its roof, a single letter of the alphabet, the figure of a running man whose head has been conjured away, and so on. Now I might be misled into raising objections and declaring that the picture as a whole and its component parts are nonsensical. A boat has no business to be on the roof of a house, and a headless man cannot run. Moreover, the man is bigger than the house; and if the whole picture is intended to represent a land-scape, letters . . . are out of place in it. . . . But obviously we can only form a proper judgement of the rebus if we put aside criticisms such as these . . . [and] try to replace each separate element by a syllable or a word.[16]

It is crucial that the solution of a rebus does not translate. A French rebus shows a man holding in his hand a large green letter "I"—*un grand I vert*—which gives as part of the solution *un grand hiver*, "a long winter," to which the English description "a big green I" has no phonetic tie whatever. Lose the language and you lose the possibility of resolving a puzzle of this sort. Think of the invitation alleged to have been sent to Voltaire by Frederick the Great: $\frac{P}{20}$ à $\frac{6}{100}$. It is indecipherable save in French.[17]

Whatever the case, the dream-content stands to the dream-thought as a rebus stands to its solution. And much the same is true of symptoms, though with this difference: the symptom is an action whose *description* must be found, for we will see that the description, again, stands to the unconscious wish in this rebuslike relationship. I want now to illustrate this with some examples from the literature.

First, we begin with the famous case of the Rat Man (a Holmesian title), a profoundly disturbed and unfortunate man whom Freud analyzed.[18] At one point the Rat Man began a peculiar regime. It occurred to him that he was too fat, and he began to get up from meals and engage in quite strenuous exercises. This was obsessional behavior, though he was able to give a perfectly good reason for doing it (and his own description of his behavior is critical): he was too thick (*dick*), and it was this being "thick" that he described himself as trying to change. The fact, I suppose, is that he was not all *that* "dick"—that is, not so thick as to merit that much exercise. Some line had been crossed, as in the case of the compulsive handwasher, for whom the ordinarily perfectly good reason "in order to be clean" seems no longer to be commensurate with the conduct.

In any case, there was something neurotic about the Rat Man's behavior, and what analysis brought out is the following: his beloved had an English suitor, the Rat Man's rival, whose name was Dick. So in getting rid of *dick* (thickness), he was in some way getting rid of Dick. It is plain that he had not selected a very efficient way of doing this, and also that he did not consciously believe that that was what he was doing; indeed, it would be absurd to attribute to him even the unconscious belief that in ridding himself of a thick waistline, he was doing his rival in—or the practical syllogism, "I want to get rid of my rival, and reducing my waistline is a good means of doing that. Jogging is said to reduce waistlines: so, I'll jog." Were the matter as simple as that, we would have only a wayward premise to rectify, and instruction in the technology of rival-riddance would take care of the Rat Man's therapeutic needs: what he would be lacking would be common sense or practical intelligence. (Of course, the matter would be different had his lady-love told him that the reason she preferred Dick to him was that he, the Rat Man, was too fat. Then, indeed, his conduct would be rational and even reasonable. But that is not the lethal sense of "getting rid of Dick" that festered in the Rat Man's unconscious.) The point is that he had no such belief as the practical syllogism requires. Nevertheless, *getting rid of Dick* (the rival)

was his (real) reason for running. It is not even a *bad* reason for that, being too insane. And this, I think, is what Alexander has sensed. Speaking of one of the lapses Freud discusses, he writes:

> The woman who read "storks" for "stocks" does not appear, by so doing, to have furthered either the end of obtaining children or of concealing from herself her own unhappiness, and it is doubtful that she or others could have seen the behavior as achieving anything except with the help of Freud's theory. . . . In general, similar things can be said about Freud's explanations of neurotic symptoms. If I am said to x for unconscious reason y, it is nearly always the case that y is not the sort of thing which we would normally consider a good reason for x.[19]

What is missing in this somewhat grudging account, which I believe is true as far as it goes, is the connection between the unconscious reason and the given one: they are related homonymically, as rebus to resolution.

Second, Merleau-Ponty (whose wife was a psychoanalyst) gives this case en passant.[20] A young girl was forbidden by her mother to see her lover anymore. The girl stopped eating not long afterward and settled into anorexia nervosa, a quite distressing eating disorder. Crude analysis suggests something like this: by ceasing to eat, she was trying to put pressure on her mother, or even to punish her mother, in a situation in which she herself had almost no other form of control over her life. The fact is, no one wants anyone to stop eating, certainly not one's daughter, and by doing what she (the girl) knew no one wanted her to do, she was asserting her autonomy and bringing her mother to her knees. So considered, her conduct was rational enough, though extreme, and therapy ought, then, to consist in finding some substitute way of achieving the same ends—or at least in showing her the suicidal consequences of protracted anorexia. Those with any experience in such disorders appreciate how ineffective such "therapy" is: the patients in some way cannot help themselves. In this instance, what analysis evidently revealed was

the following: The girl obviously resented her mother's interdiction and said to herself that she would not accept it. The actual *form* of the thought was "I won't swallow that." *Avaler*, like "swallow" in English, has this metaphorical sense. And not swallowing is what she proceeded to do, though her reason was to resist her mother's demand. Once more, we find this trivial phonetic connection between unconscious and conscious reasons.

On the basis, then, of these examples, and many more which could be cited, let us briefly sketch the structure of psychoanalytical explanations. Let R be m's reason for a piece of conduct (or any appropriate explanandum) that we call a. R is in the unconscious system, and the fact is that m has no bridging belief of the sort logically required by a practical syllogism, according to which R would be a good reason for a. And R^* *is* a good reason for a, but in fact it is not the explanation of m's doing a at all. The explanation is through R. But R^* has replaced R, and is able to do so through the fact that the phonetic values of R and R^* are *close if not perfect* (as "stork" is merely close to "stock").

Let me clarify this by drawing the contrast between it and an ordinary or rational explanation, where a is an action and R the reason for the action. In the normal case, two relationships hold between R and a: R explains (say, causes) a and a satisfies R. These relations are divided in the psychoanalytical case: here let R^* be the transform of R. Then the difficulty is that R explains a, but unfortunately, a doesn't satisfy R. Rather, it is seen as satisfying R^*, which unfortunately does not really explain a. The usual reason-action connections are divided between the two forms of the reason, and inevitably, in consequence, the behavior is at once frustrating and puzzling—puzzling because it is not recognized as fulfilling what is its real reason and because it is only apparently explained by the reason the victim accepts. The person in question is typically disturbed by the conduct, wishes he or she could stop, and so forth: *something* brings him or her to the therapist. As before, I am not concerned with the therapy; all I am saying is that if Freud is right, we

must find a reason in the unconscious, a reason that in fact is never and can never be recognized as satisfying the conduct it explains, since that conduct is understood merely as satisfying the rebus-related but wholly irrelevant reason the patient might spontaneously accept or offer. The symptom is like a puzzle that has to be solved. It expresses a thought the patient cannot admit he or she has. More important for our purposes, the case of the anorexic offers a paradigm of irrational conduct, since it exactly satisfies the conditions we have specified. Obviously, I am in no position to offer any general account of anorexia.

Third, the Rat Man and the anorexic are victims of a truth that is hidden from them, which explains the therapeutic optimism that when the truth is revealed the symptoms will dissipate. Neither of these neurotics is deluded or deceived as such; they are only mistaken as to the real reasons for their conduct. And this stems from a mistake of a more philosophical order, because each applies to irrational conduct a structure of explanation that applies to rational action. The plausible reasons they give for what they do amount to rationalizations of their behavior—in the instance of the Rat Man, for example, that he is "too fat." Thus they regiment to the structures of practical reason behavior that answers to another sort of model. And so long as they persist in misapplying this model, their conduct will never, because it *can* never, if Freud is right, receive a correct account.

Symptoms, as we have seen, have something in common with at least that order of dream that disguises unfulfilled and repressed wishes, with perhaps this difference: The neurotic is right about what he is doing, at least under *some* description—for example, the Rat Man knows that he is running. He is mistaken only in the description of his conduct under which it can truly be explained. But dreamers are deceived into believing that something is happening which is not, and so are deceived about its causes and explanations. My dog, when he dreams, as apparently he does, of chasing squirrels in Riverside Park, believes not only that he is chasing squirrels but that their presence explains his conduct, if I may be permitted to assign him this degree of ratiocination. And as there are

neither squirrels nor chase, nothing of what he believes he is explaining is there to be explained at all. What requires explanation is why he is dreaming and what; and caught up as he is in the dream, he is not aware that what he is caught up in is a dream, and misses the explanandum completely. So he is twice deceived, first in believing in the ultimate reality of his experience, and then in its explanation—like someone who believes that the presence of the palm trees in what he does not know is a mirage is to be accounted for by the presence of water.

Dreams are not, of course, disorders calling for cure, but there are cases intermediate between neurosis and dream, where the symptoms arise from the unconscious but the victim is also deluded, as we all may be said to be in dreams: and this, to a degree, must characterize psychosis. I want to mention as a concluding illustration a case of schizophrenia cited by Freud toward the end of his great paper on the unconscious. Here he cites some findings brought to his attention by his brilliant, ill-starred disciple Victor Tausk.[21] A girl, after a quarrel with her lover, came to him with this complaint: "*her eyes were not right, they were twisted.*" As it happens, the German word for deceiver is *Augenverdreher*—eye-twister—and the girl went on to say "he had twisted her eyes; now . . . they were not her eyes any more." Freud cites this in illustration of "the meaning and the genesis of schizophrenic word-formation." Again, the girl complained that her lover had "*given a false impression of his position*" (the German *sich verstellen* means to feign or disguise oneself); and now *she herself had changed her position* (verstellen = to change the place of)—she claimed that in church she had felt a strange jerk and had to *change her position.*

A *hysteric*, Freud explains, instead of claiming his eyes were twisted, would have rolled them, and wondered why; instead of claiming his position had changed because of a jerk, he would actually have *manifested jerky behavior.* "In schizophrenia," Freud writes, "*words* are subjected to the same process as that which makes the dream-images out of latent dream-thoughts—to what we have called the primary psychical process. They undergo condensation, and by means of displacement transfer

their cathexes to one another in their entirety." And finally, in explaining the strangeness of the symptom in schizophrenia, he says it derives from "the predominance of what has to do with words over what has to do with things. . . . What has dictated the substitution is not the resemblance between the things denoted but the sameness of the words used to express them." Schizophrenics "find themselves obliged to be content with words instead of things."[22]

IV

"To interpret the unconscious as Freud did," Lacan writes, "one would have to be as he was, an encyclopedia of the arts and muses, as well as an assiduous reader of *Fliegende Blätter*. And the task is made no easier by the fact that we are at the mercy of a thread woven with allusions, quotations, puns and equivocations. And is that our profession; to be antidotes to trifles? . . . And yet," Lacan concludes, "that is what we psychoanalysts must resign ourselves to. The unconscious is neither primordial nor instinctual; what it knows about the elementary is no more than the elements of the signifier."[23]

Just here, I think, we can perceive a curious blindness in Freud himself, as the very use of the expression "primary process" connotes—as though he were blocked from appreciating the import of his discoveries by a kind of romanticism, as though the unconscious itself were somehow primitive and savage. In fact, the primary process involves conduct on the surfaces of language of an almost exquisitely, ultracivilized order—the sort of conduct that goes into the most mannered of literary productions, anagrams and acrostics and self-referentiality, where letter becomes substance, and the enterprises pursued merely virtuoso, like elaborate palindromes. Even in his late writings, with a lifetime of accumulated evidence behind him, Freud was unable to perceive this.

The Ego and the Id—the "last of Freud's major theoretical works" (editor's preface)—appeared in 1923. Here Freud writes: "The real difference between a Ucs. and a Pcs. idea (thought) consists in this: that the

former is carried out on some material which remains unknown, whereas the latter (the Pcs.) is in addition brought into connection with word-presentations." He then asks the question of how something goes from the unconscious to the preconscious (or for that matter, the conscious)— "How does a thing become conscious?"—and answers, "Through becoming connected with the word-presentations corresponding to it."[24] A "material which remains unknown" indeed: when it has to be an almost logical truth that if the connection between dream-content and dream-thought, symptom and wish, is to be as I have described it, the unconscious itself must be made of the same stuff consciousness is—namely, *words*. After all, what is in the dynamically repressed is there by *repression*, and what is repressed today was once conscious, and connected then with "word-presentations," if that indeed is the criterion of consciousness. The dynamically repressed, whatever its relation to the id, is not the id. "How could a psychoanalyst of today not realize," Lacan asks rhetorically near the beginning of his essay, "that his realm of truth in fact is the word, when his whole experience must find in the word alone its instrument, its framework, its material, and even the static of its uncertainties?"[25]

I am in no position, of course, to vouch for the accuracy of Freud's accounts. I am only interested in drawing attention to what must be the fabric of the mind if these accounts are in fact true—namely, that it is a fabric woven of language, and must be so in the *normal* case if Freud's characterization of the *abnormal* cases has the slightest basis in fact. For the abnormal cases all enshrine a fallacy, broadly speaking, of *quaternio terminorum*, and a consequent substitution of words for things—and, indeed, it is in exactly these terms that we may characterize irrational thought and conduct. But then, as I have argued, there can be confusion of meaning only if there can be clarity of meaning, and only if the vehicles of confusion exchange their identities like twins in an ancient dramatic form and appear henceforward *en travestie*. Not every phenomenon can be a Freudian one, not every explanation a Freudian explanation. But to the degree that it admits *those sorts of vagaries*, we get a

glimpse of what the structure of mind and thought must in the normal case be. We are all of us, in our normal conduct, words made flesh.

NOTES

1. By causes in "non-Freudian ways" I mean cases in which something is at once a cause and also a reason for something else. For example, (1) I perform an action *a* because I believe that *b* will happen if *a* happens, and I mean for *b* to happen. Here that belief is my reason for doing *a*, and is arguably the cause of it as well. And (2) I believe that *p* because I believe that *q*, where believing *q* is my reason for believing *p*, and also arguable the cause of my doing so. By contrast, Freud cites any number of cases in *The Psychopathology of Everyday Life* in which one thinks that *s* because one thinks that *t*, but where in no sense is the latter a reason, but only a cause, for the former. That reasons can be causes is classically argued by Donald Davidson in his "Actions, Reasons, and Causes," *Journal of Philosophy* 60 (1963): 685–700. *How* they can be is elaborated in my "Action, Knowledge, and Representation," in *Action Theory*, ed. Myles Brand and Douglas Walton (Dordrecht: D. Reidel Publishing Co., 1976); reprinted here as chapter 4.

2. This is true for quite trivial reasons—namely, the *concept* of metaphoric presupposes the concept of literal usage—but there are far deeper reasons. Josef Stern, a former student of mine at Columbia University, made the clever discovery that metaphors are intensional, or at least nonextensional. I cite this fact without elaborating on it since I want it a matter of record that Stern made this breakthrough and is the first, to my knowledge, to have recognized this crucial feature of metaphors, which puts an end to those woolly genialities that "it is all a matter of degree."

3. G. E. M. Anscombe, *Intention* (Oxford: Basil Blackwell, 1957), 16.

4. This comes up, but only *en passant*, in his William James Lectures (Harvard, 1971), which to my knowledge have never been published, and in my belief never will be (alas!). I read them in a bootleg version, barely legible.

5. I owe the historical precision to my friend and colleague, the noted Indianist Ainslie Embree.

6. In a footnote added in 1909, Freud cites an observation by Dr. Alfred Robitsek, that "the 'oriental dream-books' (of which ours are wretched imitations) base the greater number of their interpretations of dream-elements upon similarity of sounds and resemblance between words. The fact that these con-

nections inevitably disappear in translation accounts for the unintelligibility of the renderings in our own popular dream-books." He goes on to observe that, "indeed, dreams are so closely related to linguistic expression that Ferenczi has truly remarked that every tongue has its own dream-language, and this is equally true, I fancy, of a book such as the present one" (Freud, *The Interpretation of Dreams* [1900], vols. 4 and 5 of *The Standard Edition of the Complete Psychological Works*, trans. James A. Strachey [London: Hogarth Press, 1953–61], 99n). Whether in charity or out of some human—all too human—impulse, Freud added the comical observation in 1930 that "Dr. A. A. Brill . . . and others after him, have succeeded in translating *The Interpretation of Dreams.*" This footnote, to which my attention was drawn by my student John Rajkman, supporting as it does the *logical* analysis of my text, must raise a fresh question about reading Freud in a language other than the one in which he wrote.

7. Jacques Lacan, "The Insistence of the Letter in the Unconscious," in *Structuralism*, ed. J. Ehrman (New York: Anchor Books, 1970), 131.

8. Goya's comment on plate 54, in *The Complete Etchings of Goya* (New York: Crown Press, 1943).

9. Freud, *Interpretation of Dreams*, 354–57.

10. Jean Laplanche and Serge Leclaire, "The Unconscious" (1966), trans. P. Coleman, in *French Freud: Structural Studies in Psychoanalysis*, Yale French Studies, no. 48 (1972), 136.

11. Arthur Collins, "Unconscious Beliefs," *Journal of Philosophy* 56 (1969): 667–80.

12. Peter Alexander, "Rational Behavior and Psychoanalytical Explanation," *Mind* 71 (1963): 324–41.

13. To be fair, Alexander's polemic is against those who regard all action as rational *from the point of view of the agent*, so the question is not *whether* it is rational, only whether the reasons are always "reasonable" from *our* point of view. Alexander is saying, in effect, that there is something wrong in calling every action rational in this extended sense; and there, I think, he is right.

14. Freud, *Interpretation of Dreams*, 277–78.

15. A striking history and treasury of rebuses may be found in E.-M. Schenck, *Das Bilderrätsel* (Hildesheim: Olms, 1973).

16. Freud, *Interpretation of Dreams*, 277–78.

17. The solution is "Viens souper à Sans Souci," Sans Souci being Frederick's palace. Voltaire's accepting note said simply, "Ga," which riddles out to

"*G* grand, *a* petit" and hence to "J'ai grand appétit," to which "Big *G*, small *a*" has no connection whatever.

18. Sigmund Freud, "Notes upon a Case of Obsessional Neurosis" (1909), in vol. 10 of the *Standard Edition*.

19. Alexander, "Rational Behavior," 339.

20. Maurice Merleau-Ponty, *The Phenomenology of Perception* (New York: Humanities Press, 1962), 160.

21. The following quotations are from Sigmund Freud, "The Unconscious" (1915), in vol. 14 of the *Standard Edition*, 198; italics are in the original.

22. Ibid., 199, 200–201, 204.

23. Lacan, "Insistence of the Letter," 130.

24. Sigmund Freud, *The Ego and the Id* (1923), in vol. 19 of the *Standard Edition*, 20.

25. Lacan, "Insistence of the Letter," 103.

History and Representation

> But this very entity, *Dasein*, is in itself "historical," so that its own most ontological elucidation necessarily becomes an "historiological" Interpretation.
>
> *Martin Heidegger,* Being and Time, *Int. II, para. 8*

> Joyce suddenly asked some such question as, "How could the idealist Hume write a history?" Beckett replied, "A history of representation."
>
> *Richard Ellmann,* James Joyce

HERE IS KONRAD LORENZ, endeavoring to describe an animal considerably lower in the scale of evolution than the dogs and geese, his fine observations of whom enlightened us all and earned him a Nobel Prize. I draw attention to the fact that he describes these beings—paramecia, as it happens—in a language he or we might use to characterize the conduct of dogs and geese or, for the matter, the conduct of one another.

> Even the primitive way in which the paramecium takes avoiding action when it collides with an obstacle, by first reversing and then swimming forward in another direction determined by accident, suggests that it 'knows' something about the external world which may literally be described as 'objective fact.' *Objecere* means "to

An earlier version of this essay was published in Dutch in *Feit en fictie* 3, no. 1 (fall 1996).

throw against": the 'object' is something that is thrown in our advance, the impenetrable something with which we collide. All the paramecium 'knows' about the 'object' is that it impedes continuation of its movement in a particular direction, and this 'knowledge' stands up to the criticism which we are able to exercise from the point of view of our richer and more detailed picture of the world. True, we might advise the creature to move in more favorable directions than the one it took at random, but what it 'knows' is still quite correct: "The way straight ahead is barred."[1]

This passage bristles with cautionary punctuation. There are single quotes around such words as "knows," "knowledge," "object"—though, oddly enough, not around "quite correct," as if the little phrase in the Language of Thought for paramecia, as gnomic as a fragment from some pre-Socratic philosopher—"The way straight ahead is barred"—were *true*. All this hedging circumspection vanishes from a gloss on the passage by the distinguished art historian Sir Ernst Gombrich, who otherwise cites Lorenz's text with great approval, subject only to a Popperian emendation, in his own book on ornamentation, *The Sense of Order*. I find the following a pure example of heavy professorial pedantry seeking to lighten itself with jocularity, but inadvertently comical because it is hysterically wrong while taking itself to be obviously and unarguably right. "Strictly speaking" (I find myself wanting to write this with a German accent!), "as Popper would remind us and as Lorenz knows" (no single quotes here!), "the creature's reactions are not based on knowledge" (and here the Materialists among us want to break into applause, stifled, alas, as Gombrich goes on to say) "but on a hypothesis" (groan); "they rest on the implicit assumption that the object which gives it a jolt would continue to remain at that point, for otherwise a change of course might bring the animal into collision with the same obstacle. It need hardly be added" (it is this "It need hardly be added" that I find so indescribably funny, emblemizing as it does all the complacent professors of my student years) "that the term 'hypothesis' is here used in a less specialized sense than in scientific research."[2]

Our little Popperian cell, accordingly, is vested with a certain competence in scientific method, less specialized than that employed by those who study the behavior of paramecia, but not so dauntingly different that in studying paramecia one is doing anything remarkably different from studying, as scientists, one another. It seems innately to be equipped with an on the whole satisfactory metaphysics through which it confidently ascribes sameness and stability to the objects it encounters. It holds a view of the external world regarding which it entertains true— and false—hypotheses. A chap, on balance, much like you and me. Students of Heidegger might even find parallels in the way in which things present themselves *as obstacles* to the paramecium: when an obstacle "loses its ready-to-hand in a certain way . . . it does not vanish simply, but takes its farewell, as it were, in the conspicuousness of the unusable."[3] In standing in the way, something *becomes* an object for the paramecium, who discovers the configurations of its world the way we discover the configurations of our own.

So much, for the moment at least, for the cognitive endowment of the paramecium, and for its *Dasein*. And since *Dasein* calls up the thought of *design*, I turn my attention to the fairly simple body of *Paramecium aurelia*, that slipper-shaped animalcule which consists of but a single cell.[4] Unicellular though it is, *Paramecium aurelia* is rather more than a single nucleus surrounded by cytoplasm, and I shall briefly describe the relevant anatomy, much of it brought to light with the advent of the electron microscope, and so unknown when cytologists had only the light microscope to work with. There is, to begin and, for our purposes, to end with, an excitable membrane, or *pellicle*, and then a certain number of ciliae, which are the organelles of this animal's locomotion. Ciliary beating propels the animal along a left-handedly helical course—until it encounters the obstacle, chemical or physical as the case may be, at which point the ciliae reverse directions, like propellers on a boat, an action that in turn reverses the paramecium's path. At a certain point, the ciliae resume their habitual direction; the animalcule embarks on a new forward course and either reencounters the obstacle (hypothesis false,

according to Lorenz-Popper-Gombrich) or, having evaded it, swims free through the medium in which it lives out its *Geworfenheit* (hypothesis true so far, according to the same authorities). Looking down through our electron microscopes, like Zeus from on Mount Ida, we can see whether or not the paramecium is headed in the right direction. But unlike Zeus, we lack a system of signs through which we can communicate our superior knowledge to the struggling creature below, who must find the unbarred path without aid from on high.

Against this picture of the pathfinding protozoon, so like in fact or in metaphor to dogs, to geese, and to ourselves, it is irresistible to ascribe to it a life of reason: a system of internal representations, the power of practical inference, and a structure through which representations become executed as actions guided in effect by maxims of prudence. That may seem like a great deal to ascribe to a unicellular being, but I only communicated a fragment of what we know of its physiology, replete as it is with mitochondria, Golgi complex, chloroplasts, ribosomes, and, as we say in advertising, much, much more. But alas, to quote Homer, it was not to be. I think we now know enough to say that this entire way of representing paramecial behavior is merely picturesque. The behavior the paramecium exhibits turns out not even to be teleological. For that matter, it is probably already too much to describe it as *behavior*.

Here, then, is the true story. The direction and rate of ciliary beat now seem demonstrably to be a function of differences in electrical potential distributed across the membrane's surface. In the normal state of resting potential, rearward ciliary beat occurs without excitation, this being the way the paramecium is built—its default state, to use the convenient computer term. Ciliary reversal correlates with the depolarization of the membrane, due to an influx of cations, this due to electrochemical reactions to the environment. As the environment changes, the membrane reverts to resting potential, the default position of normal ciliary beat takes over, and mere contingencies of the electrochemical *Umwelt* account for such changes in direction as are read, by fantasists such as Lorenz, as calculated efforts on the part of the paramecium to get around

the obstacles that bar its path. What happens is smoothly narrated in terms of electrical changes translated into physical motion on the part of an animal constructed in a certain way.

"In a certain way": in fact, something over three hundred strains of *Paramecium aurelia* have been identified, each of which reacts somewhat differently in relation to a norm that I conjecture must be regarded as merely statistical. The obstacles I shall discuss are chemical, namely, a trace of a sodium chloride. Some paramecia overreact violently, recoiling to distances vastly in excess of the norm. Some are phlegmatic, backing up so short a distance as to suggest indifference. Some change directions without benefit of sodium chloride, as if exercising free will—or, since we are being psychological, as if paranoid, suspecting salinity at every turn. And then there are those that appear truly indifferent, sailing through concentrations of salinity that define the normal, and whose conduct would have to be classed as supererogatory in the language of morals. There is indeed enough variation to license a psychology of humors, or a psychopathology of the kind we use to classify deviant or perverse behavior, ranging from unreasonable to irrational, in case avoidance of sodium chloride in some degree is actually adaptive rather than, let us say, aesthetic. But none of this survives the understanding that comes with electrochemical explanation. The strains are marked by differences in membranal curvature, and the distribution of charges, which determine completely the rate and direction of ciliary reversal. The account I have sketched is compact, leaving no room for the intervention of will, the efficacy of practical syllogisms, the weighting of hypothetical alternatives, the language of thought, a Popperian methodology. I would venture even a claim that we know enough already to recognize that the so-called Intentional Stance proposed by Daniel Dennett is appropriate only as a jocular *façon de parler*. *Paramecium aurelia*, in all its versions, does not reverse beat and hence direction *in order* to cope with obstacles strewn in its path. Rather, it forms with its environment a single electrochemical system. The design of the system suffices all our explanatory ends. It is the product of evolution and not of design.

Lorenz's punctuationally hedged account was finally false. Everything is fully explained in a way that requires no reference to cognition, to "objects" in the intensional sense assigned that term by Lorenz, that is, the way something is an object of thought or consciousness, or that which answers to the *da*—to the indexical "there"—in *Da-sein*. There is no World of the Paramecium. Or, to bring it closer to contemporary analytical distinctions, there is nothing it is like to be a paramecium, any more than there is something it is like to be a lump of cobalt. There is enough of a resemblance to the way a far more evolved animal than it deals with obstacles—to the way we deal with obstacles, say—to state that based on what that resemblance consists in, a Turing test would fail to discriminate *Paramecium aurelia* from such animals—or from us. It would, by Turing criteria, be insupportable to ascribe rationality to creatures like ourselves and withhold it from *Paramecium aurelia*. It is by tacit appeal to Turing-like considerations that Lorenz and Gombrich use the idiom of hypothesis, knowledge, obstacle, and the like. So much the worse for the Turing test then. The Turing test recommends that parity of behavior requires parity of explanation. If we were Zeus, watching the behavior, say, of Odysseus from a cloud, we might say: Odysseus has encountered an obstacle on his way back to Ithaca. He realizes that the way home is barred. He reflects, changes course, and is on his way. If Zeus liked him more he would have communicated some useful facts. Lorenz cannot help the protozoon, who has, like Odysseus, to work things out for itself. It works out its own practical syllogisms, and finds its own way through the wine-dark petri dish. But as we saw, nothing like this happens at all. Parity notwithstanding, we are not required to explain *Paramecium aurelia*'s conduct as we do that of Odysseus. Or we could use the Turing test in a reverse way: Since it proved not to be required to use the explanatory apparatus of practical reason in the case of *Paramecium aurelia*, whose "behavior" (let me help myself to some fudging punctuation) so resembles ours that it seems altogether natural to describe it as we would our own, how can we be that sure that such descriptions

are finally fitting in our own case? If it is illegitimate in the case of *Paramecium aurelia*, what makes it legitimate in our *own* case?

Philosophical turnabout is metaphysical fair play. Are we finally in any deep or serious way all that different from *Paramecium aurelia*? As the simplest of animals, *Paramecium aurelia* is still an animal, and must with its one cell perform all the functions essential to animal life performed by us with our system of organs and network of often specialized cells: it must find food and flee danger, register something like awareness of its environment, respire, eliminate, and reproduce. The transmission of nervous impulse through interchange of sodium and potassium ion is not so amazingly different from the depolarization of the pellicle through the movement of positively and negatively charged ions. Now, we have seen how, with the advantage of the electron microscope, we have been able to learn enough simply to discard, as altogether irrelevant to the description and explanation of paramecial behavior, the language of cognitive function. We do not know enough to be able to do this with human beings, at least not as yet. But from the perspective of an extrapolated neurochemistry, have we any reason to believe that the descriptions found so irrelevant, so picturesque, so merely *façon de parler* in the case of *Paramecium aurelia* will not be similarly found so in our own case? Scientists like Lorenz, finding no difference in kind but only in quantity between ourselves and paramecia, found it irresistible to describe the latter in terms altogether natural in describing us. I am taking the other direction: having found that description finally empty in the case of paramecia, what is to prevent us from going, as the French say, *jusqu'au bout* with the Eliminativists in the philosophy of mind, who claim preemptively that the language of everyday psychology must give way in time to the descriptions to be made available through an advanced neurochemistry? The Turing test runs in two directions, down the slippery slope when there is nothing to arrest it, and up the slippery slope when there is nothing to arrest it. Turing was anxious to ascribe thought to what he called "computing machinery" when its behavior was

indiscriminable from ours. The Eliminativist, conversely, is anxious to deny thought when our behavior is indiscriminable from that of an animal in the explanation of whose behavior thought has no place. How can we possibly fault him?

Let us at this point turn our attention from *Paramecium aurelia*, who has served us well or dubiously, depending upon your vision of the universe, to us.

Whatever one may think of the ingenious thought experiment designed some years ago by John Searle,[5] it does something rather rarely done in these discussions: he undertook to insert *himself* into the argument when he asked, against the evidence of consciousness, whether it could be true of him, whatever his outward behavior, that he understands something when, introspectively, he finds that he does not. The outward behavior in Searle's imagined case was indistinguishable from that of a native sinolect: he printed out (let's imagine him equipped with a keyboard), in Chinese characters, the very array of marks a literate sinolect would print out in answer to a question, itself in Chinese characters, and did this over a sustained period, so that there was no discernible difference between his "output" and that of a native sinolect. That is the way things are set up by Turing in his classical statement of the "guessing game": the thought was that if there is no discernible difference between the output of a machine and that of a human being, one could not invoke reason in explanation of the one while withholding it in the case of the other. And Searle has thrust himself into the pilot's seat, producing in response to questions answers indiscernible from those of a Chinese speaker, making, it, on Turing grounds, unacceptable that competence in Chinese should be ascribed to the latter and withheld from Searle himself. In the famous peer review system of the *Journal of Behavioral and Brain Science*, in which Searle's Chinese Room argument first appeared, many of the commentators bit the bullet and insisted that whatever *he* said, Searle really had to understand Chinese. (Some said that while he may not have understood Chinese, the system in which he

was a component understood it.) Now, we do sometimes assure people who are not confident in their English that they *understand* the language they are so apologetic about, and we may observe that we are the better judges of the matter: if *we* say they understand it, they do, however uncertain they feel. But Searle insists that he is not uncertain in this way; rather, he is altogether certain that he knows not a word of Chinese—he just has mastered some rules for combining symbols. Milton's daughters used to read Latin, Greek, even Hebrew to the blind poet without knowing what they were reading—they had merely mastered the rules of pronunciation. The printed words were input, the uttered words the output; and while their output might have been indiscernible from that of someone who read these learned languages aloud knowing what he read, they really did not know these languages at all. And this is what Searle is insisting in his own case.

I do not want to be distracted by the example, however. I am only drawing attention to Searle's sense that he belonged somewhere in the picture he was painting, a matter of almost standard amnesia, where scientists and philosophers leave themselves outside the situation they try to depict for us—as though science and philosophy were ontologically weightless, always logically external to the world as they address it from across a Cartesian distance, never asking, as it were, where would science or philosophy be if what science or philosophy said were true. Where would the Eliminativist be, for example, if what he or she said were true? How would we deal with Eliminativism as an activity if all we had were the language of neurochemistry to do it with? Or will Eliminativism, too, disappear with the psychology it assures us must disappear when neurochemistry prevails? And if Eliminativism is swept away by neurochemistry, what will happen to neurochemistry itself, considered as a scientific practice? Will neurochemistry's content be rich enough to represent itself?

A science, neurochemistry itself included, is a system of representations. It is a system arrived at by exercising that sort of cognitive endowment we giggled a bit to see thinkers like Gombrich and Lorenz seriously

ascribe to paramecia: projecting hypotheses, testing and revising them in the light of falsifying observations, arriving at hypotheses that carry us securely from experience to experience in such a way that we are prepared to call them true. Can this activity be described in the idiom of neurochemistry? Well, no. At least, not in the case of paramecia. The moment we got the electrochemical story right, the story of hypothesis, testing, observation, revision, falsity, and truth disappeared. But what would the science of neurochemistry be from which all this disappeared? It could not be the story of a scientific practice! The moment we try to bring scientific practice into its own picture, the picture becomes subject to grave pressures indeed: there seems to be no room for it. It was science that gave us the correct picture of what takes place in *Paramecium aurelia*. And it will be science, surely, that will give us a true picture of ourselves. But will science itself have to disappear from that true picture? If so, how is science, as a practice, to be accounted for? It is surely among the things human beings do, and indeed do best. How strange that there should be no room for it in the final picture of the world that science is to draw up! How can we even talk about it if Eliminativism is right?

In the late years of the nineteenth century, philosophers struggled to formulate a distinction between two kinds of science, and enlisted a sufficient number of bad metaphysical arguments in support of a sharp difference between the sciences of nature and the sciences of man—between the so-called *Naturwissenschaften* and the so-called *Geisteswissenschaften*— that it failed to make a lasting impression on the Anglo-American philosophical world, which was leery in any case of dualisms. Here the overall attitude was polemically expressed in the title of that series in which so many of the great monographs of high Positivism were published: *The Encyclopedia of Unified Science*. Actually, the notion of unified science was a way of speaking of a unified world, and the strategies of definition and reduction within the sciences was the linguistic strategy for speaking of a world in which there were no final divisions between orders and kinds of things. My sense is that the controversy today, between certain strong versions of Eliminativist Materialism and certain realist versions of the

Language of Thought, reflects this controversy. If we can succeed in representing ourselves in such terms as those with which we have succeeded in representing paramecia, then there is a single continuous line connecting the simplest of animals and the most complex, at just that juncture where, if they resembled us, they would be unicellular scientists aswim in their salty worlds or, if we resembled them, we would be storms of ions and nothing more. But my thought is that if we bring ourselves into the picture and ask, as scientists, how in electro- or neurochemical terms we are to represent what we as scientists do, represent the features of scientific activity—the formation of hypotheses, the inferring to observations, the performance of tasks, and that all too human concern that truth prevail—we are suddenly faced with the possibility that the *Naturwissenschaften*, being after all something humans do, are finally part of the *Geisteswissenschaften*, which represent, interpret, and seek to understand what humans, scientists included, do. Can we give a natural-science account of natural-scientific practice, or must we in fact remain satisfied with a human-science account, using the language one of the natural sciences—neurochemistry—was to have eliminated?

Each of the animal functions we share with *Paramecium aurelia* marks an entry point for culture in our case, though not in the case of protozoa, and hence is subject to a historical evolution of a kind even animals greatly advanced over *Paramecium aurelia* know nothing of. But none of these cultural and historical differences penetrate the human genome, so that if there were some catastrophic erasure, in which everything achieved by history were obliterated, the human being would find itself coping very much the way its first ancestors did, however many hundreds of thousands of years ago. With *Paramecium aurelia*, there is nothing to obliterate. It lives as it has always lived, since it first emerged. Genomic change takes place only through mutation. So history washes over the genetic endowment like waves against the hardest rock, making no difference to it whatever. The DNA of Homer is not especially different from the DNA that specifies you and me. In the last centuries

scholars, judging by the sparse color vocabulary of the epics, supposed the Greeks lived in a chromatically reduced universe. Since the work of Brent Berlin and Paul Kay we know that Greek color vocabulary is what one might expect at that stage of a culture. Their ability to differentiate colors was of a piece with ours. Color perception is not indexed to culture in that way at all. A cartoon in *Science* has one bystander explaining to another the project of a colleague as trying to identify the gene that accounts for our making our living by studying genes. It is (mildly) comical because we would not expect genetics, as a science, to be coded for in the genes. It is not a genetic product: it is a product of science, and science itself may be the result of culture modifying what could be coded, namely the disposition to form beliefs and the like, which scientists share with everyone else, and which cannot today be at all different from what we see in Odysseus when he computes the best strategy for slipping free of Cyclops. The *content* of the beliefs of course will differ, but that is where history and culture have their genetically intransmissible effects. The history of science is the history of representational change, and if there were representations coded for genetically, they would not change except under mutation.

The data I reported on regarding the anatomy of *Paramecium aurelia* were, as I mentioned, made possible by a great deal of laboratory technology, including the electron microscope. They were published in 1976. But the history of beliefs about protozoa begins almost exactly three centuries earlier, when they were first described by Leeuwenhoek in a letter of 1676. There he characterizes a free, living animalcule, which he discovered in standing rainwater by means of a simple microscope. Beliefs may very well be—very likely are—modifications of nervous tissue. Electrochemically, human nervous tissue is as it has been since the appearance of the genome. But before 1676 there was no human tissue so modified as to be a belief about protozoa. There were no such beliefs before the invention of the microscope. The concept of protozoa is surely nowhere to be found in the genetic endowment of

microscopists, even if their nervous tissue is in the course of education modified in the form of beliefs about them.

Here is the thrilling passage from Leeuwenhoek's letter to the Royal Society in October 1676:

> In the year 1675, about half-way through September . . . I discovered new living creatures in rain, which had stood but a few days in a new tub, that was painted blue within. This observation provoked me to investigate this water more narrowly; and especially because these little animals were, to my eye, more than ten thousand times smaller than animalculae which Swamerdam has portrayed and called by the name of Water-flea or Water-louse, and which you can see alive and moving in water with the bare eye.[6]

Leeuwenhoek calls these "living atoms," his observation of which the Royal Society sought to confirm in 1677, at first with no success, leading to a certain skepticism, or efforts to explain away what the Dutchman actually saw. But on November 15, things were seen that "by all who saw them were verily believed to be animals; . . . there could be no fallacie in the appearance."

Leeuwenhoek discovered ciliae in 1677, and in fact formed a good account of their function. But in general, the early microscopists lacked the concepts they needed to understand what they saw through the lenses of their marvelously ornamental instruments. F. J. Cole, in his *History of Protozoology*, puts it this way: "When we first read the writing of the old naturalists we experience a feeling of disappointment if not of contempt. Their statements appear to be indefinite and incoherent, as if they had no real conception of the phenomena with which they were grappling."[7] It is instructive to reflect, however, on how nearly impossible it would be to express in language Leeuwenhoek could have grasped the discoveries published in 1976 about the animalcule he was the very first to know about. The first clear description of paramecia, in which transverse fission

was noted for the first time, appeared in 1703. But its meaning did not become clearly manifest until the work of Trembley in 1745, which became in a sense *the* scientific excitement of the eighteenth century, largely because of the philosophical views, widely held, with which it collided. Trembley's polyp, if chopped up, would bud into as many polyps as there were pieces, roughly speaking, and the question was whether this meant that the soul was divisible as well as the body. The theory of the cell comes into place only in 1837. The hot question for the classical microscopists was whether these animals were spontaneously generated, it being greatly to Leeuwenhoek's credit that he was doubtful, probably by analogical reasoning from what he found out about the flea, which until then was widely supposed to come from sand. Leeuwenhoek discovered spermatozoa in insects but had no model for how things could work with paramecia, and spontaneous generation remained a question into the time of Pasteur. The important fact is that different scientists at either end of this history had vastly different beliefs; in a sense, to explain to a naturalist of 1676 what protozoologists of 1976 found out, the former would have to be instructed in chemistry, the theory of electrolysis, and cytology, to mention only the most obvious things. And to understand the beliefs of 1676 would require taking on the ignorances of the men of that period, their wild beliefs, their extravagant reservations as to whether God ever meant for us to see such things in the first place, having made the eye as He had.

But Leeuwenhoek was made much as we are made, a product of the same genetic material, with eyes that worked the way our eyes work and with nervous anatomy that cannot have differed any more from ours than the anatomy of the first sighted paramecium differed in membrane and organelles from its descendants of today. Leeuwenhoek's system of representations, however, cannot have been the same, and that difference cannot be explained through genetics or the organization of nervous tissue or the anatomy of the brain. It can only be explained through history. The advent of his beliefs calls upon explanatory considerations very different from those that prevailed at the advent of ours, made three

centuries after his powerful discoveries. Although those discoveries do enter into the explanation of our beliefs, nothing with which Leeuwen-hoek physically interacted has anything to do with us today. It is these matters that I am seeking to make central by bringing science into the world, asking what must be in place for scientists to represent the world as they do and what must be true of representations that they can form histories of the sort that the history of protozoology exemplifies, when the human body circa 1676 and 1976 has no historical development to speak of and is the same at either end of that remarkable history.

Eliminativism, in eliminating psychology or what it dismissively speaks of as "folk psychology," eliminates history, and so treats the human animal as it would the unicellular animalcule—namely, as behaving in the same way under principles of electrochemistry from century to century. But it could not conceivably explain its own behavior that way, and certainly not the behavior of the sciences whose future findings it supposes will enable a full description and explanation of human behavior without any of the terms we require in order to describe and explain science as a practice. It is ironic that the Eliminativist appeals to history—for what, after all, is being spoken of if not the future of a historical development—and at the same time projects a picture of language which has no room for history in it. Without history, it cannot so much as state its position. So what are we to say when its position has no place for history?

Let me conclude with a perhaps tenuous analogy. Consider the photo-chemical side of photography. Typically it is a process that depends on the sensitivity to light of silver compounds: silver bromide is emulsified in a gelatine, which coats a support—a plate, a piece of film—and, after exposure, the exposed bromide is reduced to metallic silver, which forms an image corresponding to the light intensity to which the emulsified silver was initially exposed. This is the basic process. The relationship between image and metallic silver is perhaps philosophically not so different from the relationship between mental representations and nervous tissue. The latter is unquestionably more complex. Little really is

known about what the "emulsion" is or how it gets "fixed" (and here I avail myself of the same hedging punctuation with which Konrad Lorenz insinuated a certain psychological story into his description of the paramecium) or about anything at that level where body and mind interface. But in some way the Aristotelian apparatus of material and formal cause applies, as much so as it does in photography. You can say, in a materialist tone, that the photograph is nothing but metallic silver, caused to be arrayed as it is by varying intensities of light on emulsified silver compound and the subsequent dissolving of the unexposed compound by hyposulphate. And in a sense you would be right. Chemically speaking, what else is there? But in a sense obvious to us all, something is left out which has no place in the language of chemistry. There is a technical history of photography, from Nièpce's first success with an unfixed positive in silver chloride, through the work of Daguerre, the collodion emulsion, and on to Land's polaroid process. In a lecture the curator of photography at the Museum of Modern Art in New York, Peter Galassi, described the histories of photography that existed when he took up the subject: they were histories without images. But in a very real way, the history of photography must be image-driven. And to talk about images, what they meant and why they were made, and how they changed, is to bring in factors for which no account can be given with the resources of photochemistry alone.

This is the kind of thing I want to say is true of us. Just getting to the point where we understand the physiology of representations, which corresponds to the forming and fixing of images on the photographic support, is at the present moment far away. Needless to say, some physiological account will have to be given of how beliefs about protozoa are inscribed in the nervous tissue of Leeuwenhoek and everyone else. But then we have to give a historical explanation of how that tissue was exposed. There is, for us, a history of representations for which *jusqu'au boutisme* allows us no conceptual room. And since that extreme position characterizes something philosophers of a certain persuasion find attractive, it might be prudent to pause and ask ourselves how, if it were

true, we could account for our discussion of it in the only terms it is prepared to allow.

NOTES

1. Konrad Lorenz, *Die Rückseite des Spiegels: Versuch einer Naturgeschichte menschlichen Erkennens* (Munich, 1973), 16; cited in Ernst Gombrich, *The Sense of Order: A Study in the Psychology of Decorative Art* (Ithaca: Cornell University Press, 1979).

2. Gombrich, *Sense of Order*, 2.

3. Martin Heidegger, *Being and Time*, trans. J. Macquarrie and E. Robinson (New York: Harper & Row, 1962), 74.

4. The following discussion is based on R. Eckert, "Bioelectric Control of Ciliary Activity: Locomotion in Ciliated Protozoa," *Science* 176 (1972): 473–81.

5. John Searle, "Minds, Brains, and Programs," *Behavioral and Brain Sciences* 3 (1980).

6. Clifford Dobell, *Antony van Leeuwenhoek and His "Little Animals"* (New York: Harcourt, Brace, 1932).

7. F. J. Cole, *The History of Protozoology* (London: University of London Press, 1926), 5.

The Decline and Fall of the Analytical Philosophy of History

THE HISTORY OF THE analytical philosophy of history very largely begins with the publication, early in 1942, of C. G. Hempel's classic paper "The Function of General Laws in History." In the mid-1950s, and for some years thereafter, there was a heated controversy over Hempel's central thesis—that historical explanation, like scientific explanation in general, involves bringing the event to be explained under ("covering it with") a general law. The argument, though, was but a skirmish in the wider wars of the time, which concerned competing views of ordinary language and the relationship to language of analytical philosophy. So far as I know, Hempel never saw great reason either to revise or to retire his account of historical explanation, or the much wider general theory of explanation that he worked out with Paul Oppenheim in "Studies in the Logic of Explanation," published in 1948; and when he came to publish a postscript to his essays on explanation in *Aspects of Scientific Explanation* in 1964, he did not even bother to defend the paper on history (reprinted without comment), and dwelt on a few matters

Reprinted from *A New Philosophy of History*, ed. Frank Ankersmit and Hans Kellner (London: Reaktion Books; Chicago: University of Chicago Press, 1995), 71–85.

only of logical detail, as if the theory of explanation as entailing general laws were in all essentials sound.

I do not think this was a case of mere philosophical stonewalling: Hempel offered, over these same years, some of the most remarkable pieces of philosophical dismantling I know of, of theories he himself had advanced. In 1946, in *Mind*, his "A Note on the Paradoxes of Confirmation," with its demonstration that examining a swan and finding it white must confirm the proposition that all ravens are black if his own analysis on confirmation were correct, pretty much blew that theory sky high: one had to either sacrifice one's intuitions about confirmation or surrender a basic piece of logic. His paper "Problems and Changes in the Empiricist Criterion of Meaning" made plain to the world that no one knew how to heal the logical wounds inflicted on the dread Verifiability Principle by those who had believed it to be true until it was found hopeless, unable to resist attacks from the side of its logic. Indeed—this was 1950—nobody any longer greatly cared to try. I recall talking about it with the logician Richard Jeffries one evening at a rooftop party in Manhattan; he said that whenever he thought of the Verifiability Principle, he was reminded of the Sybil of Cumae as described in the epigraph to T. S. Eliot's *The Waste Land:* when asked what she really wanted, the Sybil responded that she wanted to *die*. In 1958 Hempel published "The Theoretician's Dilemma," a brilliant discussion of why no one was any longer interested in empiricist foundationalism, even though it had been demonstrated, through an astonishing theorem of William Craig's, that in any language minimally formalized, any proposition using "non-empirical" predicates can be trivially replaced with propositions using predicates from the favored vocabulary. With these two papers, the props had been knocked out from under the reconstructionist programs of logical positivism, which had envisioned erecting the "language of science" on strictly observational bases. These were philosophical criticisms of an almost breathtaking finesse, worthy entries in the Encyclopedia of Refutations along with Russell's devastation of Frege, or

Wittgenstein's devastation of Russell when he showed that the latter's theory of judgment—the keystone to his epistemology—was inconsistent with his theory of types—the keystone to his way of handling the logical paradoxes. If deconstruction as a philosophical position had a single contribution as powerful as any of these, every analytical philosopher in the world would take deconstruction seriously. By contrast with Hempel's arguments, something like the charge of the "metaphysics of presence" leveled against Husserl is the kind of argument that belongs in the *class terminale* of a middling *lycée*.

In these three remarkable papers—on confirmation, meaning, and the reducibility of theoretical terms—then, Hempel showed himself to be a thinker ready to reconsider his views when the arguments, many of them invented or discovered by himself, went against them. So he evidently felt nothing especially damaging in the various criticisms offered of his model of historical explanation. My own book *Analytical Philosophy of History*, published in 1965, sought to demonstrate an equivalence between explanation as construed by Hempel, on the one hand, and narratives, on the other, thus vindicating the so-called covering-law model against the claim that narrational models were deeply alternative to it, but it was for quite other reasons that the book attracted the considerable philosophical attention that it did; and when Rex Martin, in 1977, published a very balanced and judicious account of Hempel's model,[1] I think Martin would be the first to concede that no one much cared one way or the other. The whole analytical philosophy of history, like its cousin the Verifiability Principle, hardly had enough life left in it to want to die. Thomas Kuhn's epochal *The Structure of Scientific Revolutions* appeared in 1962 (as an installment in volume 2 of the uncompleted *International Encyclopedia of Unified Science*, which was after all to have been the great monument to a philosophical vision of science, a vision that Kuhn's book did as much as anything to abort). Kuhn advanced a view of history so powerful that, rather than being an applied science, as Hempel holds history to be, history came to be the matrix for viewing *all* the sciences. It suddenly became the philosophical fashion to view science historically rather than

logically, as an evolving system rather than a timeless calculus, as something whose shifts over time are philosophically more central to its essence than the view of it as a timeless edifice of theories, related to laws that in turn were related to observation sentences—the standard way in which the philosophy of science thought about its subject *ante* Kuhn. That architectonic conception is embalmed in the article on the philosophy of science (written by me) in Paul Edwards's *Encyclopedia of Philosophy*, published in 1967. It was as though science had been swallowed whole by one of its offspring, which, under the influence of Wittgenstein, N. R. Hanson, and Stephen Toulmin, not to mention Kuhn himself, had become the philosophical *history* of science.

This transformation was consolidated under the immense prestige of Foucault's archeologizing politics of science. The world as idea became the world as will, and science itself came to be seen more and more as an all-too-human endeavor, a view confessed in such works as James Watson's *The Double Helix*. This overall view was nailed in place with the heavy antiscientism of the late 1960s and the decade that followed. Except for a few desultory efforts to account for paradigm shifts, or in what Foucault designates *énoncés*, I can think of very little of significance in the philosophy of history from the middle 1960s to the present. Somewhere someone sometime in the last decade must have written about explanation, even about historical explanation—but I cannot think of an example offhand. (It should be noted that, as editor of the *Journal of Philosophy*, I see a fair sample each year of what philosophers offer as their most advanced work: my estimate is that a contribution on any aspect of the philosophy of history occurs at a rate of one per thousand submissions.) It is not just that the topic is under extreme neglect. It is, rather, that there is hardly room in the present scene of philosophy for discussion of its issues. So to find someone actively working at them would be almost to encounter a historically displaced person, like a painter doing abstract expressionist canvases as if the whole subsequent history of art had not taken place, or Japanese soldiers on some obscure atoll who never found out that the war had ended.

I have now written a little narrative, treating a fragment of the philosophy of history as a fragment of the history of philosophy. My aim has been to emphasize that the problem of historical explanation itself belongs to history and that it has a history of its own, and that a solution of the problem can and should be tested against itself: if a theory of historical explanation is incapable of explaining its own history, it can have little claim to philosophical assent elsewhere. Philosophers are prone to exempt themselves from their own analyses. This is harmless enough when the latter bear on subjects to which philosophy does not belong, but the position is seriously compromised when philosophy does belong by rights to the subject analyzed, for example if the subject should be thought. In that case philosophy must be hostage to its own accounts, in that if, again for example, philosophers should accept an account of thought to which the thinking that went into the analysis fails to conform, then the analysis is seriously limited or flawed. A first test of a philosophical theory should be that it account for itself whenever relevant. A theory of knowledge, for example, ought to be able to explain how, in its own terms, we know it to be true, and if it is not up to this, then it is either inadequate or incomplete.

A theory of meaning should be able to explain how *it* gets its meaning, and a theory of understanding how we understand it. If somebody insists that "belief" belongs to a superannuated theory of ourselves, and that in truth there are no such things as beliefs, the question naturally arises as to the status of this very belief and what *its* status is, and whether, for example, we could express what looks like a belief about beliefs in a favored neurophysiological vocabulary that allowed itself no psychological terms whatever. Indeed, it would be extremely interesting to see how an account could be given of the argument that there are no beliefs in an idiom that had no room for the concept of belief. Possibly the argument could be expressed in terms of some transformation of states of nervous tissue, but then we would surely want to add to the normal language of neurophysiology concepts like truth and falsity and entailment, for otherwise it would not be an *argument*. And then it would be interesting to

see what would have been gained: all that would have been shown—admittedly a great deal—is what happens in nervous tissue when someone arrives at a philosophical belief. But that is a far cry from denying that there are beliefs at all. Philosophy must in general include itself in whatever account it constructs, for otherwise true philosophical closure will not have been attained and the account will be partial at best.

Hempel's model of explanation had, as its most controversial feature in the case of *historical* explanation, the proviso that the event to be explained—the *explanandum* in the logical patois of the era—must be "covered" by a general law. There really is one place in my narrative where something like a tacit appeal to general laws might be located, but this is crucially at the very point at which Hempel's distant opponents (in contrast with his immediate critics) might have insisted that a very different operation altogether from explanation is called for, namely a kind of understanding (or *Verstehen*, in the metaphysical patois of *its* era). This is where we ask ourselves why Hempel did not change his views on explanation despite the fact that his immediate opponents argued vigorously against them. Now, it is possible that there is something very like a law, modeled on Newton's First Law of Motion, that a person who has formed a view tends to maintain that view with uniform tenacity until something—some "impinging force," as Newton would say—causes him to modify or abandon it.

There are no doubt views which no impinging force will cause us to change short of damage to the brain: these would be the deep a priori principles that define experience for creatures with brains such as ours, though there is an interesting peripheral question regarding the degree of intervenability in regard to these. Quine, not a man likely to alter his political views, has an evidently light grip on the Principle of Excluded Middle, which he feels one can give up easily if the cost of not doing so is assessed as too high. But others have wondered whether it is psychologically possible to give up a principle that may be, just as Aristotle says, a Law of Thought, even if for computational purposes one can get along without it. Quine offers a general picture of the system of beliefs as totally

subject to the doxastic will, where we can pick and choose in accordance with competing priorities. But in actual practice how possible really is it to change the beliefs that perhaps define the world and ourselves together and reciprocally? Hempel's view of explanation may in fact be pretty deep, psychologically, in that it characterizes the way we do in fact proceed when we endeavor to explain, emitting hypotheses that harden into laws when they pass the tests of further experience and that are revised when they do not. Thus, learning that a certain logical positivist did not change his view on a certain subject, despite the fact that for a dozen years or more arguments against it were found compelling by a number of clever philosophers, I might explain this by saying that as a general rule logical positivists are terribly dogmatic, and that such resistance is to be explained as a matter of course. And then *you* tell me that Hempel is an extremely liberal and open person, as evidenced by the way he cheerfully gave up his views on confirmation and verification and meaning, not to mention what Quine identified as the Second Dogma of Empiricism, namely reduction to an observational base as the mark of scientific credibility. But these are views that historically defined logical positivism and that in some cases enshrined Hempel's own contribution to philosophical knowledge.

We can go still further in this discussion. It might be observed that Hempel, in each of the three retractions, made a rational decision, namely to sacrifice a piece of philosophical analysis rather than a piece of logic. Many of the difficulties with the Verifiability Principle were generated, for example, by certain features of logical adjunction, namely that if P is true, then P or Q is true, whatever Q may be. The difficulties with the theory of confirmation could have been met by sacrificing the concept of logical equivalence or of contraposition. And Craig's theorem really *was* a theorem.[2] So there are priorities here: Hempel was going to hold on to logic "come what may," as Quine likes to put it. On the other hand, to his mind at least, none of the objections to the covering-law model entailed a choice between it and some principle of logic, and meanwhile his own account rested on some intuition of what we do and

how we behave when we explain, whether we are historians or not. Challenged to explain his resistance, Hempel would have been able to give an account of it which in fact exemplified his model. And he might at the same time have been really unable to give an account that did *not* exemplify it, to be sure within its relatively loose and accommodating formulation, which in any actual case required only that an "explanation sketch" be provided.

This, then, is a kind of historical explanation of a non-change, but in history non-changes are as important as changes. It more or less reconstructs, in admittedly rough strokes, what we might call "the World according to Hempel." It was very much a world of its own time, in that the imperatives and priorities of logical positivism were among its foundations, though parts of the foundation were tested against one another, and in that, whenever there was a choice between logic and some other kind of proposition, logic held sway, even if, in the end, this meant sacrificing finally a great many principles, verificationism and reductionism being two, that were canonical to those who lived, philosophically, in "the World according to Logical Positivism." "Sacrifice" is perhaps too strong a word; perhaps there were other reasons in the air which made verificationism and reductionism decreasingly adequate accounts of how science ideally works, so that it seemed decreasingly worth the effort to try to patch them up. And so they were allowed to languish, and if—no more than the Sybil of Cumae who had struck a bargain in which she was given immortality—they were able to die, at least the distinction between death and the philosophical life grew increasingly difficult to draw.

Because mathematical logic was so firm a component in its geography, the World according to Hempel was very much a World of its own time, for logic in the form that Hempel used it had not existed before Russell or, perhaps, before Frege. It was not a world available to anyone in 1742 or 1642 or 1242, to cite some pre-anniversaries of the paper on historical explanation of 1942. A world is (at least) a stratified system of representations and it is a matter of history that certain representations

cannot be formed at certain times (and though they can be formed at other times, they perhaps cannot always be *lived* at those times). Hempel's world was overlapped by the worlds of other logical positivists, other non-positivist philosophers, other non-philosopher scientists, other refugees, and there may very well have been not one single other person whose world was congruent with the World according to Hempel in every particular. A world is something that we *grow*. To be human at all is to have grown a world. A world is what a soul construes itself as living in, so there is little sense in a soul surviving death if the world it projects for itself does not survive. In any case, to understand Hempel, to apply *Verstehen* to Hempel, is to reconstruct the World according to Hempel, which in effect is to "abduct" to its laws. But that of course is exactly what Hempel supposes we do when we explain historically!

"The World according to X"—hereafter W(x)—is, to paraphrase Wittgenstein, everything that is the case for X. It is by no means necessary that whatever is the case for X is the case, though enough of W(x) must be true that X may survive. There is, moreover, no great need to make fact-value distinctions when we talk about worlds—for that we had to worry about when we talked about the world *tout court*: the fact that all unsupported bodies fall may be as much or as little part of W(x) as the claim that it is wrong to break promises. And false beliefs may count as heavily toward X's survival as true ones, if, for example, X lives in a society where members hold beliefs that X counts false, and this brings it about that X gets executed for infidelity or impiety. We in general understand one another's behavior with reference to one another's worlds, which means in effect that we identify W(x) when we endeavor to explain a piece of behavior B of X: B happens as a matter of course for X when W(x). But this in effect is to have identified, via abduction, a world-defining law for X: $W(x) \rightarrow B$. It does not greatly matter that there should be another individual Y, such that $W(y) \rightarrow B$, for the law to be general; it is general just because it holds that anyone whose world relevantly overlaps W(x) will do B when X does B, even if there is no such anyone.

Worlds, of course, are holistic and stratified: they are not simply conjunctions of whatever is the case for whoever's world it is. In the World according to Hempel, logic trumps whatever would entail revision of it if the latter were true; and his own theory of confirmation is more readily jettisoned than the Verifiability Principle, which was a long time a-dying, and which in his heart of hearts he may never have given up, just because it may have continued to strike him as close to scientific practice, in a world in which scientific practice was canonical. But to see whether this was true, we would have to examine more of Hempel's behavior than we so far have done, and see what choices he might have made where we would expect him, *ceteris paribus*, spontaneously to invoke verificationism. But that is a task for another occasion when, so to speak, one undertakes a systematic cosmography of W(hempel). It would, beyond that, be a philosophically rewarding and even indispensable task to undertake the cosmography for the worlds of everyone, which is in effect to identify the laws of all the worlds. I take it that the Transcendental Deduction of the Categories was such an undertaking. These would be the laws for rational beings, inasmuch as to be a rational being is to behave in such a way that what one does can be understood in terms of a world. There of course may be "cracked worlds," worlds where one or another fundamental law fails, which makes the behavior of one whose world it is irrational. But these schematic remarks carry me far downstream from where I mean to be in an essay on the philosophy of history, and return to my true course.

It is somewhat ironic that my effort to explain Hempel's continued advocacy of the covering-law model by actually *using* his model should have involved me in a concept, that of a world, from within which it becomes a matter of course that he should continue advocating that model, when the very idea of "from within a world" must be repugnant to Hempel—from within Hempel's world. It is repugnant on perhaps two grounds. In the first place, it sounds very much like the very thing he meant to escape from in offering his famous model, namely, an operation

like *Verstehen*, which was meant by *its* advocates to set historical off from natural-scientific understanding. And second, the concept of a world is not one we would ordinarily invoke in the explanation of physical phenomena, so another philosophical notion that Hempel was especially anxious to confront and to deny seems to insinuate itself at the very heart of my analysis, namely that there after all does seem to be a natural distinction between the *Geisteswissenschaften*, which concern the explanation among other things of the behavior of philosophers, and the *Naturwissenschaften*, if the physical sciences should be their paradigm. And this runs counter at least to Hempel's ideas of unified science. Remember, I am talking about the World according to Hempel as indexed to 1942, when his paper on history was published. The various attacks against it did not seriously begin for perhaps another decade, since the kind of ordinary-language analysis which underlies some of the criticism of the covering-law model did not enter the mainstream of analytical philosophy until after the death of Wittgenstein and the ascendancy of Oxford philosophy in the 1950s. But worlds do not change especially rapidly: world-holders are by nature conservative. I am not certain I would know what to make of a person who changed his world every year, or every month.

In 1942 and for some while afterward, the ideal of a psychology modeled on what the positivists supposed physics was like would have been given in works like Egon Brunswick's "The Conceptual Framework of Psychology" (which was part of the *International Encyclopedia of Unified Science*), where the "principle of Extensionality" was the reigning ideal in analyzing psychological concepts, and where something like behaviorism would have been widely endorsed as best conforming to the verificationist criteria of respectable science, as that was construed by the positivists whose world in these respects was certainly shared by Hempel. It is in terms of such views as these in the World according to Logical Positivism that we would have to understand—would have to *interpret*—Hempel's resistance to change. The philosophy of psychology would today of course be greatly different from that subscribed to

in 1942, largely in consequence of a much deeper appreciation of the logic of propositional attitudes, which was very much over the horizon of the future when Hempel was working out his ideas on explanation. Even the sketchy way I have been developing the concept of worlds depends on discoveries in the concept of intentionality, which were hardly in place in 1942.

I shall now comment on the two points I proposed would account for Hempel's resistance. Needless to say, I am not saying he was wrong in resisting: I am after all adapting the covering-law model to Hempel's own case, to be sure elaborated with the support of the concept of worlds.

The idea of *Verstehen* is often connected with the idea of an "internal understanding," a taking of the agent's point of view, as if this required of the interpreter a vicarious act of sympathetic identification, a leap across the barriers of the self into the world of the other, with the outcome that one knows what it is like to be that person. We get an echo of this in Thomas Nagel's celebrated title "What's It Like to Be a Bat?" where it was Nagel's overall thought that there is something it is like to be something to which consciousness can be ascribed. Now, I think there are certain barriers to empathic leaps, and a sense in which no one will ever really know what it is like to live in the world of the bat the way a bat lives in it. But I do not think it especially important that we worry about these barriers. In part this is because not everything that belongs to $W(x)$ is necessarily accessible to, or forms part of the consciousness of, X. Nevertheless, there is something of very deep importance in the idea of *Verstehen*, and I have touched upon it so casually, so *en passant*, that it could easily have been missed, namely, that of a *point of view*. Analytical philosophers certainly invoke the idea of point of view in a nonpsychological way, as in Quine's title *From a Logical Point of View* or Kurt Baier's *The Moral Point of View*, where points of view define horizons of relevance, define what, though it may be true of a subject under investigation, is not relevant to that in the subject which is being investigated. I spoke in fact of "the agent's point of view," and here again, I think, this defines a horizon of relevance in the sense that certain things

may be true of the objects the agent has to deal with in making a decision which are not really relevant to the decision the agent has to make. I was one day looking at an exhibition of some works by the Italian *arte povere* master Mario Merz in the company of a German critic I know casually, who said she was uncertain that this was art. She went on to say that Mario Merz could certainly draw, and that he painted not badly, but *this*—and here she swept her hand grandly across to indicate the main objects being displayed in the Guggenheim Museum—*this* had no *aesthetic* quality at all. And my response, not particularly deep, spontaneously referred to the point of view from which it was not art, namely, that point of view from which it belongs essentially to art that it have aesthetic quality. That was in no sense *my* point of view, but it took very little by way of empathy for me to identify it as her point of view: I did not need vicariously to share it to know that it was hers. In fact it matters very little that I cannot imagine what it is like to have that point of view, what it is like to live in a world in which aesthetics defines what art is, as long as I can identify that point of view and describe that world when explaining someone's critical exclamations. That point of view defines my companion as a critic, and truly it identifies her as a person: "the aesthetic point of view" as criterial of art comes close, I think, to what Sartre might identify as her original project, the basic choice which defines the horizon of relevance for all the choices one is going to make in following through one's plan of life. She *was*, I all at once realized, that point of view. All the ways she surrounded herself with things and presented herself to the world and to herself radiated outward from that point of view. To change that point of view would be to shatter her world and to shatter her.

Very few philosophers have dealt with points of view as an ontological category and as constitutive of representational beings. In a sense, the monad, in Leibniz's system, is more or less a point of view and nothing more, and of course perspectivism in Nietzsche's metaphysics requires points of view as centers of power, each seeking to impose itself on blank passive reality. But in general, I think, points of view are crucial in the

explanation of behavior, especially when understood as action, and indeed I am not sure what behavior could be considered as an action that did not refer back to the horizon within which the decision of what to do arose for the agent, and with it the issues of relevance. But it is precisely with points of view that historical considerations enter explanation. Consider, for example, the point of view of the woman, which men in our culture are increasingly required to show sensitivity to, and which will be held different from the point of view of the man. The basic components of sexual bimorphism have been present immemorially in human beings, and the human genome has not changed in all that time. Is there a woman's point of view which has defined the perspective of women invariantly through, say, the past hundred thousand years? The likelihood is not: we have to index the point of view of women to specific times: 1992, 1942, 1802, 1492. The point of view of a woman in the postfeminist era is certain to differ in basic respects from the point of view of a woman in the prefeminist era; and postfeminist men are more sensitive to that point of view, whatever it is, than prefeminist men. History, in brief, defines the world available to us. Marxism insisted on the point of view of the proletariat, but envisioned a time when points of view definitive of class position would disappear. Points of view can be consistent with behaviorism, of course, which insists that all that is required to explain behavior is differing schedules of reinforcement. It is on the other hand insufficiently stressed that schedules of reinforcement themselves are historically indexed, though there is little doubt that Skinner allowed for historicism merely in virtue of his utopian point of view.

In any case, the World according to Hempel is more than a stratified set of beliefs: it is a point of view that defines a horizon. And explaining Hempel's non-change refers us to the point of view with regard to which the objections raised against his model of historical explanation were perceived by him as either irrelevant or uncompelling. This gets to be very close to what *Verstehen* itself prescribed as a method for the human sciences. Nothing could be more revealing, I think, than a comparison of the opening passages of volume 2, number 2, of the *International*

Encyclopedia of Unified Science, which was "The Structure of Scientific Revolutions," and of volume 2, number 7, which was Hempel's "Fundamentals of Concept Formation in the Empirical Sciences." Kuhn's words virtually embody what they are about:

> The essay that follows is the first full published report on a project originally conceived fifteen years ago. At that time I was a graduate student in theoretical physics within sight of the end of my dissertation. A fortunate involvement . . . my first exposure to the history of science . . . To my complete surprise . . . The result was a drastic shift in my career plans.

Hempel writes this way:

> Empirical science has two major objectives: to describe particular phenomena in the world of our experience, and to establish general principles by means of which they can be explained.

The point of view expressed in these two passages is respectively historical and conceptual or logical. What I have endeavored to do has been to force the latter into the former, and insist that we explain historically the position that historical explanation is itself a matter of logical analysis, to which history has no relevance whatever. In the passage cited, Hempel speaks timelessly, and states what he perceives as truths for any time and all times. And I have been asking what the *history* of that ahistorical outlook is, and have endeavored to think of it as indexed to a specific historical moment.

So much, for now, for *Verstehen*; now for the ascription of beliefs. This is an exercise of what philosophers, since Paul Churchland's truculent and celebrated essays, have come to class as folk psychology. Folk psychology is the theory that we explain one another's behavior relative to sets of belief (etc.), a theory that our survival as humans with humans very much depends on our capacity to master in a remarkably nuanced way. Churchland's view is that as a theory it is moribund, destined sooner

or later to be replaced with another theory in which we describe one another and ourselves only in the idioms of a neuroscience which admittedly is not yet in place. I have often argued against this view as follows. The new theory must be achieved by science. But science itself is a human activity described in precisely the terms it is supposed to outlaw, namely believing, observing, performing, testing, inferring, and the like—all categories of folk psychology. How is science to represent *itself* in the promised tongue of utopian neuroscience? Imagine trying to represent science when everything that belongs to science is taken way: it is in fact unimaginable, as is Churchland's proposal. Now, I think it true that Hempel would have found the Churchland proposal philosophically congenial, but he could hardly have supposed it possible to give an account of historical explanation in terms of it, for just the reason that the language of neuroscience (I am supposing) has no room in it for concepts like points of view, worlds, horizons, and the like, and certainly the laws of neurophysiology would hardly have ways for the kind of historical indexing we have had to introduce—for that would make it a strictly nonpredictive science. Who can predict the points of view of historical periods as yet unhappened? If one represents us in some timeless ahistorical idiom of neuroscience, there can at best be laws of a kind which depend on no historical differences, which are the same for every stage in the long history of the human genome. Once we think of ourselves as historically situated, folk psychology reemerges. Try to imagine what it would be like to explain Hempel's non-change in terms referring solely to synaptic discharges and neuronal impulses!

Now, it is true that each science wields predicates of a kind that cannot easily be defined in terms of the predicates of other sciences, though of course a unified science, which envisioned relationships of reduction between the predicates of the various sciences ultimately to those of physics, was a dream of the philosophy of science in Hempel's era. In "The Theoretician's Dilemma" Hempel expressed certain reservations on the possibility of reduction to a strictly observational base, but overall I imagine he thought of reduction as desirable and inevitable. I am

not certain what altogether he thought of psychology; at the very least, reduction to some sort of behavioral base was doubtless compassed within the horizon of desirability generated by his point of view. But it is less and less clear today that psychological predicates can be reduced in this way, and to the degree that this is so, something in the concept of unified science must give way. To refer to the World according to Hempel as a set of beliefs given unity through a consistent point of view is to bring into our description of this philosopher a dimension of intentionality, and it would have been among the axioms of positivism at the time when he was one of its great champions that the language of science is through and through *extensional*. But that means that science, even if its language is through and through extensional, would then have no way of representing itself, would have no way of housing in the universe something through and through intensional. What one might call the World of Science, if the positivists characterized it correctly, could not include science itself. Hence science in its nature would be incomplete or inadequate. Or better, science, construed in terms of a completely extensional language, would itself be addressable only through the resources of the *Geisteswissenschaften*, which alone allow themselves the conceptual resources to represent the kinds of things science does— observing, inferring, testing, and the like. In brief, the very things the positivists left outside defeat the enterprise of the *Geisteswissenschaften* of elaborating a unified science: and when we bring them in, and do so in such a way that science itself becomes something to be represented by science, the world of the positivist is burst asunder.

I want to conclude on a programmatic note. In various places I have discussed four types of causal episode which may figure in the histories of what I term *representational* beings, beings in the explanation of whose behavior the way they represent the world enters. Let R designate a representational state of an *ens representans*, and \bar{R} a nonrepresentational state. A belief is the standard exemplar of the former; perhaps the end-state of the Krebs cycle will serve as an exemplar of the latter. Then there are four kinds of episode: (1) RR, (2) R\bar{R}, (3) \bar{R}R, and (4) $\bar{R}\bar{R}$. There are

necessarily then four different kinds of law, if indeed laws are entailed by causal explanation. These would be: (1) psycho-psychic laws, (2) psycho-physical laws, (3) physico-psychic laws, and (4) physico-physical laws, which are the laws of the physical sciences. I can do no more than mention these here, but examples of the four types of episode would be (1) believing that someone loves me because I read a letter in which she said she loves me and I believe the letter genuine; (2) believing I see a snake, which causes me to shudder involuntarily; (3) hearing the door open, which causes me to fear that someone has broken into the house; and (4) undergoing a drop in blood sugar, which causes me to faint. In the psycho-psychic and the psycho-physical cases, at least, we may appeal to laws only against the background of the worlds of the individuals, which is to say: against the bodies of belief, unified under points of view, of the individuals under explanation. In physico-physical laws we do not need these background considerations—or we need only the background of the way *the* world is made: not W(x) or W(y) but W, the world to which perhaps Wittgenstein's *Tractatus* refers. Of course, *the* world contains among other things the individuals X and Y, each with his or her own world.

All this is perhaps ontological boiler-plate. I want to talk about a special kind of episode, one in which someone's world changes. I have illustrated in fact two kinds of case already, one in which, according at least to his testimony, Kuhn's world changed, and one in which, as judged by the constancy with which he adhered to his account of historical explanation, Hempel's world did not change. The World according to Hempel, from 1942 until at least 1964, is pretty much the same world, in that Hempel's point of view did not change in any basic way through that interval. It was very much as though there were no "impinging force" to knock Hempel off his philosophical tracks. A number of his beliefs of course changed in that time without this entailing that his *world* changed. But the World according to Kuhn in 1962 was a very different world indeed from his world, reckoning back fifteen years, of 1947, just because of the transformation in his basic point of view about science and

its history. His world was different, though of course many of his beliefs were the same. In effect, he describes what caused him to exchange one world for another by virtue of changing his fundamental point of view— or changing a point of view that turned out to be fundamental. What makes Kuhn's work *historically* important is the fact that a good many thinkers, whose worlds very largely overlapped Hempel's at crucial points, were caused by Kuhn's work to turn into thinkers whose world overlapped Kuhn's world instead. It was very painful for many of them to undergo this change, and I can remember one of them saying with a cry of anguish that he wished Kuhn had never written that damned book. My colleague the medievalist James Walsh quoted a sixteenth-century scholastic who said, in much the same spirit, that "the wretched Luther had emptied the lecture halls." For a long period there were questions with which scholastic thinkers dealt and which everyone who shared their world regarded as of the greatest moment. And then, all at once, almost overnight, nobody cared any longer. The issues stopped being what the rebel students of 1968 were correct to call "relevant." I recall people saying (it may have been J. L. Austin who phrased it so), "Relevance isn't relevant; truth is." They were wrong. The point of bringing the apparatus of worlds, horizons, and points of view into the discussion is to underscore the relevance of relevance. Hempel's theory in fact strikes me still as true. It just stopped being relevant, the way the whole philosophy of history it defined stopped being relevant. It was replaced with a different set of questions, a world, in effect, into which it no longer fit. As with the questions of scholasticism which were never answered but merely abandoned, it belongs to the history of philosophy to summon up enough of the world of 1942 philosophy to see what Hempel's theory meant.

I would think that when worlds in this way give way to other worlds through changes in shared points of view, we may mark moments that define the end and beginning of historical periods. Kuhn opened a new period in the history of thought, and definitely a new one in the philosophy of science. In the earlier period it was of some importance to show

the continuity between history and science, which Hempel did; in the later period the historical nature of science was so taken for granted that the earlier question lost its urgency. Hempel, of course, lived on into the new period, but he was not *of* that period. He belonged to a fading philosophical culture, one that those who acquired their worlds in the new period required special instruction to understand, as much so as they would with scholasticism. Kuhn's theory of paradigm shifts beautifully accounts for itself, since that is just what it itself was. A lot, of course, goes unaffected by the change, and there are many beliefs invariant to the two worlds—beliefs that do not change when the worlds change. It is because of this that discussion between worlds remains possible, but there remains the fact that the discussion between Hempel and his critics, who largely shared a world, differs markedly from the discussion between either of them and someone from the world generated by *The Structure of Scientific Revolutions*.

In any case, since points of view are essential to worlds *of* individuals but have no place in the natural sciences (henceforward defined by that fact), historical explanation—dealing as it must with points of view—will be different from explanations in the natural sciences, not in the sense that the latter entail covering laws and the former do not, but in the kinds of law they respectively entail. But I as yet have too shallow a philosophical understanding of points of view to go further than this here. What I can say is that since points of view are historically indexed, since, that is, the worlds of historical beings are penetrated by their historical locations, the *new* philosophy of history is in effect a new understanding of ourselves as through and through historical.

NOTES

1. Rex Martin, *Historical Explanation: Reenactment and Practical Inference* (Ithaca: Cornell University Press, 1977).

2. William Craig, "Replacement of Auxiliary Expressions," *Philosophical Review* 65 (1956): 38–55.

10

The Body/Body Problem

IT HAS SOMETIMES HAPPENED in the history of thought that what appeared at a given time to be an ineradicable distinction of the utmost philosophical moment proved to be indexed to a certain stage of scientific understanding and did not interestingly survive into the next stage. One wonders, therefore, if the distinction between the physical and the mental today might not be in something like the situation in which the distinction between the organic and the inorganic was in the early nineteenth century. This is to ask whether a position to the effect that the mental is irreducibly different from the physical, which even certain materialists are disposed to accept, is bound to succumb to the sorts of discoveries that made it no longer worth holding that the organic and the inorganic were irreducibly different, and hence that Vitalism, as it was called, was really not a philosophy seriously to be held. We do not have a name quite like Vitalism for the corresponding theory in the philosophy of mind today, but perhaps Psychological Irreducibilism will serve in an ugly, makeshift way to identify a position the word Dualism is too historically charged, too freighted with a metaphysics of

This previously unpublished essay is based on a University Lecture delivered at Columbia University in 1988.

substance and an outmoded problematics of interaction, to identify with sufficient neutrality. So the question is whether anything might do to Psychological Irreducibilism what chemistry did to Vitalism a century and a half ago.[1]

I of course refer to the stunning contribution of Friedrich Wöhler in 1828, who synthesized what everyone would have counted an organic substance—urea—from what everyone would have counted inorganic substances—ammonia and cyanic acid. Vitalism as a philosophical position goes back to Aristotle, and it continued in modified forms down through Bergson and Teilhard de Chardin, but after Wöhler synthesized a substance up to then regarded as the end-product of the metabolism of proteins in all mammals and most fishes, the division between organic and inorganic, however grounded in the common view of things, joined the distinction between terrestrial and celestial as in the end of no great relevance to the deep partitions of the universe—if there are any deep partitions. No distinction in its time could have been more fundamental than that between the earthly and the heavenly, but the discovery of sunspots damaged the contrast on the basis of presumed celestial immaculateness, and the discovery that planets moved in unedifying ellipses blunted any expectation of an invidious moral geometry. I want to raise the question, then, of whether there is anything on the scientific horizon that might serve to dissolve a distinction that still animates philosophical discussion as the discoveries of Wöhler, or Galileo and Kepler, dissolved those predecessor distinctions perhaps as intensely mooted in their day.

It is supposed by many that the Turing machine, construed as a mechanical computational device, might serve the end of metaphysical erasure, providing that computation should be reckoned as uncontroversially mental as urea was conceded to be organic. The Turing machine arose as a vivid imaginative by-product of a certain problem in logic, the so-called Decision Problem, which was to identify algorithms that would decide mechanically, in a finite number of steps, however large, that a certain formula was tautologous or provable. Turing had the

inspired thought that if something could be done mechanically, it could be done by a machine. He then proceeded to characterize what sort of machine would be needed to complete such tasks. The Turing machine has a tape as part of its anatomy (which of course yields a powerful metaphor in its own right, that the mind is a tape). The tape is divided into a finite number of squares, and these will be occupied by symbols— o and 1—one to a square. Beyond this, the machine has a monitor, or reading device, which "observes" the content of the square before it. It has, moreover, a program, or set of instructions, which tells it what to do under all relevant circumstances: it replaces one symbol with another, it moves one square to the right or to the left, or it stops. The symbol inscribed in the square at which the machine stops is the value of the function to have been computed, if instructions have been followed. Turing's mathematical achievement was to write out the instructions for the computation to be effected, but I draw attention to the fact that the machine "observes," "understands," that it "executes orders." However, observation, understanding, and action are themselves psychological operations. Does each of them fall under the concept of computation? If so, a separate Turing machine will be needed for each of the separate things a Turing machine does, and since each requires a monitor, there will be an immediate infinite regression—and so the Turing machine is impossible. It follows that more than computational accounts of mental process are needed if we really are Turing machines, since observation, understanding, and action are presupposed in the drudging labor of computing functions. Still, it was philosophically exciting to infer from the possibility that since computation, a mental operation, is physically embodied, the mental/physical duality must succumb the way the organic/ inorganic duality did under Wöhler's achievement.

Neither Turing, nor anyone taken by the idea of mechanical compu-tation, paid great attention to the other components of the machine. Nor did he, so far as I know, show that mental operations in general are computational. There is a certain distance to be covered if we are to think of machines as capable of hermeneutical analysis of obscure

literary texts. But Turing had a robust optimism that the gap could be closed, and that machines would be designed whose output would be indistinguishable from our own in our highest mental performances. And he invented a scenario in which it would be unreasonable to deny that machines think if indeed their outputs could not be distinguished from our own. This was his Guessing Game. A set of answers to questions is elicited from a veiled source. The answers are clever enough that it would be mere prejudice to withhold attributing intelligence to the source when, the veil lifted, a machine is revealed, since we would unhesitatingly have attributed intelligence were the source a human being—a professor of English, let us imagine, since the questions required literary interpretation. I don't think Turing was bent on reducing us to machines; rather, he wanted to show that machines could be as capable as we are in our highest intellectual performances. In the process, however, Turing passed from the domain of programming a task in logic to a very familiar exercise in the theory of meaning.

Turing's proposal has the instant form of every philosophical problem, which is to imagine pairs of things on either side of a line between which no outward difference may be detected, thus forcing a decision as to whether there is after all a line, or on what basis it is drawn, since what is found on either side of it cannot be told apart. Consider some cases: Descartes imagined a dream sufficiently vivid that when in it no difference in the quality of experience could be made out that would be any different were he awake. A mystic might respond by saying there then is no difference, but Descartes insisted there was one, only it could not be located where we would ordinarily think to locate it. Kant imagines a case in which something done for moral reasons is indiscernible from something which merely conforms to them, leaving the option that there is no difference, or that if there is one, it is not to be identified from behavior alone. Duchamp exhibits works of art not to be told apart from mere objects such as snow shovels and bottle racks, leading some to say that anything can be a work of art and others to say only that the differences are not such as meet the eye. Hume encourages us to imagine two

universes, one deterministic and the other aleatory, so that matches light when struck as a matter of necessity in the one and simply light when struck as a matter of chance in the other. Hume would have insisted that as we have nothing to go on in either case besides noticed regularities, there is no difference between the universes. This was largely the route followed by Turing: if there are no observable differences, there is no real distinction. And something like this must have been implicit in Wöhler's achievement as well: if there is no telling between two samples of urea whether the end-product is one of metabolism and hence organic, or the synthesis of inorganic chemicals and hence not organic, then the distinction between organic and inorganic is not metaphysically deep, however important to us the difference between lifelessness and life remains. Descartes, Kant, and Duchamp go in one direction, Hume, Turing, and Wöhler in the other, and there is an initial question of what makes the differences, since it is not difficult to imagine thinkers who respond as the first trio did to the set of examples that encouraged the second trio of thinkers to say there is no difference. After all, Vitalism did continue to attract enthusiasts after Wöhler.

The somewhat disappointing answer is that the members of either trio implicitly subscribe to different theories of meaning. It is disappointing in part because it mutes the shining possibility that philosophical problems are neatly indexed to scientific discoveries if we must after all arbitrate theories of meaning in order to profit from them. One trio is loosely committed to some version of Verificationism, namely that a term or expression is meaningless where there are no procedures in experience for verifying whether it applies, and that its meaning just is those procedures, and that terms are synonymous if their verificatory procedures are the same. How except with reference to observing its behavior could we tell whether something was intelligent, Turing rhetorically demands, going on to ask implicitly what "intelligence" could mean apart from such observation.

The difficulty, in the case at least of psychological concepts, or many of them, is that we can put ourselves behind the veil and determine

whether or not a psychological term applies to us quite apart from observing our own behavior. An imaginative example was constructed by John Searle in what has come to be called the Chinese Room. There are two slots in a wall, IN and OUT. Scraps of paper, marked with Chinese characters, are slipped through the first. Searle is equipped with some instructions, which send him to push through the latter other scraps of paper marked with Chinese characters. Searle monitors the inscriptions, follows a program, performs the action of producing scraps of paper. In effect, he behaves like a Turing machine. To someone outside, clever answers are being given—in Chinese—to questions posed in Chinese. And to someone who knows Chinese, it must appear that whoever or whatever produced the outputs understands Chinese—is, so to say, a native speaker. Well, Searle insists, it may look that way, but he knows better. He knows that the characters are unintelligible to him, that he is like Milton's daughters reading Greek or Hebrew to their blind father without any understanding of what the noises they produce mean. Searle knows only how to collate oddly patterned inscriptions—"squiggles" and "squoggles," as he disarmingly describes them—he cannot identify even as meaningful. His point is that if he does not understand, neither does a machine understand, even if its output simulates that of someone who does. So much for indiscriminability of output; so much for Verificationism that restricts itself to that; so much for the claim to have erased the boundary between machines and humans. If the Turing machine is to understand, it has to know what its instructions mean, even if what happens on the tape complies, as in Kant's example, with what might be called computation if that proceeded from understanding. But could a machine understand anything at all? Does my computer understand philosophy, even if it produces sequential sentences in philosophical arguments? The question may be open, but indiscernibility of output will not settle it one or the other way.

Searle tenders no positive theory as to how such expressions as "understands Chinese" are themselves to be understood, but he resists the proposal that they can be defined merely in terms of the outputs and

inputs of his example. Verificationism will insist that "understanding Chinese" is entirely a matter of input and output, but Searle and we know that there is something more to understanding, that the output reflects understanding when and only when the input is understood. We can, I suppose, imagine a split-brain case in which someone sincerely claims not to understand a word said to him when, with the other part of his brain, he gives clear evidence of understanding by answering questions put to him. What should we believe in such a case—the testimony or the conduct? I think Searle might answer that precisely what we would all mean by understanding must occur in the half of the brain that responds appropriately, even if the other half of the brain is screened off from the fact that understanding has taken place. One is still not obliged to concede that all there is to understanding is making the output appropriate to the input—that something beyond the pattern recognitions of a programmed recognition device takes place. And this further something is: understanding what the characters mean.

At this point an Eliminativist might join forces with Searle by setting aside the Turing test as well as the theory of meaning through which it was to settle matters concerning the ascription of psychological states to machines. The real problem, in fact, is to understand what it is that is *not* taking place in the brain when it is true that we do not understand a set of marks, and hence what takes place when we do understand such marks. This "something" is some procedure in the brain: call it Procedure U, about which we so far know relatively little. There have been two proposals concerning psychological terms like "understands." One is to say that instead of using the term "understand," we can use the term "Procedure U," the way we can speak of the firing of C-fibers in place of using the term "pain." We could describe ourselves this way entirely in the language of Neurophysiologese. "At no greater cost than linguistic reform, we could drop mentalistic terms from our vocabulary," writes a leading Eliminativist, on grounds that "what we call sensations are nothing but brain processes." One might concede this possibility, but only by recognizing that the relationship between understanding and

Procedure U has to have been *discovered*, in much the same way it has to have been discovered that the Morning Star is one with the Evening Star, to use Frege's famous example. If, after the discovery, we choose to refer to the Morning Star as the Evening Star, we may. But then we cannot state the discovery on the basis of which we talk this way, since no one can *discover* that the Evening Star is the Evening Star! So all that would have been achieved is a certain kind of scientistic jargon, of the kind spoken by the pedants Molière mocked who speak medicalese.

A more radical move would be to disallow the possibility of such discoveries by recognizing that terms like "understanding" belong to an outmoded system of representing ourselves and that the system as a whole will be replaced with a (now) visionary mode of representation, framed entirely in Neurophysiologese. Turing, on this view, sought to confer scientific dignity on psychological terminology by translating it into observational language, when the correct move ought to have been to seek its total elimination. Phlogiston, to use a favorite example, was closely connected to laboratory procedures, and explained, or seemed to explain, a great many phenomena of combustibility. But the entire theory in which phlogiston played a central role was eliminated through the work of Lavoisier, and left not a wrack behind in the scientific representations of the world that followed. It is not as though the gap between phlogisticated and dephlogisticated air was erased. Rather, the entire theory went up in the kind of smoke that awaits our representations of the world which use psychological terms. There will on this view come a time when the controversy between Searle and Turing cannot be rendered intelligible. There will still be a difference between machines and us, but it will be expressed in the idiom of silicon and protein.

I am intent on arguing that this radical and eliminative theory is not so much false as strictly unthinkable. It is in hostage to certain features of precisely that which is to effect the transformation to a new era in which that stubbornly perplexing cluster of questions that define the distinction between the mental and the physical cannot so much as be expressed—features, namely, of science itself. That is to say, we cannot

think of science without using just those terms the further sweep of science will eliminate: and so their scientific elimination is unthinkable. But that means that while we may indeed discover what takes place neurophysiologically when we understand (or believe or feel or desire), the distinction between understanding and (say) Procedure U will survive these discoveries; and hence that unlike the distinction between organic and inorganic, the distinction between psychological and physical properties is not indexed to a given state of scientific inquiry.

Such an argument has an unmistakable Cartesian flavor, in that it undertakes to impose on reality what in effect are boundaries of thought. It is therefore perhaps appropriate that I begin by canvassing the challenged distinctions as framed by him to whom we owe at least one form in which we standardly consider them. Descartes is commonly thought to have supposed true a version of Psychological Irreducibilism which depends upon a dualism of minds and bodies. In fact, I shall show, it depends instead upon a distinction between two sorts of bodies, which I think very deep indeed, and which I want to say we cannot think of as ever being overcome by science. Whether that makes it a deep partition of the universe, or only one we are required to accept because we are required to think the way we do, is beyond my competence to answer because of the way we are made, which may make it a meaningless question or simply a question that defines an ultimate boundary of thought.

The *Meditations* of Descartes is a canonical text of my discipline, and a book I think I know better than any book written, but I discover mysteries whenever I readdress myself to its less familiar passages, which have to put the familiar ones in an unfamiliar light, as though they too were mysteries after all. In the preface, for example, where he is replying to certain objections raised against the *Discourse on Method*, published four years previously, in 1637, Descartes considers an objection that it does not follow from the fact that the mind knows itself as a thinking thing, that its nature or essence is only to think. Here he says: "I shall show further on how it follows from the fact that I know nothing else to

belong to my essence that nothing else really does belong to it." Now, everyone will allow an inference from "I know that p" to p—you cannot know what is not the case has been uncontested since Parmenides, so it must be the case if you know it to be. Since I can know negative propositions, it equally follows from my knowing not-p that not-p is the case. But very few would be prepared to follow this extraordinary claim of Descartes that if I do not know it, then it is not the case. And of course Descartes would not have subscribed to it in any general form, contending, for example, that since we did not know that Fermat's Last Theorem had a proof, then it had none. But he supposed it is a peculiar property of the self, as a thinking thing, that everything true of it is known to itself, that nothing belongs essentially to the self which is hidden, cognitively, from that self: that the self is a pure transparency. There doubtless are things true of one's body of which one is ignorant—that one has a disease not yet discovered, for instance—but that only proves the body not to be a part of the self. And there are things true of other selves which I do not know, but they could not be hidden from the selves of which they are true if instantaneous self-cognition defines what it is to be a self.

Whatever the case, the limits of what I know about myself are the limits of the self, and if there are things true of me that I do not know, they do not belong to my essence. In the Synopsis of his *Meditations*, Descartes tells us that the concept of the mind is clearly and distinctly separate from the concept of the body, hence the mind itself must be clearly and distinctly separate from the body, on the grounds advanced by Hume a century or so later that "whatever is distinguishable is distinct." This, Descartes says in this very context, "is the first and principal thing required in order to recognize the immortality of the soul." Indeed, along with the existence of God, to which two meditations are devoted, the immortality of the soul "is the most certain and evident truth which can be known to the human mind." These extraordinary claims give us, I think, a fundamental insight into Descartes's motives. We can see why he is genuinely anxious to show the dubitability of such things as that "there is a world, men have bodies, and the like"—things

it would not ordinarily occur to sensible persons to doubt, things which, if someone were in fact to doubt them, would thereby forfeit their status as sensible, but which even so "are not as firm and evident as those which lead us to our knowledge of God and the soul." So the first famous meditation in which everything is darkened by the shadow of doubt is really a strategic move by someone anxious that doubt be cast on matters ordinarily regarded as certain beyond sane question, in order to abort a spontaneous contrast between them and matters ordinarily construed as abstruse, as items of mere faith and orthodoxy, like our immortality and the existence of a perfect being, which in fact, he contends, are luminously secure. There is no motive to restore the world, not that Descartes had any doubts about its being there or doubts about what some of its main properties are—after all, he thought his reputation was to rest on his scientific discoveries.

So much, more or less, is familiar. But then Descartes goes on to say that "though the mind or soul of man is really distinct from the body," it is "nevertheless so tightly bound up and united with it that it forms with what is almost a single entity." It is this "almost" that keeps us tossing sleeplessly in our beds, since it means we cannot be represented as a simple conjunction of body and soul. Body and soul can be separated clearly in thought, but when they are together they copenetrate completely, or "almost" completely, and so do not reside within the same circumference as mere metaphysical neighbors. In the Sixth Meditation, Descartes tells us that the mind is not in the body the way a pilot is in a ship, where this is just the way we would have supposed it was in the body if it is as clearly and distinctly separate from it as we had been told: the pilot leaves the ship when the voyage is done and is folded in his beloved's arms, as we leave our body behind when the voyage of life is completed and come home to our Maker. So how are we to represent the complex relationship of "being tightly bound and united"?

Descartes uses the theory of knowledge as a surgical instrument throughout his philosophy, and inevitably he does so here in speaking of myself and my body as "something like a single whole." When my body

is wounded, I feel pain, but when the ship is stove, "the pilot perceives by sight that something is broken." If my body were but my ship, "I would not feel pain, I who am only a thinking thing; but I would perceive that the body is wounded by the understanding alone, as a pilot." In brief, pilots know what is true of their ships by inference from evidence and observation, whereas we know certain things at least about what takes place in our bodies noninferentially and directly. Had the pilot not observed certain things he would not have known them, whereas the corresponding knowledge I have of my body is had without observation, and if it is true I know it to be true. *But this is to claim just that sort of knowledge of my body that was supposed to define my relationship to my mind:* so I am as tightly bound and united to my body as to myself. Descartes is entitled to another consideration he does not make explicit, though he could have done so. A pilot turns the ship by turning the wheel, but if I moved my arm by, as it were, doing something else, the question would arise as to how I turned that wheel, and the ensuant infinite regression recommends the view that the movement of the arm, by contrast with the movement of a ship, is a direct or basic action. Immediacy of cognition and directness of action may come as close as we are likely to get to Descartes's conception of a single entity compounded of mind and body in, to use his further expression, "union and apparent fusion." It is as though the mind existed in the medium of flesh and, thus embodied, confers upon the flesh properties that are, strictly speaking, mental. When I know about my body nothing but things of the sort a pilot knows about his ship, then I am in effect dead, my body having receded from me as a mere object of cognition which I know, as it were, *outre-tombe*.

In the *Second Anniversarie*, Donne writes of Elizabeth Drury—upon whom, as it happens, he has never set eyes—as follows:

> We understood
> her by her sight, her pure and eloquent blood
> Spoke in her cheeks, and so distinctly wrought
> that one might almost say, her body thought.

Once more a maddening "almost," though it is clear that Donne is paying this young woman a supreme metaphysical compliment in treating her flesh, that substance of corruption, as if it is as transparent as her immortal soul. We can know her as she knows herself, whereas in creatures less pure the flesh is opaque. It sounds as though she has a glass body—a striking thought in context, since Descartes segregates himself explicitly from those who think their bodies are glass, which must have been a paradigm of insanity in his time. To suppose Elizabeth Drury's thoughts as transparent to me denies the boundary between myself and her—what we might expect a mere complimenting poet to say—but Descartes has no difficulty with "her body thought." "Feelings of hunger, thirst, pain, and so on are nothing else but certain confused modes of thinking," he writes, collapsing the distinction he is credited with having made absolute. And yet it is clear that a great deal takes place in my body that I know about only through "the understanding," hence as a pilot knows his ship. Otherwise there would be nothing for Descartes to have discovered about the body, no point in those smelly and disagreeable dissections. It is as though ("almost") the older boundary thought to separate soul from body reappears as a boundary which separates that in one's body which presents, as it were, a face to its owner, and the part which does not. In the event of immortality, the self may divide along this fault, carrying with it to heaven or to hell those portions of itself with which it is one, bodily immortality having always been a Christian option, and the devils in hell needing something to pinch and burn.

Descartes has three concepts of body in all. One is of the body simply as something that occupies space—as extendedness: extension belongs to its essence as thought belongs to our essence. Then there is the body with which we are "tightly bound and united." This conception of the body allows us to think of the mind as extended and the body as thinking, but not as a matter of their essences, since the body ceases at least as thought at death. This leaves the body as a physiological system we are not bound to under direct knowledge and action, but by which we are

nevertheless affected by contrast to the remaining bodies of the world. In any case, the mind/body problem is solved by the recognition that, as embodied—or, if you prefer, as enminded—the body has just the attributes the mind has, so the mind/body relationship is just the mind/mind relationship. The real problem is the body/body relationship, that between the minded body and the mindless one, to which I am, to which we each are, bound certainly and united but not, perhaps, *tightly* bound and united. Descartes's model, in any case, is remarkably different from that attributed to him a generation ago by Gilbert Ryle in the spirit of metaphysical caricature, as of a ghost in a machine. The mind, construed as embodied—as *enfleshed*—might perhaps stand to the body as a statue does to the bronze that is its material cause, or as a picture stands to the pigment it gives form to—or as signified stands to signifier, in the idiom of Saussure. And to the degree that "inside" and "outside" have application at all, it is the mind that is outside, in the sense that it is what is presented to the world. But in fact the structure of geometrical relationships ought to be dropped altogether, as leading us into disfiguring metaphors, and the connection between the two bodies addressed in the spirit of awaiting a model rather than beginning with one.

The boundary between the body that is me and the body that is merely mine varies somewhat across the species, in the sense that some have immediate cognitive and performative powers that others lack. The variations can be trivial, as when someone is able to wiggle his ears, or tragic, as when someone cannot move his legs—or comical, as with males who lack the gift, as most do, to make the penis go erect or soft at will. And it is plain that the domains of performative and cognitive powers do not perfectly coincide, as there are things we may do directly without our being conscious of doing so. Nevertheless, of the body with which the self forms "a single entity," the body that thinks in the accommodating sense to which Descartes gives expression in the Sixth Meditation, we probably know very little the Greeks did not know. The body so construed is close philosophical kin to what the Phenomenologists

call the lived body: it is the lived body that enters into the basic human enterprises of working, fighting, and love, and it is made of those gerrymandered bodily parts of which we may be proud or through which we may be humiliated, and on whose effortless functioning we count—legs, arms, eyes, mouth, genitals, breasts. It is the body as we see it represented on Grecian vases, in conduct we understand as we understand the body in most artistic representations of it, however exotic the traditions these come from. We perform, mainly, the sorts of actions and have the kinds of thoughts and feelings the Greeks share with us: the body is the emblem of our common humanity. And, as with Elizabeth Drury, we read one another's thoughts through the dispositions of our bodies, eked out with a few props—shovels, swords, books, garments, musical instruments. When Wittgenstein wrote that the human body is the best picture of the human soul, it would have been the lived body that he meant. Of the self as something detached from the body, Descartes argued, as Berkeley would argue after him, there can be no picture, on the dubious grounds that he can deny the existence of any body whatever, his own included, but he cannot coherently deny his own existence. The disembodied self, the ego, cannot thus be spatially extended, which is the condition of picturability. So we peer at our mirror images, or indeed our portraits, wondering if that is really us. In any case, as "united and tightly bound" with the body, the body is less a picture of the soul than the soul itself in the medium of flesh, so a picture of the body is a picture of the soul. And because the body itself can have changed but little since ancient times, the picture of the human soul can have changed little, if at all, in this period.

Of the body as an object or thing, of course, we know vastly more than the Greeks knew or could have known, and our beliefs about it are in continual transformation, as are our beliefs about the world itself, of which the body as object is a part. This happens, for example, through the fact that models of it become available based on technologies the Greeks did not possess. Jonathan Miller observes that there could have been no understanding of the heart until the pump was invented, though

the heart itself was something people knew about.¹ The Aztecs knew enough to have crazy ideas about the heart when they did not even have the wheel. Aristotle supposed the heart a kind of furnace, imagining that blood was extracted from food by the liver, and the furnace itself heated animal spirits, which rose like steam through the arteries. The known pulsations of the heart were explained as due to animal spirits expanding, and it was doubted until the sixteenth century that the heart was a muscle. But the pump allowed a metaphor in the etymological sense that something was carried over from technology to anatomy, a structural hypothesis that subsided into fact, making it no longer a figure of speech to say that the heart is a pump.

It may be argued that we are at that stage in our understanding of the brain which consists in projecting metaphors from technologies as they evolve. Descartes supposed an analogy between the operations of the brain and hydraulic mechanisms that operated figures in the royal gardens. "We have since," Karl Lashley wrote, "had telephone theories, electric field theories, theories based upon computing machines and automatic rudders." His views of science were retrograde as against his powers as a scientist, and he continued, conservatively, to say: "We are more likely to find out how the brain works by studying the brain itself than in indulging in far-fetched physical analogies." But as the heart could not have been understood without a metaphor, how might the brain be? Is the computer the best picture we have of the human brain, given that the human brain does not give the best picture of the human soul? Keith Oatley argues that it does not give a good picture because neurons don't operate digitally, like switches, but "traffic in some form of pulse interval modulation coding an analogue representation." A few years ago, parallel distributed processing, which linked computers into networks, seemed to promise some insight into our own "computing machinery" (the expression is Turing's) but as individual computers attained enhanced speed through several generations of computer chips, the model of computers executing the programs in parallel began to appear cumbersome. At the moment it seems increasingly clear that the

differences between computers and brains are pretty considerable—the brain does not seem to work serially at all—so that an experiment of the sort envisioned by Turing is more a fairy tale than a technical possibility, more like asking what we would do were we to encounter a talking radish, since there seems no likelihood that computers as presently understood will be able to behave in a manner indiscriminable from human behavior. So it may be that the metaphor "the brain is a computer" will go the way of Descartes's hydraulic model. "It is an interesting fact," write Laughlin and d'Aquili, "that in the history of neurological sciences, the brain has been likened to the most complex technology available at the time." There may in time be developed nonserial information processors modeled on the way the brain itself works, as this becomes understood. All I am competent to insist upon at this point, however, is that we cannot now predict what the neurosciences of the future may be like, if only because we cannot predict the complex technologies the sciences of the future will draw upon for brain metaphors.

But how different are we to suppose the lived body will be thought of a hundred years hence? How difficult will it be to understand the novels of the future, supposing we were to survive into that period? Read Aristotle on the liver, the blood, the heart, and we must recognize that he is hopelessly dated and deeply wrong. But read him on the emotions, as in the great second book of the *Rhetoric*, and one sees oneself portrayed as one would portray oneself. There is an undeniable truth in Heidegger's observation that on the topic of the emotions not a step has been taken beyond Aristotle in two thousand years. Heidegger certainly did not take the next step, and this may be because there is no place to set a foot: the entire phenomenon has been charted, and the chart is not going to change until the subject changes. It is almost as though there were a confirmation here of Descartes's thought that if it is not known, it is not part of the mind: that whatever is true of the self is known to be true. The fundamental things apply as time goes by. That is one way to interpret Heidegger's remark, amounting to the claim that in all essential details human psychology is a finished theory.

There is another interpretation, however, already touched upon, which is that psychology is merely a stagnant theory. A science, or method if we think of it as such, in which not a single step has been taken for two millennia is scarcely on a breakneck course, but we ought not to congratulate ourselves on having achieved a piece of knowledge in which the competence of the learned is not much greater, if greater at all, than that of the ordinary man and woman who explain one another's behavior with reference to such concepts as anger and pride, resentment and prejudice, desire and illusion, jealousy and despair—with reference to what we want and how we believe. And this brings me to the eliminative strategy that haunts contemporary discussion, according to which the entirety of folk psychology, as it is abusively called, must give way to another kind of theory altogether, one based upon the findings of a future neurophysiology, one the details of which, for reasons just suggested, cannot be known. With this replacement must come an erasure of the boundaries between the body as lived and the body, knowledge of which may be expected to be revolutionized. Folk psychology will wither away when the human being is represented exclusively through the idiom of a future neurophysiology, which, destined to be as outmoded as Aristotle's, will have no place for its divisions and distinctions. This means that the body that is me will itself wither as a concept, to be replaced with the body that is mine—or with the body as such, as a complex electro-chemical-mechanical system, the possessive pronoun dropping out of discourse entirely, as there is no "self" left to own it. This is so total an abandonment of the language with which we describe thinking bodies—like Elizabeth Drury's and yours and mine—that Aristotle and Homer, if it should prevail, will be as meaningless to us as Chinese logograms to Searle.

This is abstractly entertainable if we think, for example, of the way the biblical view of the world, with angels and miracles and the wrath of God and original sin, has faded from the explanatory schemes of many of us. But I do not believe it actually thinkable, since it bases itself on the future of science—and science belongs to that dimension of ourselves we

share with the Greeks. A lot of Greek science is somewhat strange: think of Aristotle on the heart, the arteries, the animal spirits. But we have no difficulty in recognizing it as science—as an attempt to explain physiology in ways that make sense. Beliefs about the body as object will evolve and evolve, but the fact that they are beliefs means that they belong to the embodied self, along with the other human attributes the tragedians presented to their audience with the full expectation that it would see itself portrayed in the characters represented. Aristotle sought to represent the rational formation of our representations in ways that remain as valid as his representations of the emotions. Almost certainly, future representations of the body as object will differ as much from present ones as the latter differ from how the Greeks saw the body as object. And indeed, the scientists of the future may discover with what neuroprocesses that which transpires in the embodied self can be identified. So possibly science will discover what must be true of the body as object for those very scientific beliefs to be formed. What will be discovered will still be that which we know as scientific activity and which we recognize in the ancients when they did science, although the content of ancient beliefs about the body as object will differ from the future beliefs on which the Eliminativist banks. How could it not?

What future science will be like is something about which we can say a great deal, even if we can but guess at contents, which may depend on metaphors drawn from technologies as yet uninvented. Science is a representing activity, and if it is to be science at all, it must present a certain representation of the world its practitioners test against the world. Those future neurophysiocists will, because they are scientists, be doing what scientists today do: performing experiments, the outcomes of which can be negative; drawing inferences from whatever outcomes they do arrive at; arriving at conclusions on the basis of these inferences—and all of this presupposes representational structures we cannot describe without the resources of folk psychology. So the psychological content expunged from their theories will be needed to represent the fact that they are theories, responsibly held. To say that science in the future will

be none of this is to raise the question of the sense in which it will be science. So even if the scientists of the distant tomorrow represent themselves in the constrained idiom of neurophysiology, they will still have to be representing themselves that way—and representation is a category of folk psychology. So we truly are entitled to the kind of Cartesian argument I suggested we were: since any picture of ourselves that does not take into consideration the fact that it is a picture will be false, picturing, or representation, belongs to our essence. We are *ens representans*, however inadequately we otherwise represent ourselves.

It is characteristic that Eliminativism, in focusing on the contents of scientific representations, should have forgotten to leave a place in the world for science itself, as though it were without ontological weight. And this, I think, is because science is rarely part of its own subject matter. Hence the language we would need to describe scientific discourse itself is rarely part of that discourse, addressed as it is, typically, to nondiscursive things. The most basic of sciences—physics—has no room in its vocabulary for recording the fact that it is a vocabulary and that it represents the world or tries to through an exiguous lexicon. If physics gave the full measure of what there is, there would be no representations, since physics does not countenance them—and so there would be no physics, which is after all a representational activity. A theory that cannot account for itself, as a theory, is incomplete; a theory that, if true, would make itself impossible is incoherent. For me, science has to be housed somewhere in the world, and a complete representation of the world must show where it itself exists. If physics is part of the world, then the world itself must be structured in ways that physics, certainly as presently construed, cannot represent. The world will contain parts that have the property of aboutness, which is what Descartes specifically supposed to be the defining trait of thought, so that parts of the world will embody structures of a largely grammatical sort. Between these representations and other parts of the world, there will be relations very different from those we commonly regard as physical: relationships. These

will be of a semantical nature, like truth, falsity, reference, exemplification, satisfaction, and the like. Among the laws of nature will be cognitive laws, laws that specify under what conditions parts of the world know other parts of the world, which in effect is to say when parts of the world are characterized by representational states that are true. A picture of ourselves which leaves this out is a poor picture: it is like a picture of the world from which the possibilities of pictorialism are radically excluded.

This returns me to my hastily flashed dictum of Wittgenstein's, which I now invert: that the human soul may be the best picture of the human body. By the human soul, I mean of course a system of representations, of beliefs and feelings and attitudes, a kind of text. As our understanding of the body as object depends upon metaphors from engineering, our understanding of the lived body calls upon metaphors from the structure of texts. For Locke, the soul has the structure of a dictionary, with higher-order ideas compounded out of a finite set of empirical radicals. For Plato it has the structure of a conversation, it is the internalization of dialectical interchanges of the sort made famous by his teacher. For Turing it has the structure of a calculus, its processes combinatorial and computational. For Hegel it has the structure of a narrative. For Freud and Lacan it has the structure of a case history. For Joyce it has the structure of a soliloquy, dense with memories, resentments, eruptions and subsidings of feelings of love, longing, and disdain.

In saying that it has the structure of a text I want only to say it hangs together the way a text hangs together, that its unity is the unity of a text, that its fictions are allusions and repetitions, inversions and puns, false starts and rare moments of harmony, and that the really advanced physiology to which the Eliminativists point will, if this is so, look rather more like what literary critics do than resemble a system of mechanics. Think, for example, of what must be happening in the brain and body as object of Molly Bloom through the rush of consciousness with which *Ulysses* concludes. For an analogy, one might think of what would be taking place in a computer on which that soliloquy were typed. Inside the

computer would be showers of pluses and minuses, succeeding one another at dizzying speed as the text gets processed. For the explanation of those changes one would have to depend upon the text as it evolves. Molly Bloom's brain, if like a computer, will be a shower of pluses and minuses, and any explanation of what is happening in it will have to ascend to the thoughts that go through her mind—and the connections in the brain reflect what her soul tells itself as it rushes through the thoughts that constitute the fabric of her self. The body is finally the text made flesh.

The body/body problem is finally a scientific problem, but because it is a problem that incorporates the general feature of its solution as components of itself, it cannot be addressed by science from without: science cannot confront it, to transvert Ryle's witty apothegm, like a ghost outside the machine. Utopian neurophysiology is neurophysiology that accounts for its own theories. And this is as much as philosophy is able to contribute. How singular, even so, that what appears to be an ineradicable distinction, of the utmost moment to scientific thought, should be indexed, for once, to a certain stage of philosophical analysis, most especially if it should be a consequence of that analysis that there is no further stage of thought into which it need worry about survival. The future has been the present for thousands and thousands of years.

NOTE

1. Jonathan Miller, *Harvey and the Circulation of Blood* (London: Cape, 1968).

Beautiful Science and the Future of Criticism

ON APRIL 11, 1986, the prestigious journal *Science* published two papers by the same team of microbiologists, Jeremy Nathans and his associates at Stanford University—a remarkable event considering the extreme recognition conferred by acceptance even of a single article by the official organ of the American Association for the Advancement of Science. Beyond this, the papers were deemed of sufficient moment that the editors printed an explanatory piece—a "Perspective"—by the distinguished geneticist David Botstein. The papers themselves were on the microbiology of color vision, to which they make a clear contribution. But more than that, they take us, Botstein observes, from discovery to understanding; they exemplify "beautiful science," and constitute a "treat" for those who appreciate the "aesthetics" of this procedure. I want to cite Botstein's description of beautiful science in full:

> First the confrontation of the human mind with a natural phenomenon, then its investigation through observations and experiments, the continuing proposal of theories, the testing of predictions, and

From *The Future of Literary Theory*, ed. Ralph Cohen (New York: Routledge, 1989), 370–85. Reprinted by permission of Routledge, Inc.

finally, in best case, the convincing demonstration of the validity of one of the theories through confirmation of its specific predictions. The process can take only a few years and involve only a few scientists or it can span centuries and involve many. The practical consequence may be revolutionary and change the course of history (for example, special relativity) or it may have little or no use. In either case, a full scientific story, especially one that has been unfolding over historic times, can be a lovely thing, like a classical symphony or a gothic cathedral. (142)

I think it beyond controversy that there is, today, no settled philosophical analysis of the main terms of this elegant characterization. "Confirmation," "confrontation," "validity," "experiment," "observation," even "theory," let alone "the human mind," "the proposal of theories," "the testing of predictions," remain fiercely contested high ground in the philosophical wars. But much as philosophers will largely agree that something like "justified true belief" will serve as an analytical definition of propositional knowledge for most purposes, while at the same time disagreeing bitterly and minutely over the analysis of its constituent terms, "truth," "justification," and even "belief," so there are few in the philosophy of science who would find Botstein's characterization terrifically wrong or, at its level of generality, uselessly inexact. This is what beautiful science is—it is what science is, which is beautiful when it succeeds. Its elements, Botstein says, are familiar, and that is indeed the case. Aristotle would have found such expressions as "gothic cathedral" or "classical symphony" incomprehensible (not to mention "special relativity"), but the operative vocabulary of the account would have been largely accessible to him, and the general picture of science it depicts would have been intelligible, and convincing, to the earliest students of *The Posterior Analytics*.

It is on the other hand difficult for me to suppose Aristotle could have made anything much out of Jeremy Nathans's two reports. Even the concept of color blindness, which the research team explains through the idiom of modern molecular genetics, would not have been accessible to

him. Any native speaker is equipped with a rich vocabulary of color terms—even when they are lacking, one has recourse to "the color of . . . " —and there are always enough secondary cues that the color blind can answer correctly questions about the colors of culturally familiar objects. There would have been no occupation in Aristotle's time which would make urgent the disqualification of color-blind candidates, in the way that signal-light indiscrimination mandates their elimination as railroad engineers or ship navigators or air traffic controllers—though they might have been slow hands in harvest time for raspberries, having difficulty in red-green discrimination. And beyond that, it is difficult to know what the concept could have meant without the apparatus of spectral colors. The first reference to color blindness is said to be in the Transactions of the Royal Society of 1684. The chemist John Dalton diagnosed himself as dichromate in 1798, observing that whereas others required three primary colors to describe their chromatic array, he required but two. The misleading term "color blindness"—misleading because dichromates are not *blind* to the colors in question—replaced the more appropriate term "Daltonism" by which the relevant defect was long known (*it* may have been misleading since a description of dichromates by J. Scott had preceded that of Dalton by twenty years).

I am anxious to make something of the contrast between the extreme familiarity of the description of Beautiful Science down the ages, by contrast with the unfamiliarity and even inaccessibility of Nathans's results to early scientists among those who worked at the problem of color vision over the course of two centuries, from 1672, when Newton's account of light and color was presented to the Royal Society on February 8, until the appearance of Nathans's paper in *Science* on April 11, 1986. To all the earlier investigators in this history, beginning with Isaac Newton, John Dalton, Thomas Young, and later H. L. F. von Helmholtz and James Clerk Maxwell, some components in Nathans's work would have been incomprehensible in terms of the science of their day: they lacked the theoretical matrices for understanding various of its central terms. All of them, however, would have understood, and most if not all

of them would have accepted, the general picture of Beautiful Science which Nathans's work, like their own, very adequately exemplifies.

I am anxious to make something of this because there are two ways in which we can think of the future of science. If we think of it as an activity truly described by Botstein, then we really know what there is to know about the science of the future. It will be as much like it is today two centuries hence as it was two centuries ago. Nothing can be science which greatly differs from what science is today; but if we mean the future exemplars of Beautiful Science, well, we can have as dim an idea of what they will be in time to come as Newton or Dalton would have had two centuries ago—or J. W. S. Rayleigh would have had a hundred years ago when he discovered that persons with evidently normal color vision required different amounts of red or green in making color matches—of the Stanford results in 1986. Since I will later consider the future of criticism, it might be interesting to question whether we have any widely accepted characterization of Beautiful Criticism to place alongside that of Beautiful Science—and there are views of criticism that would insist there can be no such paradigm. Neither, I think, is there consensus that there are or can be sustained histories culminating, as in the case in science of the work of Nathans and his associates, in final critical validations. But it would be dangerous at this point to press for disanalogies that would in any case perhaps misspeak the relationship between science and criticism I aim to defend. Let me instead describe very briefly Nathans's discoveries in the historical context of the problem they solve.

Normal color vision is trichromatic, not in the sense that we really see ("really see") only three colors; we in fact see all the colors we are capable of discriminating, the seven spectral colors, say (red, orange, yellow, green, blue, indigo, and violet), and countless—well almost countless— other colors not in the spectrum: flesh tones, browns, pure purple, the metallic colors, and others. Trichromaticism means, rather, that all we require to do this is three centers for receiving color information, with the primary colors being those the effect of which on the eye cannot be

achieved by combination. These are at either end of the spectrum, red and violet, and roughly at its midpoint, green; when combined, these primaries give the sensation of white. The process is rather like color printing, which, in the form in which we know it today, was invented in 1740 by Le Blom, who produced mezzotint reproductions of paintings by analyzing them into their primary colors, using a separate plate for each, and achieving the remaining colors by superimposition.

I forbear moralizing the extension to human vision of the technological processes of color reproduction, widely practiced by craftsmen in Europe well before Thomas Young got the idea that the eye functions something like a chromograph, though my sense is that it furnishes a fine example of how our understanding of ourselves is in hostage to prevailing technologies. In any case, Young had a theory of three primary receptors in 1802, each of which is excited by homogenous light, but with different intensities as a function of wavelength: long, medium, and short waves exciting the postulated centers sensitive, respectively, to red, green, and violet. Neither Young nor Helmholtz knew enough of retinal physiology to know what these centers were or how they worked, but that there had to be three, strongly suggested by color printing technology, defined a program of research. Imagine reproducing, say, Titian's *Rape of Europa* with two primary colors and you will get a pretty fair idea of the world of the dichromate; and if we systematically make the effort using red-green, red-violet, and green-violet as primary pairs, we will get a gallery of the world as it appears to the three main classes of dichromates postulated by Helmholtz: the violet-blind, the green-blind, and the red-blind.

I now cut the story short. What Nathans et al. did was isolate the genes that specify the protein moieties, or "opsins," of the postulated three color-sensitive pigments of the human eye. They used DNA probes to analyze the defects in the DNA of the various categories of dichromates. It is quite striking how much science had to be in place before this was possible. Evolutionary theory, for example, suggests homology between the gene for human rhodopsin and its bovine counterpart. Genetic the-

ory suggests that dichromatism is X-linked: roughly 4 percent of males against 0.4 percent of females are afflicted; and since females have two X-chromosomes and are usually heterozygous for the recessive defect, they pass it on to their sons, who, having only one X-chromosome, show the symptom. Nathans (I here follow Botstein very closely) located two of the three opsin genes on the X-chromosome, and when the DNA of the red-blind were analyzed, "loss or alteration of one of the genes was observed." This then licensed the inference that the gene in question specified the red opsin ("specified" is the philosophically crucial term). And the corresponding predictions for the other forms of dichromaticism were able, precisely, to identify gene with function. It may be said that Nathans's work magnificently confirms the Young-Helmholtz theory (it even accounts for the anomalous class of trichromates who nonetheless see differently from the normal by finding a hybrid gene and postulating a hybrid opsin), but it confirms it with the help of theories of evolution, of genetics, of the topology of DNA which permits the possibility of gene crossover, which were largely unthinkable in 1802, or even in 1866 when Helmholtz's *Physiological Optics* was completed. The first actors in the history lacked the concepts, let alone the language, for framing the predictions that specify the confirmation of the theories. In a way it is not their theories so much as related theories in a different scientific vocabulary that are confirmed, which is perhaps the germ of certain radical critiques of continuity in science that have been so fashionable. But that is not my concern in this essay.

Rather, what I want to say is that we are in even darker waters when it comes to predicting the microbiology of Beautiful Science than Young and Helmholtz would have been in predicting the microbiology of color vision, except that we are all, I think, reasonably convinced that, sometime in the future, pages of *Science* will report such a discovery and preface it with a perspective by a leading scientist putting it in a historical light that we cannot easily even guess at, not even knowing if we are at or over or nowhere close to the history he or she will take for granted. With regard to familiar Beautiful Science, we are very much in the

pre-Helmholtz, even pre-Dalton stage, and the present disarray to which I referred in the philosophy of science for the analysis of truth, confirmation, confrontation, and observation may symptomize the darkness: we do not even yet know how, so to speak, the field of Beautiful Science is to be structured. There may be deep analogies between color theory and what we might term "science theory." When the formal deductive system recommended itself as *the* form of scientific representation to students of the subject, it would have been wholly natural to sense an analogy between primary colors and primitive terms—or between axioms on the one hand and theorems on the other arrived at by logical admixture of the axioms construed as primitive. There could then be dicognates and tricognates. The discovery that the choice of primitives may be arbitrary might correspond to the fact that any color sensation may be reasonably matched with three selected wavelengths, varying their intensities. The normal scientist might then be tricognate, and it should be possible to identify the dicognates genetically, to the immense enhancement of curriculum and of human happiness. (Color blindness is incurable, and so might science blindness be.) If the mind works at all the way science does, *something* like this mode of organization is called for. Introspection is of little help: even the eye is incapable of deciding whether a color is simple or compound (they are all homogenous, phenomenologically speaking). This takes me far ahead of anything I want to say for the moment, though it also forecasts what I shall want to say, namely that it would be with reference to a certain ordered structure of propositions—or sentences, if you prefer—that we would want to represent Beautiful Science if we are to imagine its microbiology achieved. Whether it will have the structure of formal deductive systems is for the Youngs and Daltons of the science of Beautiful Science to say. It is they who in effect will begin the history that will culminate in the Nathanses of the science of Beautiful Science, who will locate the appropriate genes.

Now, the microbiology of Beautiful Science will itself be an example of Beautiful Science, and it will be a great achievement of Beautiful Science

in that it will have arrived at the microbiology of itself. What can we now say about that future piece of science? We cannot say, of course, what the observations, the theories, let alone the experiments and tests will be: to *that* future we are as blind as Helmholtz was to the future of the science that vindicated his and Young's theory. But then we would not expect the microbiology of Beautiful Science to be a microbiology of these. We do not expect that Nathans's theory is itself encoded in the DNA. We do not expect that when the human genome is fully sequenced (at an estimated cost of thirty thousand person-years of effort and $2 billion) it will reveal the microbiology of itself somewhere in the twists and catenaries of the three billion nucleotides that compose the human genome. The microbiology of Beautiful Science will indeed be the microbiology of those who do Beautiful Science, but that would include the scientists at either end of the relevant history—the DNA of Dalton and Young would not be relevantly different from the DNA of Nathans and Botstein. The content of Nathans's theory would not refer us to some genes that specify exactly it. The sciences of the future, then, are not encoded in the genes of present scientists, or past scientists for the matter, so there would be no point in a visionary shift in the strategies of Beautiful Science, namely, to give over experimenting with the different sectors of the universe and instead learn to read the human genome where the science of everything is inscribed. My hunch is that such a possibility would be like having some god hand us a text in which the whole of knowledge is inscribed, so that had he possessed it, Aristotle would have gazed upon the special theory of relativity, the theory of evolution, the kinetic theory of heat, the atomic theory of matter, the theory of fractals, and the microbiology of Beautiful Science—the key to the key that unlocks itself—but he would have been unable to read it. In effect, we would still require the future history of Beautiful Science to read our own DNA; and microbiology would be a historically limited subject, requiring the future history of science, like a revelation, to render intelligible the god's pointless gift. The present would be dark for the very reason that the future is dark.

No: the structure of history would impose deep limits on a microbiology of science, if we extravagantly imagined that microbiology were to take us from genes to the content of theories—from the microbiological gene, say, to the theories of microbiology itself. So I shall suppose—who can do otherwise?—that our human genetic endowment, cognitively speaking, is invariant from Aristotle and before to Nathans and after: it is, relative to the contents of theories, a kind of tabula rasa. Any scientist—anyone with the right kind of DNA, if there is anything to that—could enter the history at any point and carry it forward, or be carried forward by it. To be sure, it would be difficult to imagine Thomas Young himself entering the history he began, only at some later point, just because it would not have been that history had he not instead been there at the appropriate earlier point. But the thought is perhaps clear enough. There may be—no, I am certain there *will* be discovered—a microbiology of linguistic competence, which accounts for the fact that any child can learn any natural language. But that is not the same as saying that in every child every language—including languages for possible worlds that never are to become actual—is stored as DNA sequences: that there are Russian, French, and Yiddish genes. So except at a very abstract level, we must suppose the content of Beautiful Science's microbiology will not be among the things of which it is the microbiology. So of what *will* it be a microbiology?

The answer, of course, is plain, and in a way it is contained already in the familiar description of Beautiful Science given by David Botstein: it is the microbiology of what scientists do when they confront nature, propose theories, perform experiments, make observations. Now, these are things we all do, at a certain level, when we perceive something, form a belief about it, infer certain propositions that must be true if our beliefs are sound, and perform certain actions to see if they are sound. I hear a certain rapatapatapa on the roof, form the belief that it is raining, infer that if it is, the ground will be wet, and look out the window to see if it is wet. It will, then, be a microbiology of perceiving, believing, inferring, and acting. Small wonder then that the picture of Beautiful Science is so

familiar, small wonder that it would have been familiar to Aristotle, small wonder, we may assume, that it will be familiar to those microbiologists of these very ordinary cognitive dimensions of very ordinary human beings (and doubtless of some very ordinary animals). In addition to these basic operations, two further sets of things required by Botstein's account might need to be reckoned in. There is, first, the very notion of aesthetic satisfaction carried by the concept of *Beautiful* Science, which renders consistent Aristotle's conception of us as rational animals with the theory of human beings as driven by pleasure. And beside this we must place another feeling, namely caring about there being answers to questions, wanting to know. There is as little philosophical consensus today on aesthetics, and on care, desire, and cognitive appetite, as there is on confirmation, justification, and truth. But they clearly belong to the picture in which such controversy is represented, if only because the philosophers who moot these matters exemplify them, caring for the truth and having some antecedent sense of what it means for a philosophical problem to be solved.

Now, just these components of Beautiful Science—belief, perception, action, inference, desire, and feeling—have lately been conjectured to belong to a science of Beautiful Science very different from microbiology: they belong collectively instead to a theory somewhat abusively designated Folk Psychology, a theory as old as our consciousness of ourselves as human. They answer as terms that have pivotal roles to play in an explanatory scheme we acquire with our language, much as we acquire our color vocabularies. And I suppose, further, that it must be their explanatory role in everyday social and human life that in the first place recommends the striking thought that this portion of our language is, as it were, a piece of science embedded in the wider framework of natural languages; and then the further thought that it is to be judged the way we do judge scientific theories. The familiar picture of Beautiful Science is in fact an explanation of what scientists do, and it is a theory that, as we say, also very adequately fits what a lot of humans and animals do a lot of the time. There is a view abroad that Folk Psychology is sclerotic

and in need of replacement, and the best candidate for replacing it is some form of neurophysiology. Of this we can know, today, perhaps as little as we can of the microbiology of Beautiful Science. Except that now, on this view of the latter's replaceability, we can say that there after all will be no microbiology of Beautiful Science, mainly because the familiar description of Beautiful Science will be inapplicable, employing and presupposing as it does the challenged vocabularies of Folk Psychology. But Folk Psychology is destined for replacement, and will finally prove as little resistant to this as phlogiston or entelechies or animal spirits or black humors or astral influences or gods did when they crumbled, as explanatory concepts, under more enlightened views.

The problem with this jaunty proposal has already been displayed: in wiping out Folk Psychology, it wipes out Beautiful Science, which is after all only Folk Psychology as applied to the characteristic conduct of scientists: they confront, infer, act, observe. To imagine that Beautiful Science will succeed in wiping out Beautiful Science is to raise the question of how it is to do this. And surely the answer is to refer to the proposal of theories, the inferring of predictions, the performance of experiments, the checking out of theory against reality—and these are precisely what was to have been eliminated. So the elimination is strictly unthinkable, just because the moment we try to think about doing it, we are enmeshed in the repudiated categories of Folk Psychology. Since we require science to get rid of Folk Psychology, it is plain that we cannot get rid of Folk Psychology by science, for we have no way of representing science save through the categories of Folk Psychology. It is exhilarating to encounter a genuine deconstruction as we approach the point at which we want to take up the question of the future of criticism, for we have settled the question of the future of science by a kind of transcendental argument. No one can say for certain that there will be science in the future. All we can say is that if there is science in the future, it will be familiar. Dalton would have no difficulty in recognizing that what Nathans and his associates achieved is science. He would, however, have a lot of catching up to do to recognize what they have

achieved. If you like, Beautiful Science can have a genuine history—a future unintelligible to its past—only if it does not itself have a history: only if it is intelligibly the same at all stages of itself as the same thing, Beautiful Science, with a remarkable potential for cognitive adventure. Those things that can have histories in some sense lie outside history, like Platonic forms. Or like souls or selves. So we may assume that Folk Psychology is not really part of history, certainly not part of the history of psychology. It was there with the first crossovers, the first duplications and divergences that account for the emergence of human DNA. It will be with us for as long as our species endures, like trichromate vision. The microbiology of Beautiful Science will in effect be the microbiology of Folk Psychology.

There is an instant problem generated by the thought that there might thinkably be a microbiology of Beautiful Science though not thinkably a beautiful science of microbiology itself—no gene that specifies the concept of gene. It is due to the fact that each component of Beautiful Science refers to what, following Bertrand Russell, philosophers designate "propositional attitudes": "perceiving that . . . ," "observing that . . . ," "believing that . . . ," "doing x in order that . . . ," "feeling that . . . ," "caring that . . . ," and the like. The "that" requires completion by a proposition. Socrates was aware that we cannot just believe as such—we have to believe something—and went on to elaborate a theory of doxastic objects which we recognize as a component in Platonic metaphysics. If propositional attitudes were in the genome but propositional objects not, it must be clear that Beautiful Science could never have come about by genetic process alone. There may, to be sure, be some innate beliefs, as Leibniz supposed all our beliefs are and Descartes supposed some of them are, and these may indeed be genetically coded (I tend to think that all the beliefs that are philosophically crucial are of this sort), but Leibniz's thesis seems to me genetically impossible: the propositions have to come from somewhere outside the genome, and the best explanation of where they do come from is through interaction with the genetic

product—us—and the world. One might ponder the human brain at this juncture, which contains 10^{14} synapses. But there are not enough genes to account for this, and, as Pasko Rakic recently argued, "Even if we knew all the genes and what they were coded for, we still could not predict in detail what kind of brain you would have." If you think of the brain as bearing the inscribed record of experience, with neuronal circuitry the product of interchange with the world, you will have a good analogy to what I am getting at. What I am getting at is underscored by the scientific project of studying neuronal circuitry by depriving animals of one or another mode of sensory input.

The world in which Dalton lived could not have been, as such, remarkably different from the world we live in, so it will not be mere interchanges with the world that account for the differences between Dalton's views and Nathans's views at either end of a history: we have to add something about the historical transformation of the world. Dalton and Young stand too early in a history to have been able to understand what could be meant, by their successors, by such an expression as "the primary receivers of color information." That expression could of course have been formed in English before Newton, but it required Newton to give it the sense "primary" came to have in the history, and it required a lot of science that came after Young and Dalton for the remaining expressions to mean what they do to Nathans and Botstein and our contemporaries. It has been widely subscribed to by philosophers of mind that the propositions which are objects of propositional attitudes form holistic systems—that we are not, in understanding the mind, to consider propositions one at a time but only in the systematic *Zusammenhang* of a whole complex of propositions, and that history must account for the difference, or some of the differences, between thinkers like Dalton and Young at the beginning, Helmholtz and Clerk Maxwell in the middle, and Jeremy Nathans at the term of a process. It is this that makes a synchronic approach to the human sciences finally so unsatisfactory. It is as though the embedding system constitutes a text, and as the text changes, the sentences in it themselves undergo a change in meaning.

And with this we begin to approach the topic of criticism, understood now as the theory of texts.

The term *Zusammenhang* is a *Gastarbeiter* in English, which lacks an honest word to do the work *Zusammenhang* does, and whose absence from our tongue may explain the fact that English philosophers balk at certain forms of thought with which Continental theorists garb themselves easily and naturally. It is meant to sound an allusion, in my text, to a famous and familiar claim by Gottlob Frege that a word has meaning only in the *Zusammenhang* of a sentence (*ein Satz*). One might partially gloss this as implying that to understand a word is to know how to use it in a sentence (which leads the philosopher Peter Geach to say that the blind of course know the meaning of "red").[1] My dog Emilio understands the words "walk" and "breakfast," and displays an expression of acute interested awareness whenever these are uttered. But he understands them as he understands my picking up a leash or handling a can of Alpo—as signals that happen to be irrelevantly vocal. To understand them as *words* would demand sentential competence, and Frege is given credit for having made the sentence—or proposition—central in logic, overthrowing the term as the unit of philosophical intelligibility (the history of the concept of understanding massively confirms this assessment). In any case, philosophers since Frege have been more or less arrested at the analysis of sentences, when what I am anxious should happen is that we press past this boundary to the thought that a sentence has meaning only in the *Zusammenhang* of a text. And a parallel to the limitations of Emilio may be found in the case of those who may not be said to understand a sentence for want of possessing the *Zusammehang* in which, as Frege might put it, the sentence *meint etwas*. That is to say, there can be no such thing as understanding just two words (as in the case of Emilio), not even if the two words form a grammatical sentence, for there can be no such thing as understanding just one sentence. The least unit of sentential comprehension is the discourse, which of course has exceedingly fluid boundaries.

Consider an example meant to tell decisively against a sentential theory of the mind. Steven Stich invokes an old family retainer, long gone senile, who is said nevertheless to remember the assassination of President McKinley.[2] At least she says "Yes" when asked if she remembers that. But it may be she says this because she is rewarded, as Emilio is rewarded for complying with "Sit." In any case, she is unable to answer questions presupposed by understanding "McKinley was assassinated." Let's say she does not remember that McKinley was president, does not understand what it means to kill, and so on. Briefly, if a certain surrounding body of propositions is erased, leaving but one sentence, it is not really a sentence at all unless we can imagine a constructable text in which it has a meaning. It is a sentence only if we can construe it as a textual fragment, as a word is a sentential fragment only if truly a *word*. The fragment-whole relationship gives us a model for the holistic concept introduced above, even if something should meet the standard grammatical and logical tests of well-formedness to be a sentence.[3] Stich's argument, that the retainer does not understand the sentence if it is the only sentence she "understands," strongly resembles arguments used by John Searle and by Hubert Dreyfus, among others, against certain claims made on behalf of artificial intelligence. There is a famous script, designed by R. P. Abelson and Roger Schank, meant to demonstrate that a computer understands narratives, since it is able to furnish answers to questions it was not explicitly programmed to know. The script is somewhat simple-minded, dealing with a man going into a restaurant and ordering and paying for a hamburger. I have seen Searle and Dreyfus make quite merry at the number of things the machine does not understand—Does the man eat the hamburger with his ear? Does he sit on the hamburger?—which any child experienced in the milieu of McDonald's would know the answers to. Stich argues from his interesting example to the reckless conclusion that Folk Psychology must be wrong and hence replaced with another model of cognition altogether— when the reverse seems to me to be the case, namely that a textual theory of the mind is entailed by the fact that someone really does under-

stand a single sentence when she or he understands all that has been erased from the brain or mind of that ancient retainer. And my point is that Dalton and Nathans have to understand the same sentences—say, "Normal color vision is trichromate"—in different if centrally overlapping ways, because of what Nathans, but not Dalton, can be supposed to understand about photochemistry, genetics, statistics, and the like. That sentence cannot have meant in 1798 quite what it means in 1986, if my augmentation of the Fregean unit to the text is justified. "Normal color vision is trichromate" is, then, a fragment that generates different texts in these two widely separated years, and would have been unintelligible or false before 1672, when Newton's work was laid before the Royal Society.

I want now to characterize criticism as the theory of texts, and to consider the future of criticism as the future of that. Here is the thought I want to advance: if the Folk Psychological premises of Beautiful Science cannot be thought away; if the propositional objects entailed by the truth of Folk Psychology themselves imply that we are structured propositionally; if the propositional attitudes true of us if we are propositionally structured imply that we are structured as texts, then criticism is preemptive psychology and even now the strategies evolved for addressing literary texts have application to us: they apply to us if the deep premises of Beautiful Science themselves apply. But then criticism defines the future of Beautiful Science if there ever is to be a beautiful science of Beautiful Science. Something like the reductions of color vision must be worked out for the textual psychology entailed by Folk Psychology if there is to be a microbiology of Beautiful Science. (You could not, for example, deduce from the microbiology of color vision the interior decoration of our rooms.) The two cultures meet at this point. They are not like two circles without a tangent point; they are like two halves of a single circle that join at the theory of texts.

I have just been striding along in my fourteen-league boots, and the gaps between steps are sufficiently wide that, as Charles Sanders

Peirce once said, a coach and four could be driven through. That matters not in the least, for any demonstration of some logical unbridgeability between the steps would have to be immensely illuminating in regard to criticism, texts, science, and the architecture of the human mind. I now draw off those boots and, replacing them with my seven-league clodhoppers, mince my way to the conclusion of this reflection.

If the mind—by which I mean that dimension of our beings specified by Folk Psychology—hangs together in the manner in which texts hang together—if we are, so to speak, a text made flesh—then a beginning might be made in addressing certain problems concerning the identity and unity of a person against the model of the unity and identity of a text. There is a very famous passage in Hume's *Treatise*, in which he disclaims having any idea of his self, since his theory requires that ideas be caused by impressions and there is no *impression* of the self: "For my part, when I enter most intimately into what I call myself, I always stumble on some particular perception or other, of heat or cold, light or shade, love or hatred, pain or pleasure. I never catch *myself* at any time without a perception, and never can observe anything but the perception." And, after a passage of characteristic irony directed at metaphysicians who pretend to find, contrary to himself and the rest of mankind, something "simple and continued which he calls himself," Hume concludes in his characterization of what we are: "A bundle or collection of different perceptions which succeed one another with an inconceivable rapidity, and are in perpetual flux and movement."[4]

Now, what constitutes the identity of a text? It would certainly be peculiar, though parallel to Hume's straw opponents, to postulate some underlying textual substance that runs through the poem and constitutes the unity of the poem, when in truth, tracking Hume's analysis, "we can never enter most intimately into what we call" the poem and encounter anything but words, or lines, or whatever, and were someone then to say that the poem is but a bundle of different words or lines that succeed one another, he would certainly be right. That, in a certain sense, is what a

poem is. If experience inscribes my history on the tabula rasa of the self, someone who was to peer into me would see the inscriptions succeeding one another and might wonder where *I* was. It would be laughable were one to say he had overlooked the tabula rasa itself, for that would be like trying to establish the unity of a poem with reference to the unity or identity of the paper it was printed on. No doubt the self has at times been regarded, primitively, as a sort of metaphysical parchment, which carries the taint of original sin as a moral watermark and which bore the inscription, as so many stains, of misdeeds and transgressions unless and until erased by confession, penance, or absolution.

But a poem is not a list of words or a mere concatenation of sentences, even though it is true that each of them is separate in the way Hume supposes, correctly enough, that our "particular perceptions" are. "All these are different, and distinguishable, and separable from each other, and may be separately considered, and may exist separately, and have no need of anything to support their existence," he writes. They are, to use his typical expression, "altogether loose and separate." I mean you can count the words, and there is no reason why, in a line of print and considered as printed, "mice" requires the existence of "three" or "blind." "Three," "blind," and "mice" are different, distinguishable, separable, may be separately considered, and certainly "need not one another in order to exist." In second thoughts on this subject, Hume is adamant on the looseness and separateness of perceptions—"All our perceptions are distinct existences"—and he doubtless entertained as a target just what an earlier resident at La Flèche had tendered, in the Synopsis of his *Meditations,* as the criterion of the mind in contrast with matter: its unity and indivisibility. Hume pretended to find no connection among these distinct existences, as indeed there are no tiny ligatures, barely visible, binding "three" and "blind" and "mice" into a single striking expression. The spaces between them are empty, as are the spaces between the words of Hume's own history of England. What prevents that history from disintegrating into a collection of separate existences? The fact that it refers

to a single entity, England? That it is written by a single individual, Hume? The text would not lose its unity were it discovered that it had been written by a team of Scotsmen, nor would its unity be shaken by the consideration that England itself got to be a unity well after the events with which the narrative begins. And what of the unity of the texts about Oz?

My sense is that Hume's psychology, constructed on the model of simple terms—"love, hatred, pain, pleasure, light, shade"—would have been impossible had the proposition emerged in his time as the psychologically central unit. Hume's theory of belief as a certain intense feeling accompanying an impression, while it got right the fact that belief is something that accompanies something and does not occur on its own, got the object wrong because he lacked the grammatical insight that beliefs require propositional objects; and then, in propositionalizing the contents of the mind—in recognizing that a term has meaning only in the *Zusammenhang* of a proposition—he would have been in a position to see that the kind of connections needed were the kind that kept his books from disintegrating into staccatos of unconnected words. What binds the self into a unity is of a piece with what binds histories and essays into unities—and Hume as psychologist and man of letters would similarly have found a unity that parallels what he found lacking between Hume as skeptic and Hume as man of the world. If Beautiful Science is an extension and refinement of the fundamental practices covered by Folk Psychology, texts, as literary artifacts, are projections and extensions of the unifying structures of a self or of a life. The principles, whatever they are, that enable us to tell and follow stories, to construct and read poetry, are the principles that bind lives into unities, that give us the sense of chapters ending and of new ones beginning. The future of criticism lies in making these principles explicit.

In recent years a number of audacious theorists in Paris have achieved something so remarkable that I am certain we will someday look back on Paris during the thirty years after World War II as we look back on Amsterdam in the three decades in which Dutch painting achieved its supremacy, or on Florence in the somewhat more

protracted period of the High Renaissance. The writings were dark, self-indulgent, portentous, agonizingly frivolous, and silly, infuriating, and absurd. But collectively they expanded upon the concept of the text to integrate history, culture, and psychology, as well as to revolutionize the reading of literature narrowly considered. Six decades of analytical philosophy had devoted itself to the exploration of the proposition as the unit of meaning and bearer of truth, culminating in the truth-conditional analysis of meaning and the thought that "S is true if and only if S." But when we seek to widen our horizons beyond "Snow is white if and only if snow is white," this analysis helps us very little. Logic takes up some of the slack; language-game or speech-act theory takes it up in a different way: but these leave us with the thesis that the larger encompassing contexts are calculi or *Lebensformen*. Even when Jerry Fodor advanced the singular thesis that there is a language of thought, he continued to construe it as formulating T-rules for propositions, raising the particulate theory of Hume to a higher level, treating propositions one at a time as though each were a tiny vessel of meaning. If the mind *zusammenhangs*, as Jacques Lacan insists; if cultures *zusammenhang*, as Claude Lévi-Strauss proposes; if history *zusammenhangs* in the manner conceived by Michel Foucault or Fernand Braudel, then even if texts do not hold together the way Jacques Derrida supposes they do, Hume really was a victim of the metaphysics of presence, which is another name for atomist, and the scope of textual theory is collectively widened and a redistribution of the map of learning is in order. Criticism is then the paradigm human science, and I find it surprising, even exhilarating, that the matrix for understanding the physiology and ultimately the molecular biology of human cognition should be those strategies which are applied to analyzing the poems of Donne and the plays of Shakespeare, and that the humanists, with all their touching inadequacies, should be in the forefront of science. We had always been taught that the last shall be first, but whoever would have suspected metaphysics of becoming once more queen of the sciences?

NOTES

1. Gottlob Frege, *The Foundations of Arithmetic*, trans. J. L. Austin (Oxford: Oxford University Press, 1950).

2. Stephen Stich, *From Folk Psychology to Cognitive Science: The Case against Belief* (Cambridge, Mass.: MIT Press, 1983).

3. R. P. Abelson and Roger Schank, *Scripts, Plans, Goals, and Understanding: An Inquiry into Human Knowledge Structures* (New York: Wiley, 1977).

4. David Hume, "Of Personal Identity," *A Treatise of Human Nature*, bk. 1, pt. 4.

In Their Own Voice: Philosophical Writing and Actual Experience

IN CONTEMPLATING THE PROSPECT of having to undergo congressional scrutiny in connection with her confirmation as director of the National Endowment for the Arts, the esteemed actress Jane Alexander said—half in jest and half as boast—"It's the first time I've had to audition for an awfully long time." She had attained that level of professional acclaim where those with parts to give out came to *her*, hoping she would consider accepting them, knowing her participation in a play would enhance its success, as art and as enterprise. There are those in philosophy of whom something like this is true as well, who do little or nothing by way of writing "on spec" but nearly always write in response to requests to give keynote addresses, symposium papers, named lectures, invited papers, contributed essays—and whose books themselves are often simply gatherings of these. Donald Davidson once told me that of the then close to forty papers he had published, none had been refereed—none had been *submitted* for publication and subjected to the processes of editorial or peer review, and exposed to requests for revi-

From *Beyond Representation: Philosophy and Poetic Imagination*, ed. Richard Eldridge (Cambridge and New York: Cambridge University Press, 1996), 90–106. Reprinted by permission of Cambridge University Press.

sion. Instead, those parts of his papers which an editor might peremptorily have written "Clarify!!!" next to in the margin have given rise to mighty rivers of commentary and analysis, and doubtless have seen more than one critic through to tenure as a specialist in the philosophy of Donald Davidson. There are exceptions, some surprising, but what is true for Davidson is in large measure true for philosophers of any reputation to speak of. It is difficult to imagine most of them submitting to the indignities of audition, exposing themselves to the humiliation of having their work turned down, or, if accepted, then on terms set by unnamed referees. They are *stars*.

Most of these star-philosophers have pretty distinct voices, possibly in consequence of the fact that so much of what they have written has been composed to be read before audiences, and hence is filled with devices of a kind calculated to hold an audience: turns of phrase, ingenuity of examples, sparks of wit, and an aura of presumed intimacy between speaker and hearer. In general, I should think, most who are literate in contemporary philosophy would be able to identify the authors of sample anonymous texts, as much by voice as by the positions they advance—would be able to say that this passage must be by Jerry Fodor or that by Richard Rorty or Hilary Putnam or Daniel Dennett or Saul Kripke or John Searle, let alone Quine, Goodman, Davidson, or Chisholm. The jokes, the asides, the syntax, the punctuation (like parentheses), the vocabulary, the imagined cases, the authorities appealed to, the *tone*, give the author away. This familiarity of voice perhaps comes from having heard these philosophers speak, so that one can virtually hear them as one reads, whatever may be the problems with logocentrism and its relationship to *l'écriture*. The presence of these philosophers gives one a reason to attend the lecture, the panel, the disputation, the meeting—and this is no less true of the apostle of *l'écriture*, Derrida, who is as much a philosophical presence as the individuals cited. We may not always admire these personal styles; we may in fact wince at the jocularity, the confessional disclosure, the flaky examples, the feigned simplicity, the flaunted technicalities, the contrived analogy, the fruity

metaphor—or the aggressiveness, the mock humility, the pedagogic sneer. But it seems to me incontestable that to have evolved a philosophy sufficiently marked that the author is exempt from audition is also to have evolved a philosophical style and personality that are readily marked and easily imitated. It is even possible to suppose that the strongest philosophers of our era possess the strongest styles, to the point where no one would think of writing in their voice, let alone in the voices of the towering masters of writing like Heidegger, or Wittgenstein, or Dewey. To do so would straightaway be reckoned imposture. Does that mean that philosophy and philosopher are inseparable? Or that there is a deep connection between philosophy and voice?

It is reported that, as early as 1920, Hans-Georg Gadamer heard that Heidegger, in a lecture of extraordinary originality, used the phrase "it's worlding."[1] And it became a matter of international scandal, at least among the Positivists, that Heidegger used what they regarded as the paradigm of nonsense in connection with the word *das Nichts*, namely that *es nichtet*.[2] To transform nouns into the verbs one needs is certainly more than a style—it is the very substance of a metaphysics, and one is very grateful—one is in any case if one admires Heidegger at all—that he was not obliged to submit the manuscripts of his lectures to some arbiter of editorial correctness. But is style always and invariably internally related to substance in this way? Admittedly, it would at the very least be difficult to imagine Heidegger—or Wittgenstein, for that matter—using the literary style, hence speaking in the voice, of another philosopher, like John Dewey or A. J. Ayer—hence as exploratory, the way an animal explores a field, leaving an involuted trail, or as supercilious. But are these thinkers' thoughts so involved with their voice that we cannot state a Heideggerian or Wittgensteinian "truth" without using the Heideggerian or Wittgensteinian style to do it with? Thus Wittgensteinian "truths" (I am employing quotation marks because I want to leave the reader a bit edgy with the idea that there are such things as Heideggerian or Wittgensteinian truths rather than truths which happen to have been uttered by Heidegger or Wittgenstein) often appear by way

of responses to vivid questions in little scenarios. Does this circumstance in any way penetrate the "truth" that comes as a response? And we report "it" by saying, perhaps, "Were someone to ask—or think . . . then one might say. . . ." So that Wittgensteinian "truths" are things one might say in certain choreographed circumstances, in case a worry arose which it then helped mute. It is almost medicinal, bearing a tacit label "To be taken in the case of mental cramp." As if only to someone genuinely provoked to make the query does the "truth" come as an answer. I am not comfortable with this idea, but it strikes me that something like it has been advanced by Stanley Cavell, who is one of the few to have made philosophical voice a central concern of his philosophy.[3]

Here, apropos a well-known argument of Kripke's based on a no less well known thought (or "thought") of Wittgenstein, Cavell

> suggests a piece of advice [he has] for one who (for a moment, or from now on) has freed himself or herself from Wittgenstein's spell, and would like to believe that the writing, while no doubt distinguished, is not really essential to the teaching; not just that it fails sometimes, which is inevitable, but simply that it cannot matter *that* much, as much, say, as its fervor continually seems to declare. My advice is to take the writing of the *Investigations* as perfectly straightforward—or as straightforward (say undigressive) as any can be with spade turned, empty of theses, no agenda to complete. It is Wittgenstein's posture of philosophy, always arriving at a standstill ("peace"), as if there were no (other) goal. That there is limitation in this manner I would not deny, but the unstraightforward is as much part of its power as of its impotence. Images associated with the turned spade, the unassertive pen, will continue to return.[4]

That is to say, the unstraightforward in Wittgenstein's writing is *in its own way* straightforward, once we grasp what the posture is. Kripke, on the other hand, had supposed that all the backing and forthing was a kind of ornamentation, and that it could be erased in favor of asserting a straightforwardly straightforward proposition which can be discerned

behind or beneath the style. "So Wittgenstein perhaps cagily might very well disapprove of the straightforward formulation given here. Nevertheless, I choose to be so bold as to say: Wittgenstein holds, with the skeptic, that there is no fact as to whether I mean plus or quus."[5] And Cavell is disapproving on Wittgenstein's behalf: getting rid of the "unstraightforward," saying flat out in robust Anglo-Saxon terms what one is getting at, is a project as misguided as that of the Walrus and the Carpenter, who see the sand as a form of dirt, making the beach disagreeable, when in fact the sand *is* the beach. "Holding" is not something Wittgenstein does ("empty of theses"). He is not searching for a thesis but for peace. There are sentences in Wittgenstein which look like theses (which in the *Investigations* look like the propositions in the *Tractatus*)—extractable, detachable, capable of being set down in a kind of breviary and bound in red and titled in gold lettering: *Wittgenstein's Philosophical Thoughts*. So one might even imagine Wittgenstein using the very words Kripke uses: "There is no fact as to whether I mean plus or quus." But that would not be a thesis of Wittgenstein's, as it is *the* thesis of Kripke in his text on rules. Rather, there is something in Wittgenstein as a writer, in his mode of presentation, which could ("I fancy," Cavell writes, leaving it open as to whether or not he "holds") "have given the words a voice that prompts a countervoice." And so Kripke's view "cannot just be right."[6]

The thought, if I follow Cavell, is that it is inconsistent—it is an inconsistency of philosophical practice—to believe that as a philosopher Wittgenstein held or could have held anything, writing the way he did. And this in effect means: you cannot free yourself from the spell of his writing, and bear away a nugget of philosophy. That would be like rationally expecting to find in your hand the coin you dreamed you found. No: to read Wittgenstein, in Cavell's view, is to enter into a peace-bringing discourse as one of the voices sooner or later expresses a worry and the countervoice administers relief. It is like entering a poem. You cannot flatly say, "Frost said, 'And miles to go before I sleep.' " Of course the words were his. But he said them in a poem, and that line has

to be reached by reading through the poem which it closes, resolving the tensions of the poem by its repetition. It is not separately assertable, not something Frost *held*. This is to treat philosophy as if oblique. It is, indeed, to treat it as *literature!* Is this true of just Wittgenstein, or is it generally true of philosophy? Is it true of Cavell, for example? Few writers are less straightforward than he, but in the end he is making a claim about how Wittgenstein is to be read which is true or false. Cavell reads Wittgenstein the way a gifted literary critic would read him. Consider the passage in Wittgenstein to which the phrase "as straightforward . . . as any can be with spade turned" refers:

> "How am I able to obey a rule?"—if this is not a question about causes, then it is about the justification for my following the rule in the way I do.
>
> If I have exhausted the justifications, I have reached bedrock, and my spade is turned. Then I am inclined to say: "This is simply what I do."[7]

The word "justification(s)" occurs twice in this passage, Cavell notes, but a different German word is translated each time. In the first paragraph the German is *Rechtfertigung*. In the second the German word is *Begründungen*. By translating the two terms the same way, the English version "misses the chance to register that the metaphorical strain in *Begründung*, that is, grounding, or following, is followed out as this sentence in which the image of ground occurs continues the image by invoking hard rock and the spade it turns back."[8] One might even go further: the sound of *Grund* could have awakened the thought of *Grund*, and hence the powerful metaphor of the turned spade. This is a wonderful way of having one's text read, but not, I think, if it vaporizes philosophical writing into poetry. That is not the way I want to think about philosophical writing or voice, nor is it the way with the prominent philosophers I began by citing, who are beyond audition but have burning truths to transmit, whatever the poetics or rhetoric of their discourse—about reasons being a class of causes, about consciousness being

the essence of mind, about the existence of a language of thought which it makes sense for scientists to look for. Having listened to Cavell's advice, does Kripke not in the end have to make his mind up whether or not he was right, hence whether or not Wittgenstein holds that there is no fact by which I can tell which of two things I mean? He may be wrong, but not for the Cavellian reason that there is no holding in the *Investigations*, but rather for the reason that Wittgenstein does not hold *this*.

Wittgenstein's *Philosophical Investigations* has, rather rare among philosophical works, a claim as a work of literary art, not so much because of its vivid and compelling imagery—its "fervor," to use Cavell's expression—but because it somehow embodies what it is about. Digging is not deflected by bedrock, it is a search for bedrock; and bedrock itself is defined by the kinds of tools one has for digging of this sort and for this purpose. It is bedrock only for the spade it turns, and there is no value in the suggestion that one can easily go deeper with a pneumatic drill or a backhoe, or, as Nietzsche liked to say about his own writings, with dynamite. If I were an engineer, charged with digging a tunnel, bedrock would be an obstacle to get around: saying my spade had been turned would be a call for heavier equipment. The point is not to make a hole of a certain depth, come what may, but to find where bedrock is, using a spade. For Wittgenstein, the plain and simple tools of manual labor are metaphors for the plain and simple tools of philosophical investigation, the ordinary methods of inquiry where probes are made in the search for limits, where digging has to stop. In its own way, the *Investigations* is composed in the Kantian spirit of finding the boundaries, beyond which we are unable to pass, however great our appetite for doing so, and where our spades are turned. And when he says, "This is what I do," he refers to the common practices for which the simple tools are metaphors. He means: This is where I am, this is how it is, this is what my house—my life, *my being*—rests on and is confined to: This is *what I do*. A countervoice—Don't you need a better shovel? Are you sure this is what you were looking for? Do you not want to try digging a foot or so to the left?—would come only from a philosophical kibitzer whose

ambition is to deprecate our powers. But the kibitzer is the nemesis of peace, and the *Investigations* demonstrates how to shut him up, not how to allow him to flourish. Peace comes with the finding of limits we then learn to live within, which is a kind of stoicism. And this fits in with so much of what Wittgenstein wrote, in *On Certainty* and elsewhere, that one feels it has to have been the project of his life. The writing *shows* what can also be *said* (even if Wittgenstein, famously, but to another purpose, said: "What *can* be shown *cannot* be said").[9] And what can be said can be detached and asserted. As Doctor Johnson said, "The mind can only repose on the stability of truth."[10] It could not be more reassuring to learn that there is bedrock, a point beyond which digging cannot go. There is also a certain comfort in seeing the digging done, embodied in the way the text is written. But the spirit of the *Investigations* in seeking the foundations of the world is finally not that different from that of the *Tractatus*, which also seeks bedrock. Finally, let's face it, we know enough of Wittgenstein's life and personality to appreciate that it would be as a man with a spade that he would want to be perceived. Not with a shovel—he was not moving dirt or manure. He was a digger.

One cannot imagine Cavell with spade in hand, and this is reflected, or inflected, in his chosen voice, which is easy to recognize—he perhaps holds the record for the largest number of parentheses to appear in a single paragraph—but difficult to condense into an image other than the image, perhaps, of a conversation in which different voices occur and concur and diverge. "Becoming intelligible to oneself," he writes, "may accordingly present itself as discovering which among the voices contending to express your nature are ones for you to own here, now. (The contention among voices may shift without settling once and for all.)" Regarding his own "sound" he writes, "It may help to say that while I may leave ideas in what may seem a more literary state, sometimes in a more psychoanalytical state, than a philosopher might wish . . . I mean to leave everything I will say, or have, I guess, ever said, as in a sense provisional, the sense that it is to be gone on from." But he adds, "Philosophy should sometimes distrust its defenses of philosophical form."[11]

This mistrust of form, however, together with what one must call an advertisement for his own form, acts to soften up the anticipated opposition to his urging us to take Emerson, a favorite philosopher of his, as philosophically seriously as he does. But (of course in a parenthesis) "Emerson's prose exists as a kind of conversation with itself." Given his voice, it is natural, or at least understandable, that the texts he admires are conversational, and that in consequence he shall listen for the essential countervoice between the lines in the *Investigations*, and that it be essential there that the conversation go on—and hence that nothing be held, that everything be provisional, so that if conversation stops it does not end. He invents a conversational theory of justice in order to accommodate Rawls, and he all but apotheosizes J. L. Austin for having licensed recognition of voice, without which conversation is impossible. Curiously, one sees—or, not having read every word, I have seen—very little celebration of Paul Grice, who after all devoted his major effort to what one might call the ethics of conversation: Cavell is interested in conversing, not in the theory of conversation. I can see him, eccentrically so far as the philosophical canon is concerned, extravagantly admiring Emerson, who has opposed views on certain matters, so that his writing is by way of transcript of the internal conversation, one side of him trying to get the other side to see things in a certain way, it not greatly mattering which side comes out on top—it almost being a shame if one side in fact comes out on top if that means conversation ending.

Cavell has a certain investment in that conception of the self as something with different sides, between which the life of the self is conversational (it is not a split self where the sides are incommunicado). He, for example, cites Thoreau with approval for having written, "With thinking we may be beside ourselves in a sane sense."[12] Cavell indeed rather pounces on "beside ourselves," which he paraphrases as "ecstasy," which really is not so much being beside as outside ourselves. Generally, a person is said to be "beside himself" when the pressures are of a degree that he is unable to cope—"beside himself with worry," for instance. I in any case do not know what ecstasy "in the sane sense" would amount to, just

because one is really outside oneself in the ecstatic moment, which is a little bit of controlled madness. But I concede that philosophers have used "ecstasy" in a non-ecstatic sense—Heidegger, for example, in his discussion of the temporal dimensions of *Dasein*.[13]

I surmise that what Thoreau meant, sticking his tongue out at the reader, or at least sticking it in his cheek, was that thinking involves putting my thoughts at a certain distance—it means, in effect, reflection. Not just having thoughts, which everyone does, but directing my thoughts, which is a form of regimentation into syllogisms of theory and practice, and the very opposite of ecstasy. Cavell has a somewhat different and perhaps deeper view, which he throws out as an aside by locking it into a parenthesis: "(Thinking does not start from scratch: it as it were sides against and with the self there is and so constitutes it. The question is what must that be in order to be sided, to be capable of asides, to require parentheses.)"[14] This in effect is a comment on Descartes's thesis of the thinking nature of the self, with the emendation that if the self is essentially thought, it is essentially sided, for thinking is conversational. But does that mean that one has to write that way, with all those parentheses and asides? It could be that the style expresses the writer's self, but, if the theory is any good, all selves are sided, however they write. And on this perhaps a few words of commentary will not be amiss.

An aside is a speech outside the action of the play and unheard by the characters in the play, the action of which in no way turns on what the aside says or on the fact that it is said. It is addressed to the audience, who are not part of the action at all. The aside-deliverer has to be part of the action, except when in the posture of aside-delivering. Through delivering it he underscores his complex status as within and without the action of the play. He mediates between audience and the action of the play exactly by putting the play at a certain distance, and by settling the audience in a different relationship to that action than when it is in the action's grip. Usually, asides are scripted, though I suppose I can imagine the possibility of a conversation between aside-deliverer and audience about the meaning of the action: but it would require the other

actors to freeze until the conversation stopped. It in any case is not a conversation between the aside-deliverer and the other characters. It can happen only when the action stops. So it is a bad model for conversation. If I were at this point to deliver an aside to the reader, it would be at right angles to the text. Cavell's asides, his parentheses, are delivered not to the reader but to himself, or to one side of his self from another; the reader, in fact, is ignored. That is why, because internal to the prose, they are so annoying and distracting, keeping the reader's mind off the flow, unable to follow what is action and what is not. Or they are a bit like the patter of the magician, distracting us from seeing how the rabbits are pulled from the hats, with the difference that no one can tell hat from rabbit, action from aside, except that they do not fall into the linearity of good expository prose. It divides the self of the reader into sides, perhaps, as if the style were a kind of ontological proof of what the author says the self is, since reading itself becomes as fissured as the self described and exhibited by the prose. And that is the point: described and exhibited. But philosophical descriptions of the self do not have to be mirrors of the self described; they do not have to show what the text also says. In any case, even if they do show that, this contributes not a shred of evidentiary support for what the text says. So, in even the extreme case of Cavell, I am uncertain there is an internal connection between style and philosophical substance, even if the style exemplifies the substance in a literary way. Of course, there may be this connection: the style is the man, and the theory was evolved in order to justify what Cavell is as a person— a thinker, a talker. But then it goes too far, for it gives the same theory for selves as different from Cavell as he is from everyone else, and who, as persons, thinkers, and talkers, are not like him at all.

This being said, a page or two of Cavell—a paragraph or two, in fact—is almost unmistakable. No one would have the slightest difficulty in identifying it as his, even if it illustrates what one might consider the dangerous side of not holding philosophers to the constraints of audition. And in general this is true of the other philosophers I mentioned in my beginning paragraph, whose styles have been allowed to

flourish, and even to be appreciated. But that leaves my question still unanswered, if it is not already answered in the negative, namely, what is the connection, if any, between the what and the how of saying? The philosopher may be the writing, which means that to discipline the writing is to regiment the philosopher. But is there any internal connection between the writing and the thought? Can, that is, any thought be expressed in any voice, even if not all styles will embody or exemplify it? If the philosopher and the voice are one, do we need to have the philosopher in the writing if we do not need the voice?

Any philosopher with a voice strong enough to be recognized will have a philosophy strong enough to have been commented on, and indeed it will in general be the strength of the philosophy that has allowed the voice to emerge. So each in consequence will have generated a secondary bibliography of articles devoted to his or her philosophy, including, now and again, an article or so by the voiced philosopher on his or her own philosophy. On occasion, one of these is submitted to the *Journal of Philosophy*. Not long ago, for example, we received a paper by a philosopher of world renown defending his position against criticisms of it made by another philosopher of parallel reputation. Given that the submission was by a philosopher who had made it into the no-audition class, it was somewhat affecting that he had actually submitted a paper to us, and it suggests that there remains a value in philosophical journals after all: it gives someone like him a forum for reaching four thousand or so subscribers who would have a natural interest in a paper by him defending his views, as well as the large dilating circle of library readers, recipients of xeroxes, students who may be asked to consider the paper, together with the original critique, in seminars on contemporary philosophy. The editors thought it a valuable paper, since the writer is known to all and read and discussed wherever philosophy itself is read and discussed. The decision to publish it was uncommonly easy.

I remember thinking at the time about the difference between his article and one we might have received from someone who undertook to examine the criticisms of philosopher X of philosopher Y, and who found them

wanting in the same way that philosopher Y found them wanting when he undertook to respond, as in the paper he submitted to the *Journal*. Let us imagine such a paper, by someone named Z, and that Z's paper and Y's paper have pretty much the same content: clearly, Z understands Y's philosophy as well as Y himself does. They examine the same criticizing texts of X, find them deficient for just the same reasons, and conclude that Y's philosophy emerges from the ordeal unscathed. We receive a good many papers of this sort, and we publish a lot of them as well: the papers that seemed to me breakthroughs in my own tenure as editor are few and far between, and I think I can remember them all. Most of what we publish consists of attacks and defenses and counterattacks.

Close in their conclusions as I am supposing the papers by Y and Z to be, it is hard to imagine them as indiscernible. I could not really imagine Y referring to himself in the third person, for example. Suppose, though, he did. Having gone to the trouble of submitting a paper, he might have written: I did not know whether or not you have a policy of blind review, so I have arranged the pronouns in such a way that the referee would be unable to tell that the author and the subject were one. Probably there is software for this: you double-click "Blind Review" in the Edit window, and "I" and "my" get replaced by "Y" and "Y's." And now we can imagine, as I always like to do in doing philosophy, that the papers of Y and of Z are indiscernible. There could be no basis for publishing one rather than the other, and so we might toss a coin and publish Z's paper on Y rather than Y's paper on himself, because that is the way the coin falls. Or suppose the coin falls such that when the veils are lowered, it is Y's paper upon which fortune smiled. Then we rejoice that we have—our readers have—Y on Y. Too bad for Z and his publish-or-perish circumstance. He has only the thin, cruel satisfaction that he is as good on Y as Y is, for whatever good that does him.

In fact, Y's paper was altogether too personal to imagine the blind-review command could regiment it into a state of anonymity. Thus Y might say, "I believe, in matters of this sort. . . . " If the blind-review command transformed this into "Y believes, in matters of this sort . . . "

—which is exactly what Z writes—we would be reluctant to print it. How does Z know what Y believes? But that question does not arise for Y himself, writing "in his own voice." Recently a hapless biographer of Kennedy was not quite able to exploit certain deconstructionist attitudes that there is no real difference between fiction and history, and ascribe thoughts and feelings to the subject for which there is no documentation, the way a novelist does where the issue of documentation is beside the point. The question was always how the biographer knew. People who bought the book wanted fact and not entertainment, and I for one rejoiced, I am afraid, in the book's failure. In any case, Y, speaking in his own voice, has a right to say what his beliefs are when, were these ascribed to him by some third person, the latter would have to be documented. So the blind-review command would have to be quite sophisticated indeed, and instruct Y to document what, in the first person, he can state with no documentation whatever. But beyond this, I am uncertain the software exists which could depersonalize a text by Y, irrepressible as he is as a writer and a person and with the sort of voice everyone in philosophy is sensitive to. On the other hand, it is possible to imagine that Z, Y-ist that he or she has become, has begun to imitate as an inadvertent tribute the voice of Y. There is always a danger in matters of blind review that referees will be taken in by imitations, especially when the model imitated has a strong and identifiable voice. It is an open secret that the judges picked a certain submission for the Paris opera house design at Bastille because they were certain it was Richard Meier's, having all the marks. The result was a Meier-like edifice, derivative in style and banal in conception. The danger could be dissipated were judges to employ the criteria of "good architecture," but the difficult truth is that voice is as complicating a factor in architecture as it is in philosophy. It may not be part of good architecture, but there is no good architecture without it. And thinking the building was by Richard Meier gave the judges a good reason to choose it, thinking how important it would be to Paris to have an example of this artist's work. Paris is an architectural museum, after all.

But the *Journal of Philosophy* is not a philosophy museum! And I can
at this point hear someone say: What difference does it make? After all—
as I myself have argued—the voice does not really penetrate the philos-
ophy: the philosophy is the arguments. The question is in the end
whether or not X was right about Y, and it does not matter who comes
up with the good answer, its goodness being independent of who
comes up with it. This is the bottom-line view of philosophy, that phi-
losophy does not vary in any significant way depending on whose fingers
it comes out of or out of whose mouth it issues. The bottom-line view
of philosophy is what underlies blind reviewing, and that means sup-
pressing whatever does not on the bottom-line account belong to the
philosophy. And that means, as I see it, the suppression of voice. For if
the voice is allowed to seep through, the conditions of the blind review
have been violated.

"What difference does it make?" is a question I have dealt with in the
philosophy of art, where it might arise with the differences, never rele-
vantly visible, between a photograph and an appropriation of that
photograph, between a painting and its appropriation. Here one is able
to show that even the subject differs, and that all those facts about the
artist—the artist's time and place and psychology—make immense dif-
ferences in how the work is identified and interpreted, and even in aes-
thetic assessment. If philosophy were literature, the strategies that
worked so well in the philosophy of art would work with philosoph-
ical writing too. But here we are not dealing with the poetics of philos-
ophy, with philosophy's rhetoric, but with philosophy neat, clean, and
simple, where issues of logical consistency and truth trump those that
pertain to the expressive dimension of writing. If Wittgenstein held no
theories, he would never be falsified, and so the test can never arise as to
whether his writing would retain its charm in the face of philosophical
falsehood. But, as even Cavell, the great expositor of voice must hold,
there are theses—about, among other matters, self, conversation, theses,
voice—and so truth or falsity, to the assessment of which voice seems
hardly to matter, at least if my arguments have been sound. Once that is

allowed, voice may be written off as whatever it was that Kripke alluded to as "caginess," and the theses advanced in what he also calls a "straight-forward" way. And why not then go all the way, to the philosophical format that passes the test of the bottom line, and which answers the question "What difference does it make?" with a curt "None." So I have argued myself into something of a quandary, having incompatible attitudes on voice. I am not sure I know the way out of the quandary, but I will end this essay with a sketch of an exit. It turns on distinguishing voice from self.

The degree to which Y has come to take the privileges that accompany his reputation for granted is testified to by the casualness with which he submitted a paper through which his own familiar and famous voice speaks directly and clearly, with no effort whatsoever to disguise it in the interests of blind review. He has obviously sent his pieces to places for a very long time where the presumption was that they would be printed, subject to minor editing. It is true that the *Journal of Philosophy* has no policy of blind review, but I dare say Y knew nothing of this widely criticized fact. Had he sent his paper to a journal that insists on blind review, the editors, pleased as they would have been to publish Y's article, would have had in consistency to demand that he comply to their strictures of anonymity. This at the very least would mean the elimination of the possessive case from descriptions of his own writings and thoughts, so that there would be no grammatical mark to the effect that he was writing about his own philosophy, and hence no grammatical evidence of the authority he commands regarding what he means and how he sees the implications and consequences (not to speak of his hopes for its future development). He would have to write about himself as if he were a third person, which directly affects the content of what he can consistently describe. The reason voice is relevant to philosophical writing is that philosophical writings by a single person form complex systems and constellations of ideas—they have pasts and futures as well as presents—and the reasons we are interested in voice are those which explain our interest in philosophical creativity. Creative philosophers do

not do philosophy by producing atoms of bottom-line "good" philosophy. What they write carries what they have written and what they hope to write as the aura of a total vision.

Now, in truth, I am uncomfortable with the idea of producing papers from which a zealous enough referee can infer nothing about one's gender, one's race, one's age, one's place, or indeed infer anything that can be elevated into a fulcrum of prejudiced rejection. A well-known art magazine for which I occasionally write does not, of course, insist on blind submission—there are no submissions for the most part, but commissions instead—but its publisher insists on a stylistic difference between the articles, where the author is not to speak in his or her own voice, and the columns and departments, where one is expected to speak in one's own voice. One would think that philosophy would have the natural standing of a column, an expression of the writer's views and the writer's philosophical personality. So it is somewhat striking that blind submission should have the effect of transferring writing from the columnist's to the reporter's codes, where the latter complies with the "Just the facts, please" stance of the forensic examiner. At the very least we cannot expect very colorful philosophical personalities to emerge from under that order of regime, nor very colorful philosophy.

Now, of course, as a general rule, all that blind submission amounts to is the suppression of information on the title page in which the name of the author and his or her institutional affiliation is recorded, but I have often pointed out how transparent authorship really is, if only through the fact that the longest number of bibliographical entries is a dead giveaway of who the author is. Anyone anxious to find out who the author is can have scant difficulty, for manuscripts are really strewn with clues. So, strictly speaking, blind reviewing is ritualized suppression of title-page information. But were the policy really strict, authors should not refer to their bodies in a gender-specific way, since that would enable a biased reviewer to turn a manuscript down. Nor in fact should they refer to any of those distinguishing features for the sake of which blind review was instituted, to ensure that there be no prejudiced rejection. This would

244 / In Their Own Voice

then have the inadvertent consequence that everyone would sound alike.
But we really do experience the world and life as gendered beings, as
beings with all the attributes that expose us to the danger of prejudice.
This means that suppression of our facticities results in a distorted rep-
resentation of the world, the world according to Nobody. And this
makes bottom-line philosophy abstract and distorted and surrealistic.
We talk of Twin Earth, of being connected in some science-fiction way
to a violinist who depends on us not to "abort" him, of veils of ignorance,
one important criticism of which is that they presuppose a view of
humanity which blind reviewing as a practice institutionalizes. In gen-
eral we indulge in thought experiments of various kinds where universal
intuitions of readers are appealed to, which have nothing to do with the
way we are embodied or situated or encultured. And my view is that in
detaching writers from their own reality the resulting philosophy is air-
less and detached, with no tethers to human reality beyond the dubious
intuitions alleged to be universal. Yet think of how those who believe in
blind review are likely to be critical of Kant for treating human beings
as vehicles of pure reason with nothing to connect them to the world
save semantics, as though how we decided had nothing to do with our
having bodies, or with having to grow up.

Needless to say, all this cannot be blamed on a reasonably benign
practice meant to secure fairness in the place of publication. Philosophy
in its professional practice has loosened itself more and more from the
world as we really experience it anyway, in our embodied and historical
natures, in its drive to secure something disembodied and timeless. And
I think a dreadful price, the price of irrelevance, is paid for this: nobody
reads philosophy but philosophers. Here is one philosopher who is privi-
leged to speak in his own voice, Stuart Hampshire, writing about an-
other so privileged, John Rawls, in the pages of the *New York Review of
Books* about Rawls's recent book, *Political Liberalism:* "One tends to be
lulled into acquiescence because the noise and muddle of actual politics
are altogether absent, and history is scarcely called upon at all." This
makes Rawls's analysis too remote, "too gentle and too temperate in tone,"

too much finally of the seminar room and not of the negotiating table or the war room.[15] It lacks the teeth of engagement and commitment.

Some years ago an essay appeared, dispiriting in its title for aestheticians, called "The Dreariness of Aesthetics." These days, I am afraid, I find almost everything in philosophy except aesthetics pretty dreary, and the dreariness has been driven out of aesthetics, it seems to me, by virtue of the fact that it is more and more written by philosophers engaged in the raw world of artistic conflict, far indeed from Twin Earth, and where brains in vats might be things that turn up at the Aperto in Venice or at the Whitney Biennial. Let blind review continue, but blind philosophy might to everyone's profit stop being written. Philosophers should be encouraged to speak in their own voice about the world that means something to them. The freer the voice, the better the philosophy. For now, that is the only connection I see.

NOTES

1. Theodor Kiesel, *The Genesis of Heidegger's "Being and Time"* (Berkeley: University of California Press, 1993), 16.

2. Martin Heidegger, "What Is Metaphysics?" in *Existence and Being* (Chicago: Henry Regnery, 1949), 369: "Nihilation cannot be reckoned in terms of annihilation or negation at all. Nothing 'nihilates' *(nichtet)* itself." The chief finger-pointer was Carnap; see especially his "The Elimination of Metaphysics through Logical Analysis of Language," trans. Arthur Pap, in *Logical Positivism*, ed. A. J. Ayer (Glencoe, Ill.: Free Press, 1959), 69–73. In my generation, such translations of "Das Nichts nichtet" as "(Ahem!) 'Nothing noths'" could always be counted on for a mirthful audience response.

3. Thus in his *A Pitch of Philosophy* (Cambridge, Mass.: Harvard University Press, 1993), 69, he praises J. L. Austin for curing "the repression of voice (hence of confession, hence of autobiography)" in philosophy.

4. Stanley Cavell, *Conditions Handsome and Unhandsome: The Constitution of Emersonian Perfectionism* (Chicago: University of Chicago Press, 1990), 79.

5. Saul Kripke, *Wittgenstein on Rules and Private Language* (Cambridge: Cambridge University Press, 1982), 70–71.

246 / In Their Own Voice

6. Cavell, *Conditions*, 79.

7. Ludwig Wittgenstein, *Philosophical Investigations*, trans. G. E. M. Anscombe (New York: Macmillan, 1955), no. 217.

8. Cavell, *Conditions*, 81–82.

9. Ludwig Wittgenstein, *Tractatus Logico-Philosophicus* (London: Routledge & Kegan Paul, 1923), 4.1212.

10. Samuel Johnson, "Preface" to *Shakespeare: Works*, in *The Yale Edition of the Works of Samuel Johnson* (New Haven: Yale University Press, 1958–), 6:62.

11. Cavell, *Conditions*, xxxvi.

12. Ibid., 9.

13. Martin Heidegger, *Being and Time*, trans. John Macquarrie and Edward Robinson (New York: Harper & Row, 1962), 377–78.

14. Cavell, *Conditions*, 9.

15. Stuart Hampshire, Review of *Political Liberalism* by John Rawls, *New York Review of Books* 40, no. 14 (August 1993): 46, 47.

Index

Abelson, R. P., 220
aboutness, 21, 41, 203
action: agency, 53; as basic concept, 55; causal relationship in, 75–76, 93; causation and truth in philosophical accounts of, 13; explanation of, 90–91, 132, 177; Hume's theory of, 68; ideational attitudes as, 34–36; intentions and, 75–76; and knowledge, 55–57, 66, 73, 75–76, 79–80; as known immediately to the agent, 50; and misperformance, 13, 69; reasons as causes of, 57–59, 76–79, 144n. 1; representational cause as criterion of, 57, 60; Sartre on, 66, 73; and sentential states, 90–91; truth-component in, 76. *See also* basic actions; intentional action; nonbasic actions
aesthetics, 176, 245
agency, 53
Alexander, Peter, 131–33, 138, 145n. 13
analytical philosophy: and Analytic of Concepts, 53–55, 57; and ordinary-language analysis, 174; point-of-view idea in, 175; propositions as focus of, 225; translational theses in, 84–85.

See also analytical philosophy of history
Analytical Philosophy of Action (Danto), 15
analytical philosophy of history, 164–83; as beginning with Hempel's "The Function of General Laws in History," 164; diminished significance of, 167, 182; representation in, 13
Analytical Philosophy of History (Danto), 6, 15, 16, 166
Analytical Philosophy of Knowledge (Danto), 15, 16, 27, 87
Analytic of Concepts, 53–55, 57
animals, 93, 157
Anna Karenina (Tolstoy), 27
anorexia nervosa, 138–39, 140
Anscombe, G. E. M.: and example of mental causation, 124; and example of shopper and detective, 56; "I do what happens," 72, 76; on intentions, 71–72; on knowledge without observation, 50, 70; and phantom limbs, 73; on practical knowledge, 69–72
appearance, 104

Compositor:	BookMasters, Inc.
Text:	10/15 Janson
Display:	Gill Sans
Printer:	Data Reproductions Corp.
Binder:	Data Reproductions Corp.